The Filthy Reality of Everyday
DIRT

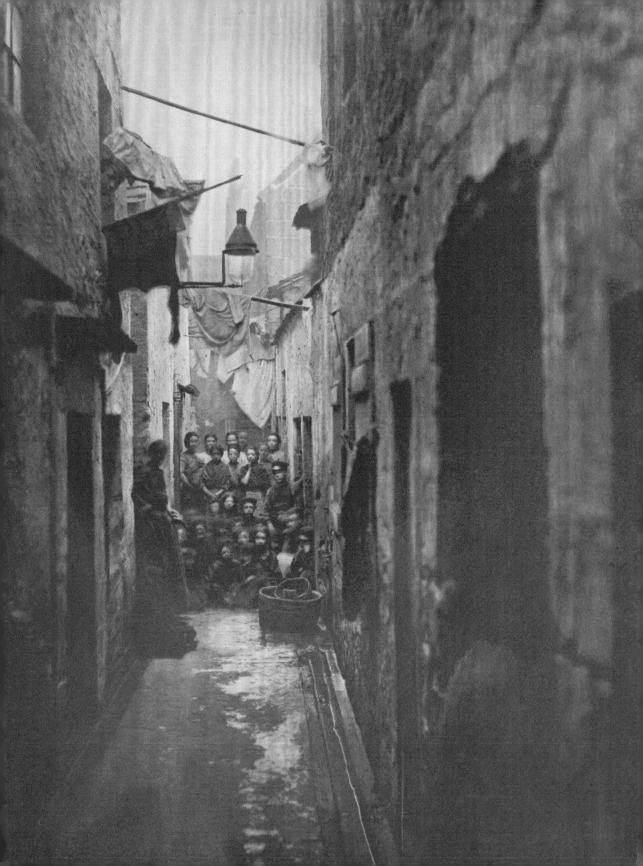

The Filthy Reality of Everyday Life

DIRT

Rosie Cox
Rose George
R. H. Horne
Robin Nagle
Elizabeth Pisani
Brian Ralph
Virginia Smith

P

PROFILE BOOKS

First published in Great Britain in 2011 by
Profile Books Ltd
3a Exmouth House
Pine Street
London EC1R 0JH
www.profilebooks.com

In association with Wellcome Collection

**wellcome
collection**

Wellcome Collection is a free destination for the incurably curious devoted to exploring
the links between medicine, life and art. Three galleries, a range of events and the unrivalled
Wellcome Library root science in the broad context of health and wellbeing.

See www.wellcomecollection.org

Wellcome Collection is a part of the Wellcome Trust, a global charitable foundation dedicated to
achieving extraordinary improvements in human and animal health.

'The History and Future of Fresh Kills' by Robin Nagle on pages 187–202 is an edited, updated
and fully revised version of 'To Love a Landfill: the History and Future of Fresh Kills', first published
in *The Handbook of Regenerative Landscape Design*, edited by Robert France, published by
CRC Press, 2008.

Copyright and other information about illustrations appears on pages 213–14. All illustrations
not attributed elsewhere are reproduced by permission of the Wellcome Trust.

10 9 8 7 6 5 4 3 2 1

A CIP catalogue record for this book is available from the British Library.

ISBN 978-1-84668-479-1
eISBN 978-1-84765-742-8

Edited by Nadine Monem
Editorial consultant: Paul Forty at Brookes Forty
Text and cover design: Rose

Printed and bound in Great Britain by
Butler Tanner & Dennis Ltd, Frome and London

Any omissions and errors of attribution are unintentional and will, if notified in writing to
the editor, care of the publisher or the Wellcome Trust, be corrected in future printings.

Previous page (frontispiece):
Thomas Annan was a nineteenth-century Scottish photographer who is widely
known for being the first to document the housing and living conditions of the poor.
Here, Annan photographs the inhabitants of a crowded Glasgow lane.
Thomas Annan / Close 118, High Street, Glasgow / 1868 / photograph

CONTENTS

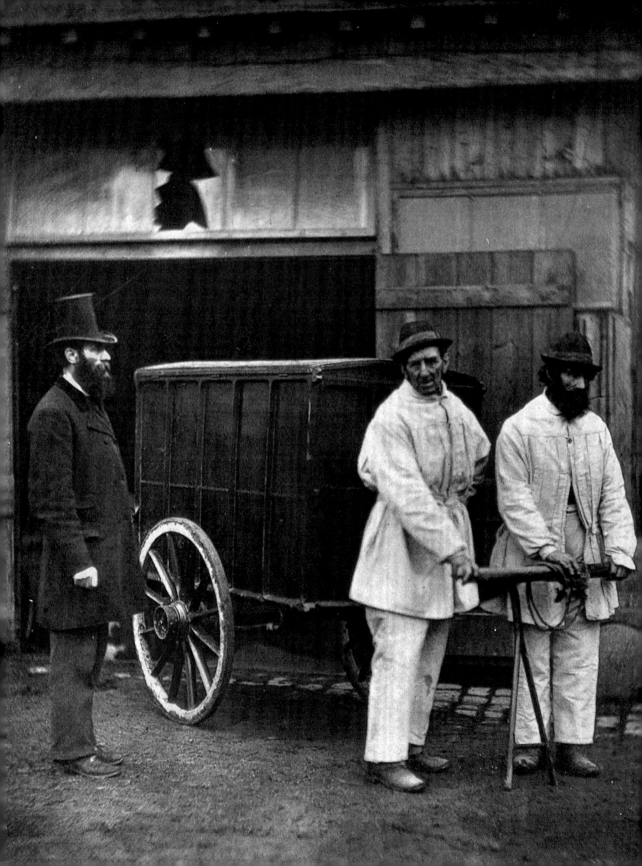

Opposite:
Two men wearing white overalls are shown pulling a covered hand-cart through the parish of St George in Hanover Square, London, in the 1880s. The cart contains a mobile disinfection unit, and the workers are observed by the Inspector of Nuisances, a Mr Dickson.
J. Thompson / Public Disinfectors from the Parish of St George / 1887 / Woodbury Type / 11.6 × 6 cm

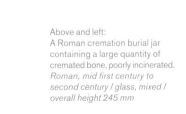

Above and left:
A Roman cremation burial jar containing a large quantity of cremated bone, poorly incinerated.
Roman, mid first century to second century / glass, mixed / overall height 245 mm

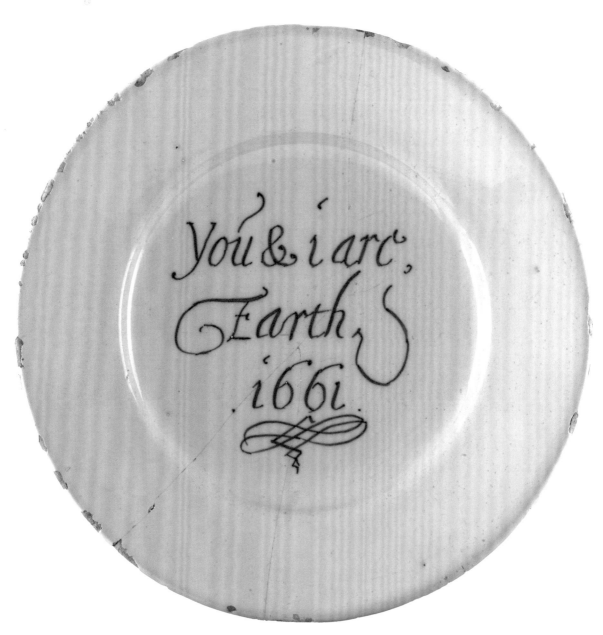

A delftware plate with the inscription
'You and I are Earth, 1661', possibly
as a reminder of mortality.
English, 1661 / diameter 210 mm,
thickness 34 mm

INTRODUCTION

KATE FORDE

This book is about dirt, something we are often reluctant to confront, and might prefer others to deal with. Dirt is ubiquitous and takes many forms, from the palpable to the symbolic. In the following pages, and in the exhibition of the same name staged at the Wellcome Collection in March 2011, dirt encompasses dust, refuse, excrement, bacteria and soil, and is used to describe unethical, irreligious or obscene behaviour. Though we struggle to avoid it, humans, like every other living organism, are extremely efficient generators of dirt, our excretions proof of a world beyond our rational control, which may explain why dirt arouses such visceral responses as disgust and anxiety. Indeed, the deterioration of our own bodies, our inevitable return to dust, is perhaps the most profound and unsettling reminder of how, in the end, everything disintegrates – hardly a subject for the sentimental.

Paradoxically, dirt is also a marker of civilisation; the variety and scale of the waste produced in our factories is the uncelebrated evidence of industrial and economic progress. And dirt is magical – crops grow in soil, strains of antibiotics are discovered in sewage, and in the Old Testament Adam was created from clay. In fact, the planet's ingenious methods of recycling waste, from the process of decomposition to the production of oxygen in photosynthesis, turn out to be the reasons for its very survival.

As this book goes to print, and the exhibition it accompanies opens to the public, we are living in a new and unmistakably filthy era. According to the United Nations, the early years of the twenty-first century marked a decisive demographic shift, with over half the world's citizens living in urban rather than rural habitats for the first time in history. From a public health perspective the risks associated with dirt are especially evident in the metropolis, as a consequence of overcrowding, poor sanitation and inadequate public hygiene. Today the inhabitants of slums such as Dharavi in Mumbai and Kibera in Nairobi are threatened by the same infectious diseases (cholera, typhoid, typhus and so on) that killed millions in the cities of Europe and North America during the nineteenth century, before sanitary reforms. While access to basic sanitation remains a luxury for 2.6 billion people (a fact which ought to arouse disgust), some scientists in the West have discovered a curious appreciation for dirt. Proponents of the 'hygiene hypothesis' suggest that children growing up in hyper-clean environments are not exposed to the kinds of bacteria necessary to help their immune systems to develop. They argue that over-sterilised environments can lead to an increase in resistant forms of microbes, lending scientific credibility to the old adage that we must eat a peck of dirt before we die.

Although spectres of monstrous landfills, overflowing sewers and catastrophic oil spills might disturb our dreams, Western civilisation has become adept at overlooking the filthy reality of everyday life. For centuries our strategies for managing dirt have been the responsibility of an underclass of women and minorities, and in our modern

'throwaway' culture, the job of sweeping up usually falls to migrant workers. In addition, those who do the work of keeping dirt at bay are often felt by others to be contaminated simply by their association with it, something psychologist Paul Rozin attributes to a kind of 'magical' thinking.

As unsalaried artist in residence at New York's Department of Sanitation, a post she has held since 1977, Mierle Laderman Ukeles has created a number of works which both reveal the human labour sustaining our cities and seek to transform our relationship to the things we throw away. Presently Ukeles is part of a team working to regenerate Fresh Kills on Staten Island, the world's largest municipal landfill until its closure in 2001. By 2030, if everything goes to plan, the landfill will become a massive public space, almost three times the size of Central Park and, so Ukeles hopes, not only a symbol of relentless consumerism but an opportunity for redemption. She intends to invite a million members of the public to donate something they value to the site, each item small enough to fit in the donor's hand. These things, the opposite of cast-offs, will be carefully collected, recorded and displayed at Fresh Kills in a process designed both to renew the landfill symbolically and to reconnect people directly to the once-degraded land. Ukeles' proposal tackles the fundamental issue governing public perception of Fresh Kills. Namely the millions of tons of scorned objects making up the essence of the landfill are considered abject and worthless because of their volitional abandonment by their original owners along with the effects of their decomposition, and this has infected the perception of the whole place. The task, as she sees it, is not only to re-develop the living landscape (a huge undertaking in itself), but also to definitively transform the meaning of this land by creating a continuous counter-layer 'kissing the surface' of valued, preserved individual offerings, also volitionally released from individual ownership, yet not rejected. Rather they are offered to be 'shared in community' as a symbol and a marker that the meaning of this land has now changed where its material, though publicly possessed, retains its value, identity and connection to the citizens all over New York City. In this way, the land itself can be redeemed.

The essays in this book are intended as provocative introductions to this vast and complex subject. Taking their lead from the eminent anthropologist Mary Douglas's well-known observation that dirt is dependent on its context for definition, that it is 'matter out of place', they play on ideas of location and scale ranging from the microbial to the environmental. Virginia Smith considers dirt that is intimately connected with the human body and the ingenious techniques we have developed to get rid of it, in the process highlighting our physical attachment to the earth. Rosie Cox investigates the politics of dirt in the domestic sphere, explaining how changing constructions of dirt and cleanliness have shaped our use of private and public space and influenced our relationships with each other. Brian Ralph's graphic essay is a witty celebration of dirt, envisaged here as both a source of creative inspiration and indicator of authenticity. Elizabeth Pisani offers a hymn to dirt in the community, integrating a variety of social and cultural perspectives, and warning us of the dangers of being too clean. Rose George presents an impassioned case for the evolution of our existing sanitation systems, pointing out that the invention of the flush toilet eliminated not just excrement itself, but also any serious discussion of it. Finally, Robin Nagle contemplates the mutual dependency of the city and the landfill; eloquently reminding us that the dump is a modern incarnation of a public commons – shared land set aside for the benefit of all. Nagle's chapter makes for illuminating reading next to an excerpt from R. H. Horne's 'Dust, Or Ugliness Redeemed', first published in Charles Dickens's journal

Household Words in 1850. Horne's portrait of the great dust heap at Gray's Inn Road reveals London's reliance on an astonishing economy of waste, and its debt to the scavengers who eked out a living there by trading in everything from dead cats to broken pottery. We hope readers will be similarly inspired by this fascinating selection of essays, and may even be encouraged to reassess a subject which, though all around us, often goes unexamined.

The task of investigating this challenging subject has been made immeasurably easier and more enjoyable by the conversations those of us involved in the exhibition have had with a number of people, too many to mention by name here. In addition to the contributors who have provided such fascinating perspectives to this book, we would like to thank the editor Nadine Monem and our publishers, Profile Books, in particular Andrew Franklin and Paul Forty, who have provided consistent support and advice throughout its production. In relation to the exhibition we would like to thank Mierle Laderman Ukeles and our curatorial advisors Claudia Banz, Vibha Chauhan, Meghna Haldar, Colin Martin and Paula Summerly. Special thanks are due to our colleagues Lucy Shanahan (Curator, Temporary Exhibitions) and Poppy Bowers (Exhibitions Coordinator) and the staff of the Wellcome Library and Science Museum. We would also like to thank the artists, designers and all those who so kindly lent material to the exhibition. Last, but certainly not least, we would like to express our thanks to Victoria Escobar and her team of cleaners at the Wellcome Trust's London office, who manage the dirt in our working environment so that we don't have to.

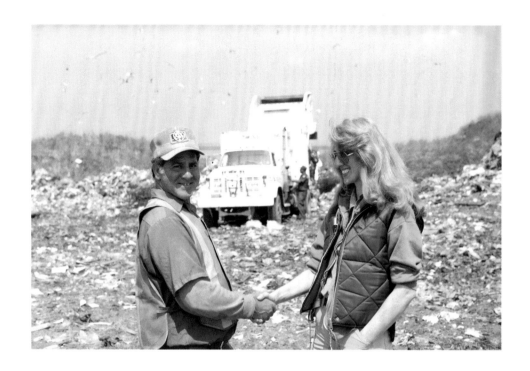

Touch Sanitation was Mierle Laderman Ukeles' first performance
as unsalaried artist-in-residence of New York City's Department
of Sanitation. After one and a half years of research, Ukeles performed
ten 'sweeps' around New York City, travelling to all of the city's
community districts to meet 8,500 workers, facing each one to shake
their hand and say 'Thank you for keeping New York City alive.'
Mierle Laderman Ukeles / Touch Sanitation Performance:
Fresh Kills Landfill / 1977–80 / photograph / 152 x 229 cm

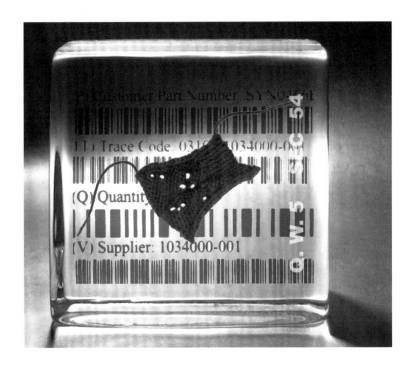

Maintenance artist Mierle Laderman Ukeles has put forth a conceptual proposal for a public artwork called 'Public Offerings Made By All Redeemed By All' for Freshkills Park. To renew the site's meaning, one million 'donor citizens' are invited to offer an object of value to the site, no bigger than the palm of their hand. Each object, with a barcode linked to a web archive listing its origin, would be suspended in its own glass block and embedded in paths and vertical surfaces across the park. *Mierle Laderman Ukeles / Public Offerings Made By All Redeemed By All / 2000–2011 / example of an embedded offering, housed in a recycled glass block with integral barcode.*

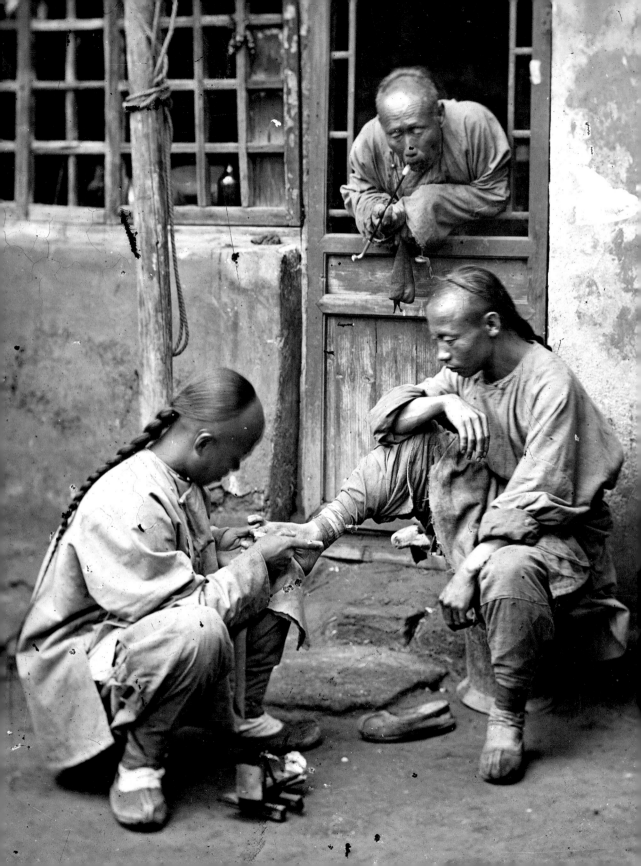

EVACUATION, REPAIR & BEAUTIFICATION

DIRT AND THE BODY

VIRGINIA SMITH

A short time ago, our family was buying large containers of hair conditioner on a regular basis for a reason that will be familiar to most parents. Nits were rife in our children's primary school. There was always one child who escaped the vigilance of the school secretary and re-infested the rest. We all had to learn how to deal with nits, and cope with the long after-bath sessions fiddling with nit-combs and various lotions. After trying products containing toxic nit-killing chemicals, and extremely expensive organic herbal concoctions, we decided that liberal application of simple conditioner did the best job. The nits' little legs (and eggs) literally could not keep hold of the slippery hair, and were easily swept off with a comb. We settled into a routine, and the parasites slowly disappeared. It seems that the nits were quite fussily age-specific – our children's nit woes lasted from about age six until about age ten, and they haven't returned since.

Nits, fleas and body-lice have always been considered shameful – and dirty – because they seem to act as proof of neglected or unkempt bodies. Apart from sheer discomfort and disease, there are indeed strong social reasons to remove them. Parasites are not dirty in themselves, of course; they are just small animals fighting for survival. Indeed, definitions of dirt are almost always a matter of perspective. Dirt is intrinsically amoral. It can be destructive, but it can also be fertile. For humans, dirt is acceptable 'in its place', where it seems natural or necessary, and where it can be

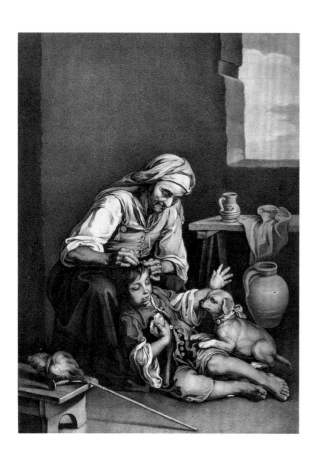

Previous page:
A travelling chiropodist at work in Peking servicing the feet of a customer in the settlement's common space, while a local looks on.
John Thomson / A Travelling Chiropodist, Peking / 1869 / photograph

Left:
An old woman picking fleas out of a small boy's hair.
Barolomé-Esteban Murillo after Ferdinand Piloty / A Domestic Scene / 1810–21 / lithograph / 44.8 × 32.9 cm

controlled. But if 'dirty' matter appears anywhere it shouldn't, it is perceived as disunity, or as a potential threat. It seems that dirt represents things that are alien to our physical and conceptual boundaries and is often met with a mixture of distrust and fear. Only very occasionally is dirt praised as a force for good.[1]

My investigation here focuses on the dirt that is intimately connected with the human body, how we perceive it and how we get rid of it. In the long cosmic history of material 'dirt', we are, methodologically speaking, dealing with two different but overlapping stories: human history and biological history. Both operate simultaneously, and we experience them simultaneously; indeed, there are legacies of our biological history built into the practices and behaviours that we consider our most refined – hygiene for example. Our universal biological and cultural aversion to dirt has created a physical dirt-ridding culture – technical, mental and economic – that operates worldwide, and has been doing so for some time.

Anyone seeking a link between a public toilet in Mumbai, a slum street in nineteenth-century London, a modern landfill, a hygiene museum and a hospital will find one in the Bronze Age. This was when all Eurasian peoples, east and west, started using sophisticated metal grooming tools and wearing washable clothes. They also had public rubbish dumps and public fountains. Five thousand years from the Bronze Age to the present is a blink of an eye in evolutionary terms, but the historians of hygiene have tended to overlook the long primeval periods in favour of much later events. Despite this, the facts and developments of those primeval periods certainly affect human practice today; indeed, our biological history still plays a daily role in our lives, and is responsible for much of our dirt-removing behaviour.

The processes through which human physiology, and human behaviour, maintain and adorn the body can be thought of as falling into two main categories. Evacuation, or how the normal human organism maintains a healthy internal balance; and repair, or how human behaviour has developed to identify and correct physical problems on the body's surface.

Zoology shows us that we share our parasitology with all other animals, just as we share most of our physiology with all other mammals. We also share a dirt-removal system which is both familiar and unfamiliar – animal grooming. Grooming is our second line of natural defence against dirt (evacuation being our first) and is closely linked to the development of various artificial technologies, including the laboriously constructed philosophy we know as 'hygiene'. Indeed, biology and zoology explain a lot about some of our most cherished 'habits, customs and manners'.[2]

The evacuations – internal and external physiology

A fully equipped bathroom, with hot and cold water, mirrors, lotions, towels and toilets, is a truly luxurious facility for those lucky enough to have one. But in the days before the advent of these modern comforts, nature had already devised ways of dealing with dirt, both inside and outside the human body, which worked extraordinarily well. If they had not worked, we would have been wiped out as a species long ago. In fact, our old mammalian physiology is still on 'dirt alert' every moment of the day, in most cases without us even being aware of the process.

The literary remains from Bronze Age and classical medicine show that early populations were extremely health conscious. One of the most important tools for diagnosis in the past was the constant watch kept on what was known as 'the

This study depicts the lifecycle of the flea, from egg to adulthood.
Anthony van Leeuwenhoek / The Development of the Flea /
from Arcana Naturae / 1695

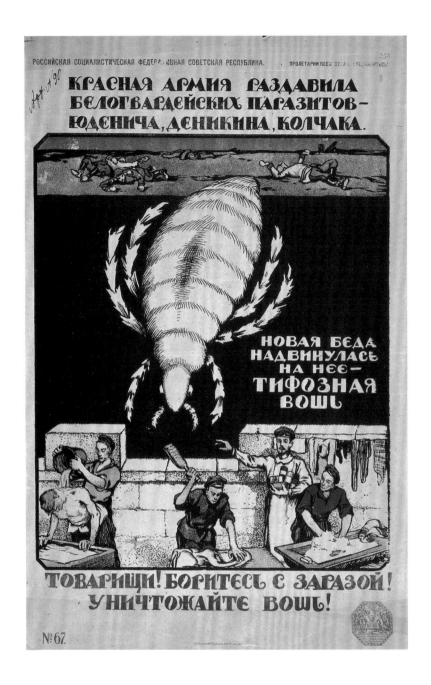

A public hygiene poster warning of the dangers
of the typhus louse and instructing Soviet 'Red
Soldiers' to fight the threat of typhus by washing
themselves and their clothes vigorously.
*Artist unknown / public hygiene poster / 1921 /
colour lithograph / 52 × 33.5 cm*

evacuations' – the matter that came out of the body. Internal cleansing was the rationale behind the many types of 'purging' devised by the practitioners of early Eurasian medicine, from China to Rome, for example bleeding, vomiting and bowel evacuation. Ancient people knew that the body processed what went into it, and then ejected it in some form or another, but they did not know exactly how the different processes worked. Many centuries later, the evacuations can still provide a good indicator of health or disease, but we now know much more about the different layers of the body's defensive systems.

The war against dirt starts in the body's cells. Our cells are bathed in water, which is consistently kept at the correct degree of purity. Should that degree of purity reduce, the cells become damaged and begin to die. Restorative or healing processes start immediately at the site of any damage to the body. Every cell has a designated systemic response to foreign or 'alterior' invaders, which is triggered as soon as they become a threat. It is this system, our immune system, that deals with the external pathogens (such as bacteria or viruses) which the body is constantly coming into contact with and which it usually succeeds in defeating.[3]

Then there is the dirt-defensive system represented by the major organs. For example any food or drink going into the body has to be sufficiently pure for the body to ingest. Otherwise, the body's nervous system expels it by vomiting, in some cases immediately. So important is food to life that virtually all major internal organs are dedicated to its processing: the stomach, whose enzymes break it down into useful chemicals; the kidneys and liver, which filter and cleanse the resulting liquids; the bowels, which evacuate the physical waste, or redundant water and solids. Food is also our major source of dirt, so the body is particularly attentive to its ingestion and metabolism. The skin is another major waste remover, constantly shedding excess water (which we call sweat) through vaporisation.

Interestingly, while human sweat is a more or less socially acceptable 'dirty' substance, and even human urine apparently seems to have been historically more acceptable than it is today, human faeces are certainly not. We have a very low threshold of tolerance to turds – even the mention of them. This is probably due to their powerful smell, which triggers an immediate response in the brains of all humans, perhaps more so than any other fetid smell on earth. This is where the brain's defensive system comes into play, via the sensory organs, producing an immediate recoil response, also known as 'the disgust response'.[4]

The body's sense organs (in this case the nose) tell the brain, far quicker than any of the brain's thought processes could, to recoil, to physically move away from the source of the bad or harmful odour. We avert our heads, stagger backwards or hide our faces, experiencing the same physical recoil when we touch, see, hear or taste anything else that is unfavourable to the body. Human blood, however, has a slightly different sensory trajectory – somewhere between high and low tolerance. Its taste, smell and appearance are not unpleasant, and generally not immediately disgusting to us. The same applies to a lesser extent to pus, the watery discharge produced during the healing process. It is tempting to ascribe this ambivalence to a functional cause – that the body 'needs' other people's assistance when there is any blood or pus on its surface. And other humans will generally provide this service, in most cases, without any disgust recoil.

Menstrual blood is a different matter. Visible menstruation is unique to humans and to our close relatives, the chimps. In other animals, all the endometrium (the lining of the uterus) is reabsorbed into the body, but in humans only some of it is. Menstrual

blood, though it issues naturally, is widely believed to be dirty or disgusting, and an extensive worldwide raft of human purity rules surround it, prohibiting touching or sometimes even associating with a woman who is menstruating. In some tribal societies the woman is sent away from the home to another place until she is 'clean', and is often required to bathe before she is admitted back into the group. Menstrual bleeding must have been a huge practical problem for ancient women wanting to keep their clothes clean, as it continues to be for women in many parts of the world today. Before the introduction of paper hygiene products in the early to mid twentieth century, women used home-made pads of rags sewn onto a cotton belt; before that they may have used woven grasses and absorbent mosses or leaves, or (as the Romans did) absorbent sponges. Menstrual blood seems to have produced a heightened sense of danger and fear in early societies – perhaps even its insistent monthly regularity was perceived as a threat.[5]

Your body can call upon so many natural cleansing processes that you have to be very unlucky for a microbial disease or poison to penetrate these inner defences. Genetic predispositions aside, the natural state of the body is health and wholeness, rather than ill-health and unsoundness. But the other major threat is the surrounding macro-environment. The body guards itself very carefully against the dangers of the 'alterior' world. The sense organs literally stick out into the world, acting as the main interface between the internal and the external. These highly delicate receptors evaluate the different degrees of threat posed by foreign bodies, as well as (just as importantly) the objects or activities which the body desires or needs.[6] But whatever the eyes, ears or nose detect, the hands mostly deal with. This is where grooming, or maintenance of the body surface, comes into play.

There is absolutely no reason to distinguish ourselves from other animals when it comes to our body surfaces. No matter how sophisticated our grooming behaviours may appear, many of them are pre-programmed and find their roots in our biological history. All mammals must look after their outer covering – their pelage – to make sure it remains healthy and undamaged and can continue to protect that vital internal environment. Humans are no exception.

Human grooming – an ethological system within a historical context

Zoologists have been studying Care of the Body Surfaces, or COBS, for many years, and have developed a good corpus of knowledge of how different grooming systems work from species to species. It seems to be significant that primates (our direct ancestors) spend up to 20 per cent of their time grooming, far more than any other mammal. Grooming apparently promotes the intricate bonds of affection that are so important for social animals. In larger primate groups there is some additional 'vocal grooming', or intimate sounds accompanying normal touch routines. It is even suggested that vocal grooming may have contributed to the development of language. Zoologists interested in grooming practices generally divide behaviour into two categories, auto-grooming and allo-grooming. Most of the routine grooming that humans and animals do can be classified as auto-grooming, the grooming of oneself by oneself. Allo-grooming, on the other hand, is defined as the practice of grooming, or being groomed by, others.[7]

Animal grooming is done on a preventive basis – stopping small problems from becoming big ones – and consists of many small practices that depend on repetition for their effectiveness. Grooming in animals is usually done from the head

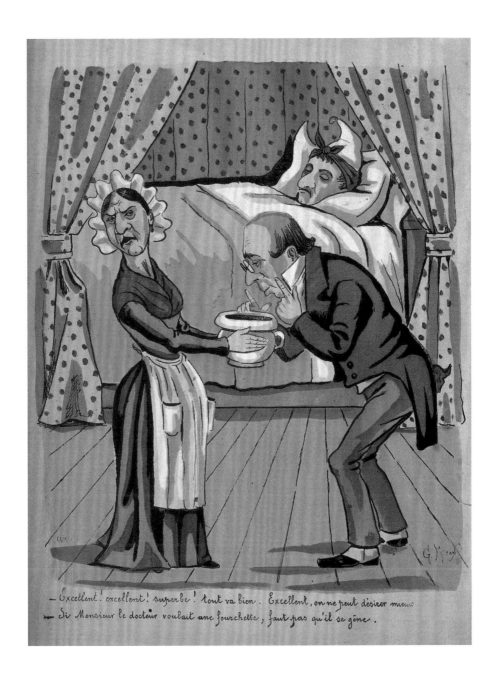

— Excellent! excellent! superbe! tout va bien. Excellent, on ne peut désirer mieux.
— Si Monsieur le docteur voulait une fourchette, faut pas qu'il se gêne.

A physician examines a patient's bedpan, appearing pleased
by the contents. The maid asks him if he would like a fork.
Gustave Frison / A Physician Examines a Patient's Bedpan /
1890 / coloured lithograph

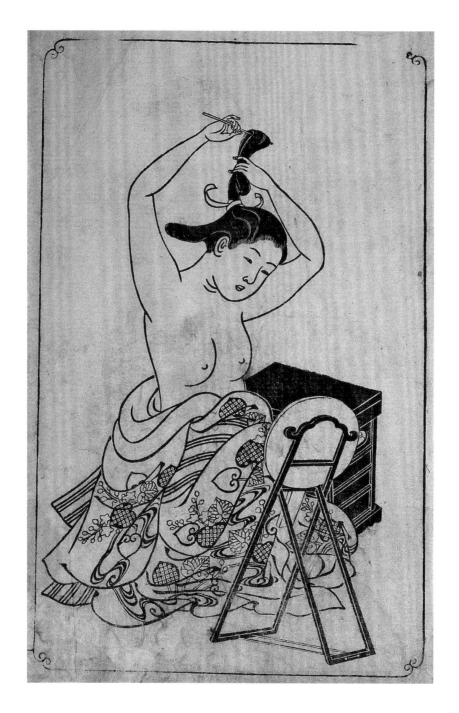

An eighteenth-century woodcut depicting a woman
dressing her hair before a mirror stand.
Sukenobu / untitled / 1739 / woodcut / 24.1 × 15.3 cm

downwards, top-to-toe, with special attention given to the head and the sense organs. No body part is completely ignored, and problem areas will be given special attention to repair any observable damage. This was once impressively demonstrated by a chimpanzee called Belle, who was chief female allo-groomer in a captive group of chimps in Tanzania. Every day she would groom members of the group in turn, but she was always on the alert for medical problems. One day she detected a dental crisis in one of the young males, who was losing a molar tooth, so she worked on him for long extra sessions, picking the teeth clean with a stick and massaging the gums, until one day she was able to gently tug the tooth out. Belle was both grooming and nursing – to her the two were indistinguishable.[8] Care for others, or 'nurture', is built into the protective grooming system.

One revealing finding from the study of animal grooming is that zoologists are usually able to identify the power structures of any given group simply by looking at who grooms whom, and the circumstances in which that grooming takes place. In animal ethology, 'A'-ranking animals (alpha-males and alpha-females) are usually groomed by 'B'-ranking animals, who in their turn groom 'C'-ranking animals. For those lower down the chain, offering grooming is a sign of supplication, or an act that can be returned for a favour or protection. But animals will also groom up and down the hierarchy, as circumstances dictate.

Because the physiology, and the psychology, of our living genetic cousins has been so closely observed, we can make reasonable assumptions about what we have, or have not, inherited from our biological or genetic history. Although the human anthropology of grooming has been less intensively studied, COBS grooming chains clearly exist in human societies.[9] The basic unit of grooming is the nuclear family group – parents and their offspring – but larger groups have more intricate micro-societies, full of particular roles and allegiances, expressed through grooming.

If you are looking for a human analogy of animal grooming hierarchies, historical records of royal, or otherwise affluent, households are a good place to start. The all-powerful etiquettes of courtly life were centred around the bodily needs and well-being of the alpha-male king (or head of the household), and the alpha-female queen (or mistress of the household). The 'B'-ranking courtiers or friends who waited on the royal family and its kin acted as a protective social layer around these royal bodies. Lords and ladies-in-waiting managed the royal wardrobe, served at the royal toilette, waited at royal mealtimes and organised or joined in with whatever pastimes the royal family preferred, including sexual activity if required. Both 'A' and 'B' ranks were waited on by 'C'-ranking palace servants, the top echelon of whom had their own specialised roles to play, for example doctors, barbers, cooks and 'bolster-makers'. The wealthier the household, the more intervening ranks there often were.[10]

For the average person, though, grooming did not take place in a palace with the aid of two tiers of ready allo-groomers. World history shows that the vast majority of lower-rank people were dependent on their own family group, just like many other long-lived species. But it is also clear that the size of a family household was ultimately flexible, and that extra help was often provided by others joining the group. Additional members who came in for food and shelter included grandparents, close kin, friends and paid servants, any one of whom could function as supportive allo-groomers or nurturers.

Beyond these two 'zones' of care lay an additional support-circle of body-service providers that extended to local neighbours and other acquaintances. And beyond this, specialised body-services were proffered in the open market by

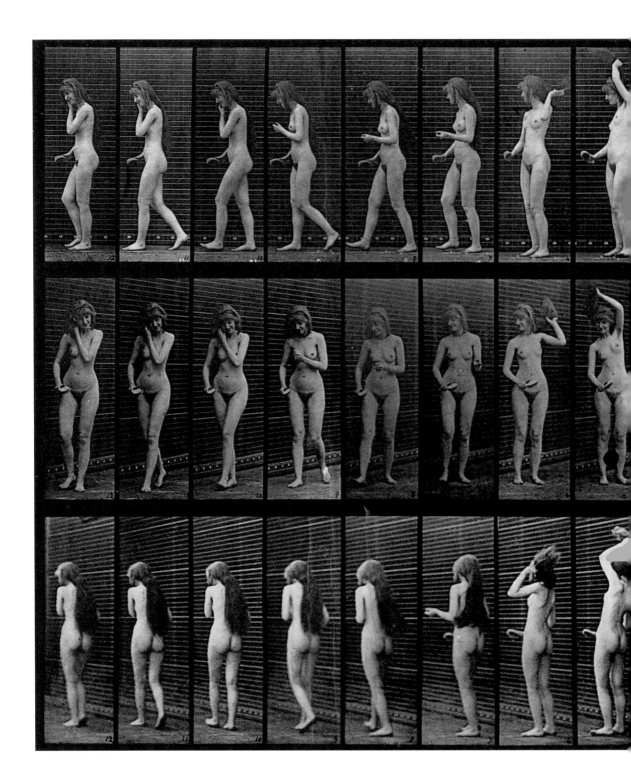

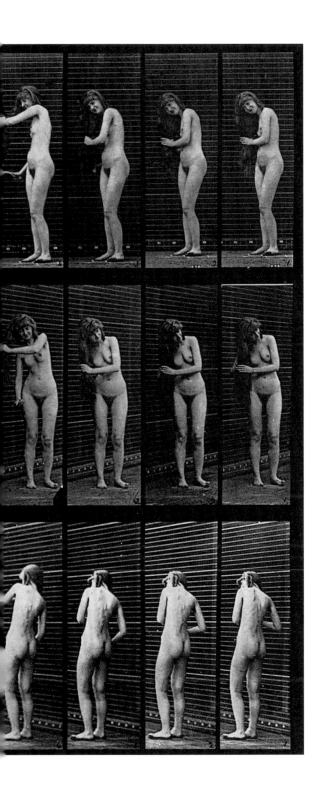

A series of images depicting a naked woman brushing her long hair, by Eadweard Muybridge, a nineteenth-century English photographer known for his pioneering work on animal and human locomotion.
Eadweard Muybridge / Woman Brushing Her Hair / 1887 / photogravure / 23 × 31 cm

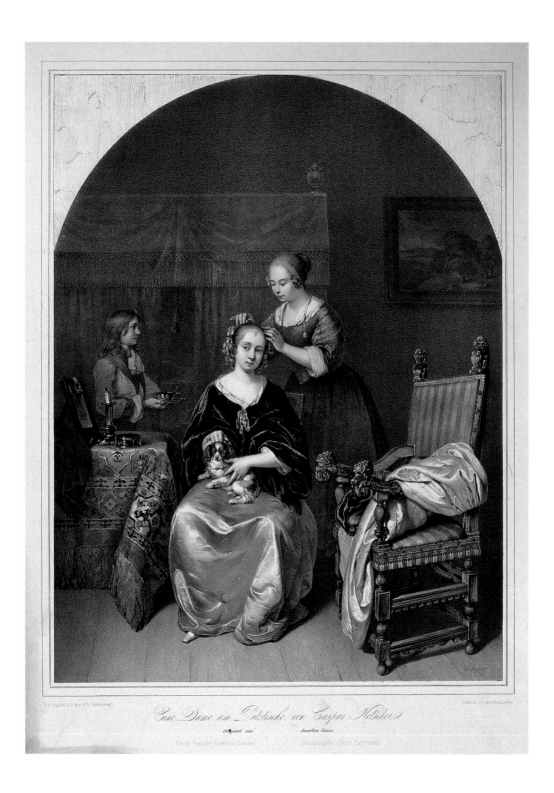

Eine Dame am Putztische, von Caspar Netscher
gestochen von derselben Grösse.

Königl. Gemälde-Galerie in Dresden Herausgegeben v. Heinr. Rademann

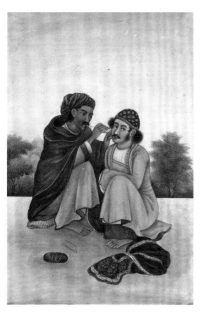

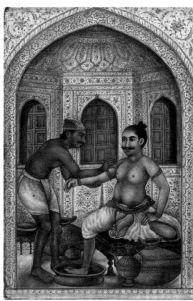

dentists, bathsmen, herbalists and various other types of specialised medical or religious practitioners. These anthropological findings are remarkably constant across continents, and are confirmed by contemporary patterns of care found by medical sociologists.

Where did all this grooming take place?[11] From the Pleistocene to the Bronze Age, *Homo sapiens* went from living in huts to living in cities in the course of approximately 20,000 years. Grooming continued to be an outdoor activity until fairly recently in the story of human history; indeed, in many parts of the world activities such as hairdressing and bathing continue to be done outside the home, as in the public barbershops of China, India or Africa. There are good practical reasons for this, of course: it cuts down on the mess created indoors, trimmings can be swept away and dirty water easily disposed of. It also may be more relaxing and enjoyable. The outer courtyard, the roof, the garden or simply the front step have always been used for grooming – somewhere people can sit in safety with a view 'outside'. Interestingly, animals will also choose a safe spot with good sight-lines before starting a grooming session. The ancient Greeks certainly preferred alfresco grooming (providing them with a favourite artistic theme) and medieval public baths were invariably outdoors.

Wherever the separation of the sexes was enforced, women did more of their grooming indoors, in the private areas, than men. But this is not an absolute division – hair could be dressed outside, even bodies bathed outside, but the circumstances of these personal toilettes were, and in many ways still are, a matter of social, religious or moral etiquette. Indoor grooming was an altogether more private affair, and centred around the bed-space or sleeping area. Bedrooms with en-suite washing areas (and private roof gardens) were a Bronze Age invention, originally designed for royalty, and these 'cabinets-of-the-morning' or 'boudoirs' subsequently formed the core of all royal

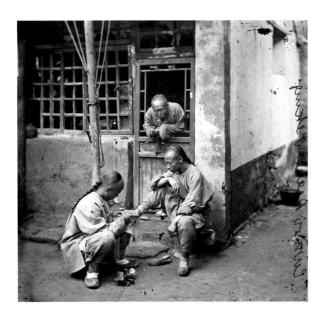

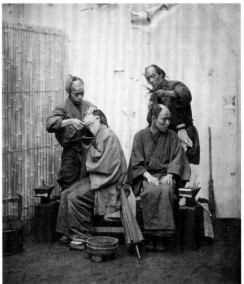

A travelling chiropodist at work in
nineteenth-century Peking, servicing the
feet of a customer in the settlement's
common space.
*John Thomson / A Travelling Chiropodist,
Peking / 1869 / photograph*

Two Japanese barbers at work,
one shaving a client, the other
dressing another's hair.
*Photographer unknown / untitled /
date unknown / photograph*

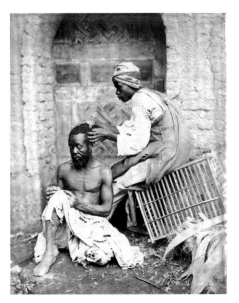

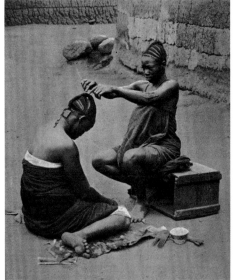

A woman grooming a man's hair in the
common areas of an unidentified settlement
in late nineteenth-century Egypt.
*Photographer unknown / Head Grooming /
1890s / photograph*

A Yoruba female hairdresser from Saki
dresses the hair of a female customer
in the open air, Lagos.
*A. W. Gelston / untitled / circa 1810 /
halftone after photograph / 8.3 × 7.6 cm*

palaces.[12] When huts became storied houses, the private space usually moved up from the darker and messier ground floor to the lighter, cleaner and more exclusive upper floors, for example the 'solarium' in medieval and Tudor architecture.

The human grooming life cycle carries over certain elements from our genetic past, but also expresses the developments of our cultural history. In all households the young infant or child plays a central role, since it needs to be groomed continuously, especially when very small. Training energetic young children of two or three into social habits such as using a toilet may have been a communal enterprise, since human maternal concern declines sharply with age, as it does with all other primates. Once children can groom themselves, there are only a few more years until the next stage of the grooming life cycle begins – puberty, courtship and mating. As with other animals, humans put a great deal of effort into finding a mate, through physical displays of health and attractiveness.[13] This phase of the grooming life cycle culminates in the supreme ritual celebration of a partnership or marriage. Grooming at marriage has, throughout recorded human history, been the most expensive and elaborate grooming ritual of an individual's life, an optimistic display of social status and the communal affirmation of that status. Grooming at death is the last human social rite, and has taken various forms throughout history and across cultures. Interestingly, grooming at death is something other animals never do.

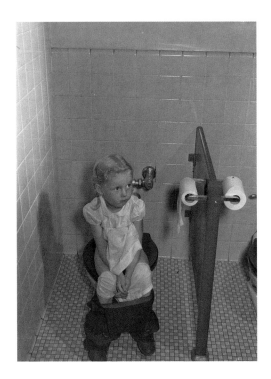

Left:
A young girl is toilet trained at a nursery school at Queensbridge Housing Project in Queens, New York, in the 1940s.
Arthur Rothstein / Queensbridge Housing Project Hygiene Program / 1942 / photograph / negative 8.9 × 8.9 cm

Opposite:
A nineteenth-century Manchu bride in her matrimonial clothes, pictured with her maid on her wedding day in Peking.
John Thomson / A Manchu Bride in her Wedding Clothes / 1869 / photograph

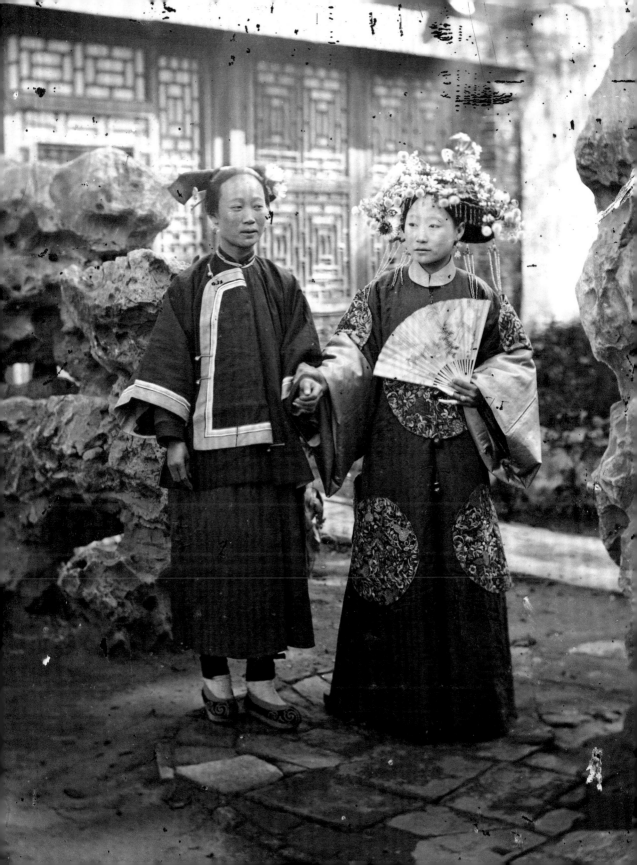

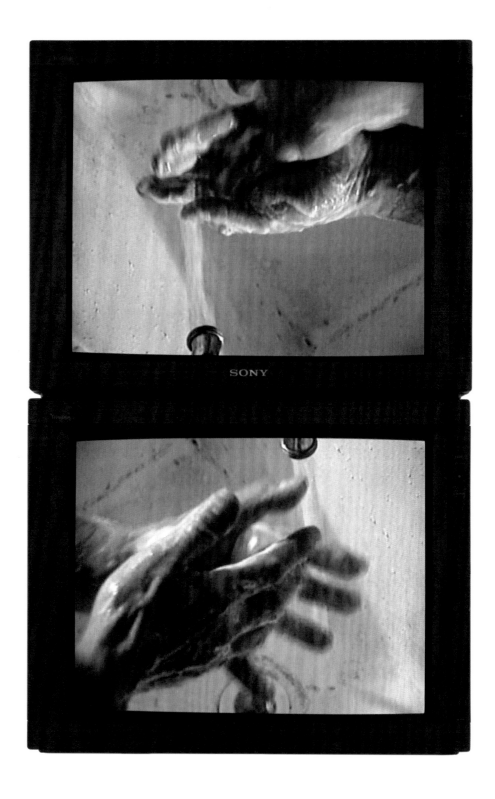

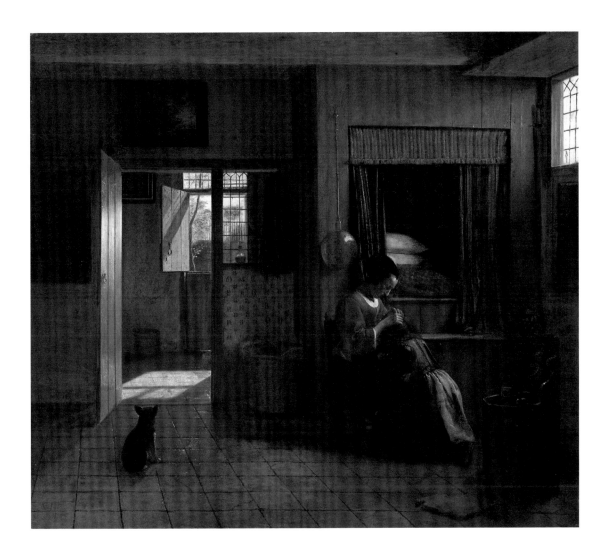

Opposite:
Bruce Nauman's *Raw Material
Washing Hands* depicts the process
of washing one's hands repeatedly.
*Bruce Nauman / Raw Material
Washing Hands, Normal (A of A/B)
and Raw Material Washing Hands,
Normal (B of A/B) / 1990 / video
installation / 55 min*

Above:
This painting, known as
A Mother's Duty, by the
seventeenth-century
Dutch painter Pieter de
Hooch, depicts a domestic
scene with a mother
delousing her child's hair.
*Pieter de Hooch / A Mother's
Duty / 1658–60 / oil on canvas /
52.5 × 61 cm*

Repairs – the servicing of the body surface

If we lick our skin – or a spoon – we are using our tongue as a dirt-removing tool. When we scratch our heads or rub our eyes in the morning, we are grooming; when we pull down a jumper, straighten a jacket, remove cat hairs or brush off a speck of dust, we are adjusting our pelage. When we stroke a pet, we are allo-grooming its body surface. In fact we use these 'relic gestures' all the time, almost unconsciously, and they remain the primary actions of first aid and self-care.

Though grooming, and being groomed by, others is an important social activity, the body has automatic mechanisms for removing unwanted or dirty matter from its surface before it becomes a physical threat. Skin lesions heal, scabs fall off, nails are worn down and rotten teeth fall out, without us having to lift a finger. Nature can be given significant help if the body is regularly examined and scrutinised by its owner. There is a repertoire of physical actions that we perform almost instinctively, or learn when we are very young. Most of our grooming is performed with our hands, but there are also various mouth-grooming actions such as nibbling, licking, sucking and spitting, which we now use rather less often but which are still part of our preening repertoire.

Bare-skinned mammals (and humans) will clean their skin in water, apply mud or earth to dry it, or oils to moisturise it. There is a distinction here between bathing (or full-body immersion) and washing, which is a sluicing of different parts of the body. Washing has various interconnected histories. Hand washing appears to have been both instinctive and customary, and was one of the most public forms of ablution. When eating was done with the fingers in the classical world, it was a mark of status and etiquette to be offered a basin for washing the hands. But instinct was the trigger for

A public health poster promoting personal hygiene as part of a public health campaign in America during the early twentieth century.
Erik Hans Krause / 1939 / silkscreen on board

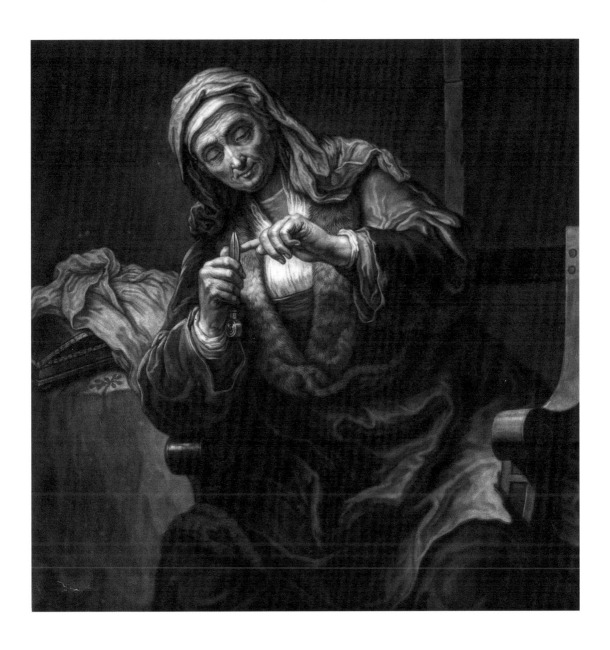

An old woman inspecting
and trimming her fingernails.
Rembrandt Harmenszoon van Rijn,
after Johann Gottfried Haid / untitled /
1764–7 / mezzotint / 45.5 × 35.4 cm

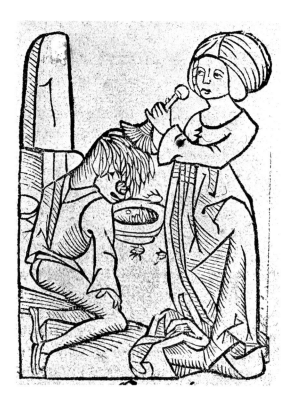

this cultural practice. We seem to dislike the feeling of stickiness on sensitive areas of the body such as the hands and the face, or things adhering to the skin there, and usually an attempt will be made to wipe it off one way or another – usually by transferring it to a less sensitive area of the body, or to an external surface such as grass or a cloth. Although that is sufficient for most purposes, the addition of water makes a more effective cleanser for heavy soiling, black grime or things that leave a bad odour, especially if it contains a cleaning agent. Natural detergents such as saponaceous herbs or mild astringents such as witch hazel have long been used in this manner. Soap made from ashes and vegetable oils, or from alkali sodium or potassium salts, was in use by at least 2000 BC by the ancient Egyptians and Babylonians.

 Hand washing as a historical practice was therefore either comfortable, respectful, or purifying in the religious sense. Hand washing as a public health issue, however, was a later development, taken up (in the West) after the concept of sterility emerged in the late nineteenth century and hands were discovered to be very effective transmitters of germs.

 While hand washing has always been a relatively public affair, the cleansing of the private parts has a very well-hidden history of which we know little. It is tied into the history of sexual mores and practices and has links with the spread of sexually transmitted diseases such as gonorrhoea and syphilis. Historically, bathing or washing were the only ways to remove contaminating blood or semen, so personal sexual hygiene depended on access to such facilities, with standards varying considerably over time and across cultures. The bidet was invented in eighteenth-

century France, but standards in eighteenth-century England seem to have been lower. Doctors were obliged to insist that their female patients 'wash the fundament', and complained in print that there was too much unnecessary secrecy and modesty surrounding the private parts.[14]

Allo-grooming was always a public affair, and remains so for both human and animal groups. The allo-grooming practices that we call 'nursing' were essential for group survival (with assisted childbirth being the obvious example). Even now one of the core activities of nursing – the bit that nurses apparently miss most when they are moved from the hospital floor to computers or other machines – is touching, and tending, the patient's outer body.[15]

The historical evidence of human allo-grooming practices is most commonly observed in surviving images of nit-picking. Despite being one of our oldest ongoing Neolithic activities, there are few literary references to it in any century, owing to the universal dislike of 'low' or 'dirty' subjects on the part of authors and readers. The number of images depicting nit-picking increase from the seventeenth century in Europe as artists started to record scenes from daily life, but of course it was not nearly as popular a subject as nude bathing. Occasionally, nit-picking will be recorded in diaries – which is how we know that group village nit-picking was being practised in certain isolated rural communities in Europe until at least the Second World War.[16] Nit-picking is still sold as a public grooming or beauty service in South East Asia.

We do know that on every continent nits, body-lice and fleas have barely survived the bath, the vacuum-cleaner and the washing machine, so these later forms of technical assistance have certainly been effective. The same applies to other small insects, such as the bedbug, or the cockroach, which also found a comfortable ecological niche in our homes or bodies. In the past sixty years we appear to have successfully modified our body-parasites' behaviour; but successful parasites do not willingly give up their hosts. Nits, body-lice and fleas still flourish in pockets of urban and rural poverty, or in battlefield conditions – anywhere in which lack of time, resources or personal care encourage infestation. All our parasitic species are down in numbers, but they are certainly not extinct; they are just being temporarily restrained.

The benefits of allo- and auto-grooming extend beyond the realms of health and hygiene. Indeed, the touching of the skin also brings the body's chemical and nervous system into action, in ways that affect us both physically and emotionally. Stroking and smoothing, especially in areas where there are major nerves or clusters of nerve endings, will produce a relaxing effect. Zoologists have established that massage stimulates a rush of endorphins, or a mild opiate effect, which is often the prelude to a bout of grooming.[17]

The timing of grooming is also important here. Broadly speaking, our major grooming sessions occur in the morning, before the period of full alertness, and at night, when we are relaxing before sleep. Additional daytime sessions can last for a few minutes, or up to an hour in periods of relaxed private time, during which we do not expect to be disturbed, reflected in the American designation of the bathroom as the 'rest room'.

What we conclude from the chemistry of grooming is that grooming behaviour gives off a clear signal of personal non-engagement – it represents non-threatening, amicable behaviour. This friendly, loving aspect of grooming is strongly displayed during courtship and mating, when each partner allo-grooms the other, or, in a lesser way, when grooming is used as an act of friendship or kindness.

As the story of human history progresses, both allo- and auto-grooming
have been augmented by a range of lotions, tonics and topical applications to make
the process more effective and enjoyable. Of the many hundreds of very early
medical receipts that have been preserved, most were for skin-infection treatments
or skin-improving products. All these different preparations sat easily alongside the
growing market for items that would adorn the skin and enhance its appearance.
The admiration of, and aspiration to, beauty resonates in our biological history too.
Like other animal displays of strength and attractiveness, beauty is considered to
be an indication of good physical health and fitness. Each human culture around
the world – even the poorest and most isolated tribes – developed a 'high' style of
cosmetic beauty that reflected its own local identity and local hierarchies. Hair-
dressing, for example, emerged at a very early date, as we can see from figurines
or paintings which show plaited or braided hair as far back as 20,000 BC, and
probably earlier, for men and for women. Moreover, you did not have to be rich.
Ornamentation required only careful allo-grooming by willing kin or friends, and
hours of spare time, which was often not a rare commodity. But well-crafted
cosmetic tools and rare objects and ingredients were part of the growing Neolithic
agricultural, manufacturing and trading economy, and the luxury body-trades
soaked up the surplus wealth nicely. The repair of life-threatening lesions, ulcers,
skin infections and growths is obviously more vital than the correction of minor
imperfections or natural blemishes, but personal appearance has historically
been given equal importance in the care of the human body surface.

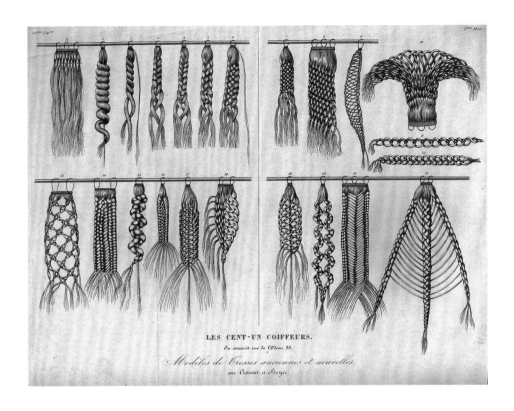

LES CENT-UN COIFFEURS.

Ou souscrit rue de l'Odéon. 33.

Modèles de Tresses anciennes et nouvelles,

par Croisat et Heyer.

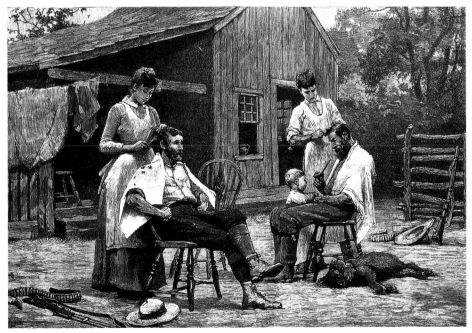

Conclusion

Human society, which revolves around the needs of the human body, is above all governed by a wide range of external or environmental factors – such as when and where people are born and into what type of family, the prevailing socio-political situation and so on – all of which will inevitably affect lifestyle choices and practices. *Homo sapiens* has always had what might be termed a flexible, opportunistic, approach to cleansing and dirt removal, which has allowed us to adapt to almost any conditions. It was mid-twentieth century historians, reflecting the era with its enthusiasm for all forms of hygiene in theory and in practice, who began research into the *longue durée* of human hygiene. In this chapter I have shifted that investigative framework somewhat further back in time, to reveal how our sophisticated cleansing and adornment practices have their roots in our biological or genetic history.[18]

There have indeed been dramatic changes in our attitudes to hygiene and practices of dirt removal over the course of human history, but there are also remarkable continuities. It is not unreasonable to assume that many of our dirt-removing actions are predetermined, and will remain so. The history of our Neolithic past clearly demonstrates the cultural, mental and economic consequences of our biological aversion to dirt. Unlike other animals, humans not only created tools and technologies to keep dirt at bay, but also ideologies that co-opted the dangerous power of dirt to frighten, coerce or educate others. Along the way, humans have managed to turn a natural dirt-repelling biological technique – the manual grooming of the body-surface – into a major world industry. Throughout the world, local histories of body cleansing and body management will all be different and unique, while at the same time, at the deepest levels of sociobiology, they are all fundamentally the same.

An Oubangui-Chari girl from French Equatorial Africa (now the Central African Republic). *Jean D'Esme / Oubangui-Chari Girl Wearing Implement in her Hair / 1931 / photograph*

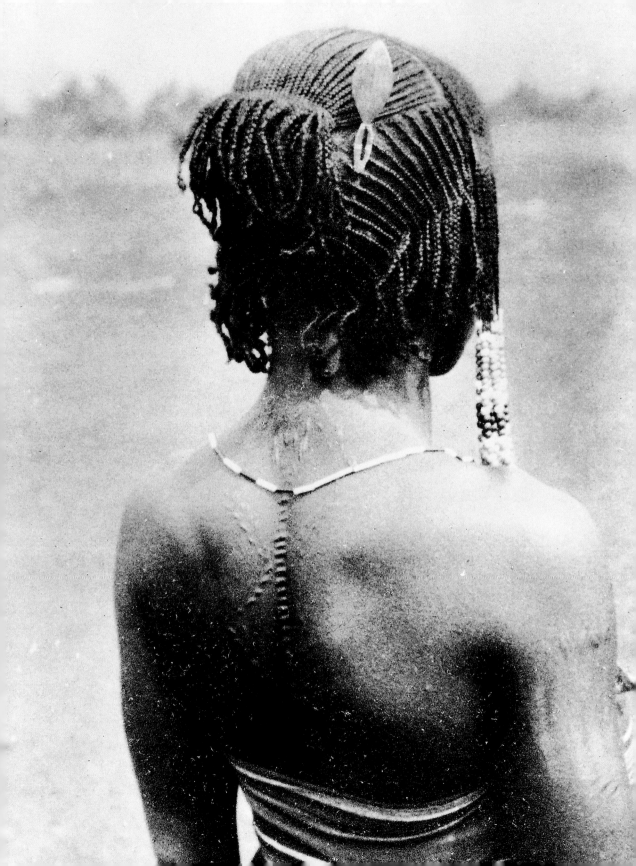

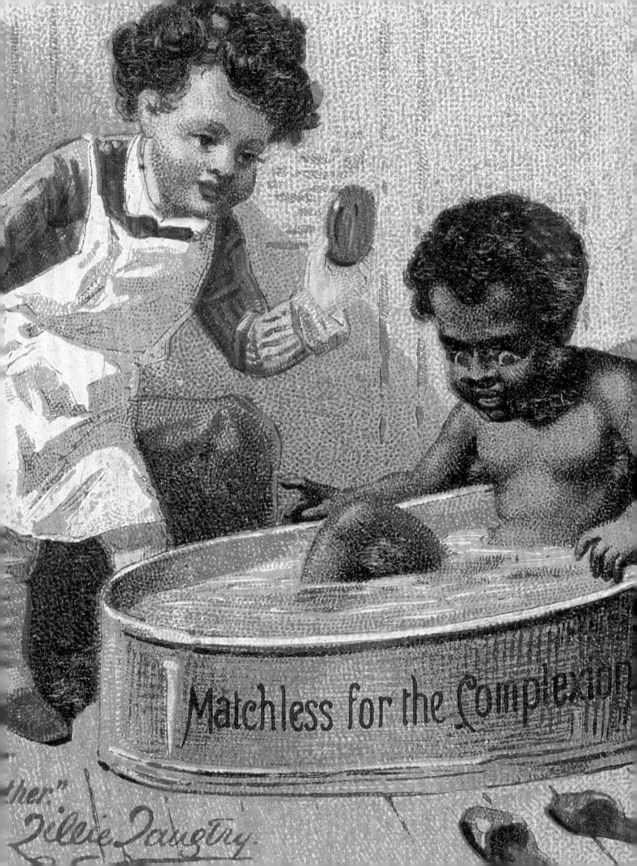

Matchless for the Complexion

"her."
Lillie Langtry

DISHING THE DIRT

DIRT IN THE HOME

ROSIE COX

*I*t is a cold morning in March 1823. It won't be light for more than an hour, but Beth the laundry maid is already up to get on with her work. Her main job for today is soaking the linens, the first stage in a washing process that lasts most of the week. Every day the housemaid pours the chamber pots from the bedrooms into a barrel near the wash-house, and today Beth will empty urine from the barrel and use it to soak the washing. Tomorrow it will be soaked again in lye and after that boiled in a copper and rinsed twice before being hung out in the sun to dry. It's not a nice job, but Beth is used to it. The urine does get the clothes nice and white and it doesn't sting your hands quite as much as lye does. Before she turned fourteen and came to work at the Big House, Beth helped with the wash at home. There, they had to use urine from a barrel shared with the neighbours and there was never enough to go around, especially because they had to use it for washing themselves too. At the Big House they're not allowed to do that because the Master doesn't like the smell it leaves, so they have to make their own soap out of leftover pig fat from the kitchen to bathe with. Beth doesn't think that smells much better – nothing like the lovely new scented soap the Mistress has sent from London – and it's a real palaver to make, but what the Master says, goes.

As we push the Hoover around, wipe grease off kitchen surfaces or squirt bleach into the toilet, we behave as if we know what 'dirt' is and how we determine what is dirty. Yet few people ever think about what it is that is 'dirty' about dirt and why some substances and organisms need to be banished while others are welcome to share our homes. Why we clean, and how we know what to clean, is rarely discussed even among the most enthusiastic homemakers, yet the cleanliness or otherwise of homes is implicated in our health and comfort. More importantly for our purposes here, cleanliness in the home is also implicated in class, gender and racial inequalities.

Domestic dirt is a little-examined yet always present axis of social organisation. Notions of what constitutes dirt or cleanliness directly and indirectly influence the arrangement and use of all interior and exterior space, informing the minute details of human behaviour and actively influencing relations between people. In the contemporary West it is generally assumed that our ideas about what dirt is and how it can and should be cleaned are logical and have developed in response to scientific knowledge, such as germ theory. Yet when we look at what people actually do when they clean their homes we find little evidence that cleaning is organised in response to scientific evidence. Rather, we clean because we believe that dirt exists. In fact, what is 'clean' and what is 'dirty' is defined in historical and social context, rather than being discovered within a laboratory. Our approaches to cleaning are emotional as well as logical.

Standards of cleanliness and ideas about what constitutes dirt in the home vary wildly even among members of the same family. If we look back through history or at different cultures around the globe we can find examples of beliefs and practices that seem entirely at odds with contemporary Western notions of what is clean and what is dirty. These illuminate some of the assumptions that underpin domestic cleaning practices today and help to reveal how little we really know about dirt.

So what counts as dirt in the home, and why is it important? We'll start by looking at how definitions of dirt and the aims of cleaning have changed over time and then discuss the social relations that surround dirt and how these can be described as a political issue. Dirt is implicated in class, gender and ethnic hierarchies, with people at the bottom of the pecking order having more contact with dirt and doing more cleaning than those at the top. People who routinely work with dirt often find that the low status of dirt becomes their status too.

Discovering domestic dirt

Attitudes to dirt in domestic space are intimately related to beliefs about the human body and the origins of disease. The idea of dirt as something which should be banished from the house as a threat to the inhabitants' health is a relatively new one. For many hundreds of years domestic dirt as we know it today was not a source of great anxiety – particularly not on health grounds. Quite different ideas about sources of disease and wellness prevailed until quite recently and shaped commonsense understandings of what was and what was not considered dirty. For example, in the sixteenth century the human body was popularly believed to contain four 'humours' – blood, yellow bile, black bile, and phlegm – which needed to be kept in a state of relative equilibrium in order for a person to avoid ill health. As the body was also thought to be permeable to heat and water, people avoided bathing. Taking a bath

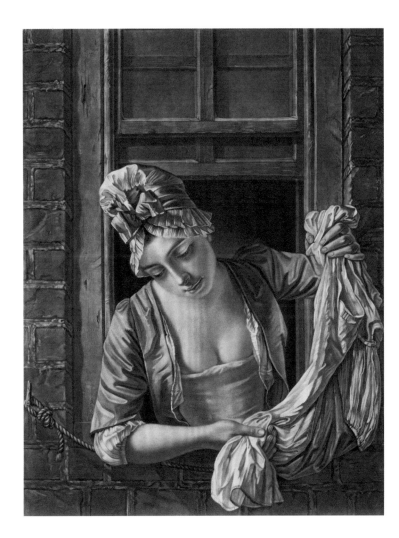

Previous page:
An 1880s advertisement for Pears' soap showing a black boy being washed in the bath. When he emerges, his dark complexion is apparently removed to reveal white skin. Racist images of black people were commonly used in advertisements for cleaning products at the end of the nineteenth and beginning of the twentieth centuries.
A. & F. Pears Ltd / Advertisement for Pears' Soap / 1880s

Right:
A late nineteenth-century print depicting a laundry maid at work.
Henry Robert Morland, after Philip Dawe / A Laundry Maid / 1895– 1925 / intaglio print / 35.5 x 27.2 cm

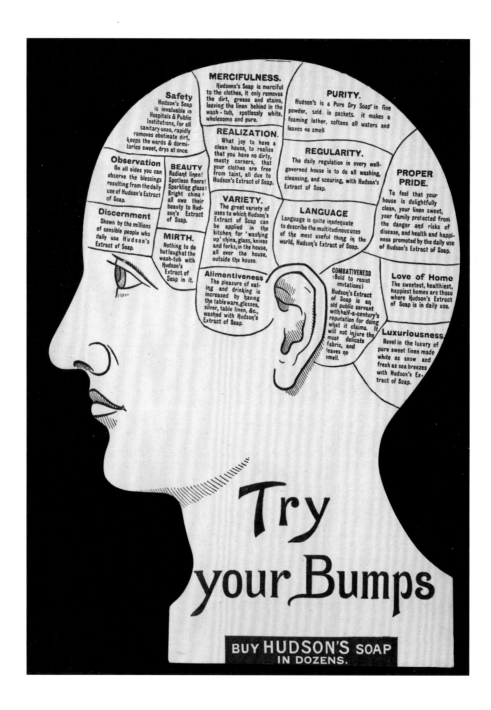

A die-cut advertisement card for Hudson's Soap in the shape of
a phrenological head, with the slogan 'Buy Hudson's Soap in dozens'.
*R. S. Hudson Ltd / Advertisement for Hudson's Soap / 1910 /
die-cut card*

was thought to be dangerous to the health as vital substances might seep out which would unbalance the humours and let in pestilence and disease. The result was that people rarely washed their bodies or their clothes thoroughly and dirt in houses or public spaces was cleaned away only if it was aesthetically displeasing, not because it was seen as a threat to health or well-being.[1]

As theories of disease changed, so too did approaches to domestic cleaning. In eighteenth- and nineteenth-century Europe, miasmatic theories of disease were popular. These suggested that foul air transmitted pestilence and therefore the danger to health came from the bad smells and gases that accompanied filth and decaying matter, not from the matter itself. This interest in miasmas meant that circulating air became an important part of the domestic cleaning routine. There was increased emphasis on ventilation, bringing fresh air into rooms and 'purifying' them with perfumes to mask foul smells. This focus on fresh air also influenced the design of houses. During Victorian times, windows became larger and opened wider, rooms were bigger with higher ceilings and some houses were even designed with complex systems of pipes and vents to circulate air throughout the building. Older houses with their low ceilings and smaller rooms were considered unhealthy and intrinsically dirty because they were less airy. Miasmatic theories, while not considering matter as a cause for concern per se,

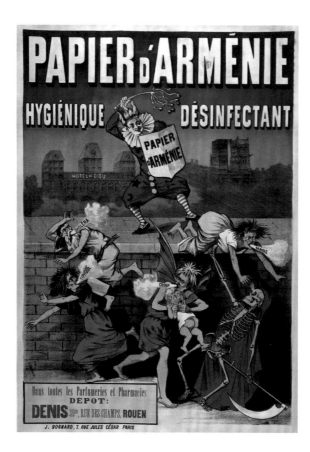

A jester representing the disinfectant product, Papier d'Arménie, which would have been burned to cleanse the air of harmful smells.
Papier d'Arménie advertisement / A. Van Geleyn / 1890 / 130 x 93.5 cm

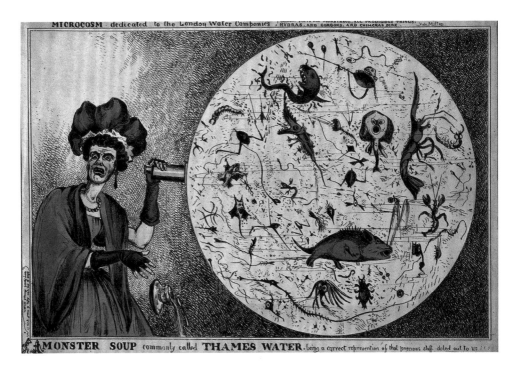

A woman drops her tea cup in horror upon discovering
the multitude of bacteria present in drinking water drawn
from the River Thames in the 1820s.
William Heath / Monster Soup / 1828 /
coloured etching / 22 × 34 cm

did underpin desires to separate sources of foul smells (such as rotting food
and human or animal waste) from living areas. This marked a new approach to the
organisation of domestic space, prioritising for the first time the separation of what we
would now consider 'clean' and 'dirty' objects or activities. A visitor to the Hebrides in
the 1780s commented that, traditionally, tenants shared their huts with cows, goats,
sheep, hens and dogs. The accumulated animal droppings would be removed from
the hut once a year, not because they were considered dirty, but so they could be used
as manure for the barley crop.[2]

 More recent thinking about dirt both on bodies and in the home has been
influenced by bacterial explanations of the spread of disease. The nineteenth-
century discovery of invisible organisms that spread infections and illness produced
anxieties about the threat posed by all dirt. It also resulted in an almost obsessive
attention to eliminating both invisible and visible dirt, particularly in the form of dust,
which was thought to be lethal at the end of the Victorian era. The new knowledge
about bacteria had a transformative effect on attitudes towards domestic cleaning.
Because bacteria could be neither seen nor smelled, householders had to develop
new understandings of which substances were 'clean' and what cleaning meant
now that invisible dirt could be hiding anywhere. Existing cleaning already included

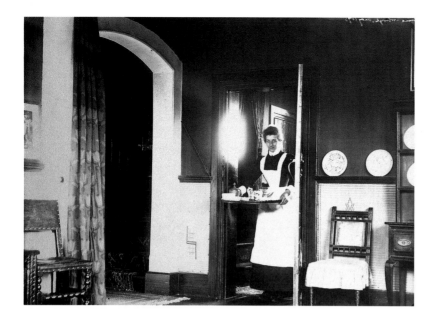

A typical late nineteenth century middle-class domestic scene, with a parlour maid holding a silver tray with refreshments. *Collection of Sir Edward Albert Sharpey-Schafer / Little Gillions, Croxley Green, with Emma the parlour maid / c. 1880–90 / photograph*

an element of what we would now think of as disinfecting – for example scrubbing floors as a way to banish bad smells, or keeping kitchen utensils clean to prevent food from 'turning' – but this was just a side effect of processes aimed at a slightly different result. Following the discovery of bacteria, disinfection became the cornerstone of domestic dealings with dirt.

The rise of germ theory coincided with the widespread development of manufactured and branded cleaning products, which offered homeowners ever more effective whitening and brightening. The anxieties raised by consumer knowledge of bacteria offered manufacturers the perfect environment in which to market their new wares. As germs are invisible to the naked eye, there are no obvious indicators of their successful removal, hence no limit to the amount of cleaning that might be necessary. Also, if germs can be eliminated by scrupulous hygiene, then the presence of disease in the home can only be due to a failure on the part of the housekeeper.[3] This logic has created untold anxiety for housewives for over a century and been firmly grasped by manufacturers and advertisers for just as long. Television commercials have been particularly effective as a means to instil concerns about such unseen hazards. They tend to follow a common pattern, the camera zooming in on thousands of animated bacteria wriggling around on an apparently spotless kitchen work surface, toilet or floor while the voiceover tells us that something isn't necessarily clean just because it 'looks clean'. It is interesting that ads for cleaning products that claim to make cleaning easier or faster often feature men, while those that focus on invisible dirt almost always show women, their faces a picture of worry, with their small children nearby about to become victims of the bacteria that their sub-standard cleaning with an inferior product has left behind.

Cleaning the pre-industrial home

We know very little about cleaning practices in medieval and early modern periods, particularly in terms of what happened in the homes of ordinary people. Even in the grandest houses there is some evidence that cleaning up took a lower priority than it does today. Theories of disease suggested no reason to worry about dirt, and the gloomy candlelit interiors of these tiny-windowed homes made it easy to overlook. Large houses required vast amounts of labour to function, and employed a great many domestic staff, but these workers were there primarily to sustain the household by growing food and flax for linen, tending livestock or producing butter, cheese, candles and beer. Cleaning was often a necessary part of these productive processes – for example, equipment used to make butter had to be cleaned and sterilised to keep the butter 'sweet' – but cleaning was rarely pursued as an end in itself.

By the eighteenth century there is evidence of domestic cleaning practices that are similar to those undertaken today. Regular activities included sweeping and washing floors, dusting, cleaning the hearth and scouring pots. Other tasks, such as polishing furniture, beating carpets and washing curtains, were done less frequently if they were done at all. Travellers in Europe at the time commented on the different standards of cleanliness in different countries. A Frenchman, César de Saussure, travelling in England in 1725, described the English as being remarkable in their

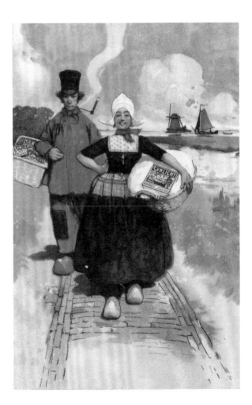

Promotional 1920s magazine insert for Sunlight soap depicting a man and woman walking down a red brick path in traditional Dutch costume.
Lever Brothers Ltd / Advertisement for Sunlight Soap / 1920s / magazine insert

commitment to domestic cleanliness, while not being 'slaves' to eradicating dirt like the Dutch. Per Kalm, a Swede travelling twenty years later, also commented on the cleanliness of the English home, particularly the effort put into cleaning floors. These vaunted cleaning measures apparently did not extend to Scotland, and the Scots were often criticised for their lower standards. John Loveday, who travelled from Berkshire to the Lowlands in 1732, complained that the locals didn't empty their 'close stools' (stools containing a chamber pot) until they were 'full to ye top', creating an unbearable stench.

While the English were praised for their dirt-removing energies, travellers such as Per Kalm noted that cleaning was often just for show, consisting of practices intended to improve the appearance of the home, such as shining metal ranges and cooking utensils and decorating cleaned floors with coloured clay or plant extracts. Cleaning dirt was a display of the virtue and skill of the housewife, and not necessarily distinguished from decorating the home. Writers from the time highlight that cleanliness in England was at least in part for appearances' sake. Their comments contrast the spotlessness of the reception rooms with squalid kitchens and filthy bedrooms infested by bedbugs.[4]

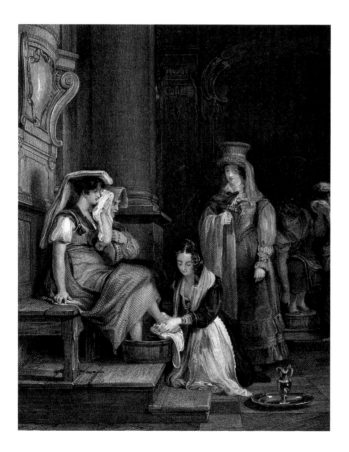

In this engraving from the late nineteenth century, two women are seated on a bench in a church. A servant girl washes the feet of the woman in the foreground, possibly in a religious rite, while an attendant looks on.
Artist unknown / untitled / 1839 / engraving

Domestic dirt has long been inextricably related to social status and the keeping up of appearances. In pre-industrial times, keeping dirt at bay was time consuming and difficult. The use of open fires and candles for lighting, difficulties with drawing, carrying and heating water, the lack of cleaning products such as soap or washing powder, not to mention the ubiquity of mud and dirt surrounding houses, all meant that homes got much dirtier than they do today and getting them clean was much more difficult. Poor people simply could not maintain their houses to the same standard as the better off, who had servants to take care of most of the work. Cleanliness, therefore, was a mark of wealth and status. Being able to maintain a distance from dirt was possible only for the privileged few.

One historian, Pamela Sambrook, has commented that the primary purpose of cleaning within English country houses was to indicate status.[5] Wealthy households employed armies of servants to create a clean and comfortable environment that would clearly signal their status to the world. Servants chased dirt and cared for their employers' furniture and furnishings, themselves important status symbols. The employment of servants was also an indicator of status, and servants' lives were organised so as to enhance their employers' standing as much as possible. Female servants were generally required to go about their cleaning work unseen, and particularly had to ensure that house guests saw neither dirt nor any evidence of its removal. Male servants, in contrast, were more expensive to employ and likely to be on prominent display, attending to the needs of guests or riding on carriages. Brightly coloured formal liveries for footmen both identified their employers and showed that they did not engage in dirty work. Being able to employ a man but not use his labour productively was a true mark of wealth, and as a result the tallest and strongest-looking footmen were the most prized and better paid than their shorter or less muscular colleagues.

All servants in large households were organised into complex hierarchies with differences in rank reflected in pay as well as in standing within the servants' hall. Status within these hierarchies was largely dependent upon a servant's proximity to dirt. Those who cleaned for other servants, or in areas such as kitchens that only servants used, were the lowest, next were those who cleaned the other parts of the house (parlour maids and chamber maids) and above them were 'body servants' (valets and ladies' maids) who had physical contact with their employers and did little household cleaning.

Dirt, cleaning and social status were so intimately related in the nineteenth century that the act of domestic cleaning became a definition of class. When the industrialist and social reformer Seebohm Rowntree conducted his survey of York in 1899, he took the 'keeping or not of servants' as the dividing line between 'the working classes and those of a higher scale'. Impoverished members of the middle class would struggle to maintain a single servant in order to preserve this status even when they could ill afford to do so. Those who could not afford even the meagre wages of a 'maid of all work', and who had to clean for themselves, would try to disguise their situation and hide the labours which required them to come into close contact with dirt.

For poorer families, cleanliness was associated with respectability too. Since at least the eighteenth century, when John Wesley declared in one of his sermons that cleanliness was indeed next to godliness, there has been a strong association between cleanliness and moral virtue and, conversely, dirt and depravity. For working-class women, the appearance of their houses was seen as a measure of their morality, and they went to great lengths to indicate respectability to the world.

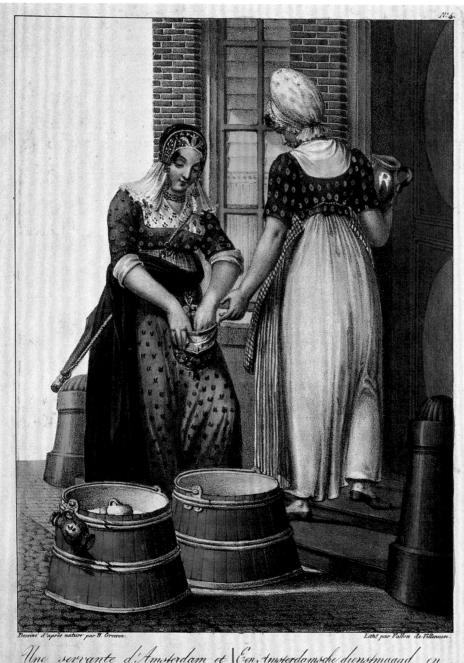

Dessiné d'après nature par H. Greeven.

Lith.t par Vallon de Villeneuve.

Une servante d'Amsterdam et
une laitière des environs.

Een Amsterdamsche dienstmaagd en
een melkboerin van dezelve omstreek.

Chez François Buffa et Fils

Kalverstraat, au coin du Gaaperstreg N.º 221.

One of the important ways in which this was done was the cleaning and colouring of doorsteps. Women would clean and re-colour their doorstep every day if possible, to project an image of a spotless household into the wider world. In different parts of the United Kingdom different substances and colours were used, including chalk for whitening in Wales, brownstone and blue mould in Salford and ochre-coloured ruddle-stone in Huddersfield. Cleaning the doorstep was usually done early in the day and the most assiduous housewives coloured window sills and the pavement outside the house as well.[6] These practices lasted into the twentieth century, and the washing of painted doorsteps lasted longer still. While the cleanliness of her doorstep may no longer be the measure of a woman's virtue there are still strong associations between domestic dirt and imagined immorality. Words such as 'slovenly' and 'sluttish' encapsulate the relationship between women's housekeeping standards and their perceived moral worth.

House cleaning in the industrial age

As with so many other areas of life, the Industrial Revolution in the West transformed the way cleaning was done and what a 'clean' house could look like. The Industrial Revolution brought together a whole range of processes that profoundly influenced the ways houses were lived in and, therefore, how they were cleaned. Urbanisation and advances in sanitation gave more families access to clean water and to sewers for disposing of their waste. The introduction of mains gas for lighting put an end to the domestic chores of making candles and filling oil lamps, and the electricity which supplanted it was soon powering an ever-growing range of appliances. The items being cleaned also changed. The replacement of linen by cotton, and later the introduction of synthetic fibres, made a huge difference to laundry practices. Mass production transformed cooking utensils, crockery and cutlery as well as furniture

Opposite:
A Dutch maidservant stands on the doorstep of her employer's house in early nineteenth century Amsterdam, purchasing milk from a travelling milk seller.
Vallon de Villeneuve, after H. Greeven / A Maidservant on the Doorstep of an Amsterdam House / 1828/9 / lithograph / 21 x 15.7 cm

Right:
A bar of 'superfatted' resorcin, salicyclic acid and sulphur Medisoap, manufactured in Manchester in the 1940s by Charles Midgley Ltd.
Charles Midgley Ltd / Resorcin, Salicyclic Acid & Sulphur Medisoap / 1940

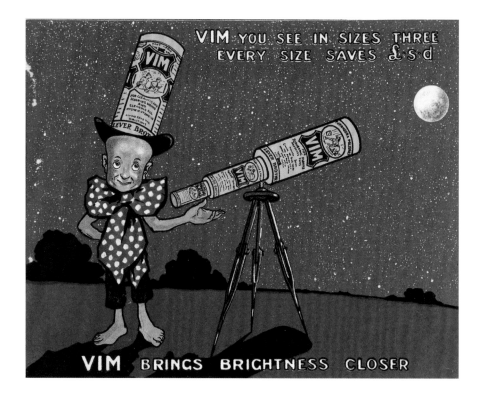

and furnishings. Not least, new refining and manufacturing processes allowed the mass production of cleaning products, and new transport systems enabled their distribution over thousands of miles.

These new technologies revolutionised the work of dealing with dirt, and as domestic cleaning became more dependent on bought-in machines and products, the role of women within the household changed. As the twentieth century progressed women became less involved in producing things for the home, such as food and clothing, and were increasingly cast as consumers. The growth of consumer culture is no better illustrated than by looking at changes in how we clean our homes.

Until the mid nineteenth century most Western households made their own cleaning products, and many poorer and rural families continued to do so well into the twentieth. Other than bath soap, only two commercial cleaning agents were advertised in the United States before 1880 – ammonia and a gritty cleaning soap called Sapolio. All other cleaning products were home made. Soap for washing pots and clothes was made by adding lye – itself made from ashes – to rendered waste grease.[7] Substances such as sand, milk, vinegar, lamp oil, turpentine and borax were all used for cleaning. Householders would have their own recipes for mixing cleaning products to produce the best results and a range of manuals offered advice to new housewives on making their own potions that could remove every conceivable mark or stain.[8]

Cleaning with these products was laborious, unpleasant and sometimes dangerous. Without modern chemicals, removing dirt relied more on physical labour – 'elbow grease'. For example, floors had to be swept and scrubbed on hands and knees, and stone floors in kitchens might be cleaned daily using an abrasive mixture of sand and soap. One of the most labour-intensive elements of cleaning was the collection, heating and disposal of water, making laundry one of the more exhausting tasks. The very strong and abrasive substances used for cleaning clothes and houses soon had an effect on their users' hands and arms. Without gloves for protection, women's hands would blister, split and chap until they eventually formed hard skin and calluses. Other products used for cleaning, such as lead (used on fire grates and oak floors), were positively dangerous as the toxins they contained could be absorbed through the skin. Over time, lead poisoning can cause memory loss, gastrointestinal problems, fatigue, anaemia, seizures and even death.

Mass production made entirely new products available to households. Companies such as Pears and Lever Brothers, still household names today, produced new commercial soaps and detergents. Manufacturers responded to new knowledge about bacteria and often marketed their products with messages about invisible dirt and disease. Such advertising encouraged new approaches to cleaning, shifting the focus to disinfecting the home and killing germs rather than scrubbing and scouring.

Electricity offered huge new opportunities for both cleaning and consumption. The first popular domestic appliance was the electric iron, patented in New York by Henry Seeley in 1882. By 1926, 59 per cent of households polled in an American market research survey had one. The Hoover vacuum cleaner was patented in 1908 and by the 1920s this was also in widespread use across urban

Opposite:
A 1920s cartoon advertisement for Vim soap.
Lever Brothers Ltd / Advertisement for Vim Soap / 1920s

Right:
An 1880s advertisement for Pears' Soap, depicting three judges endorsing a bar of soap.
A. & F. Pears Ltd / Advertisement for Pears' Soap / 1880s / magazine insert / 14 × 21 cm

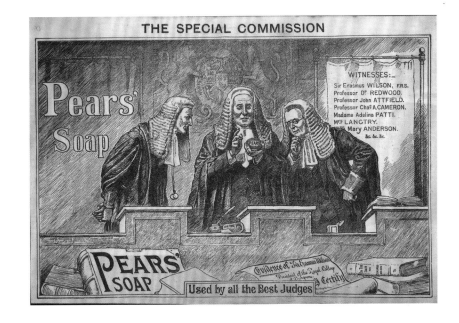

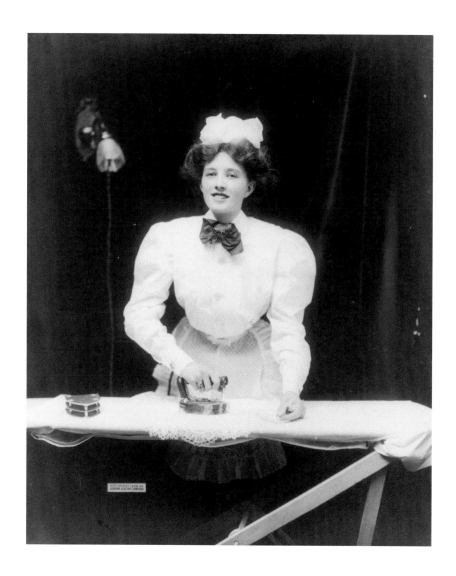

Domestic servant ironing with an electric
iron, an implement patented in 1882.
*Photographer unknown / House Maid
Ironing a Lace Doily with Electric Iron /
1908 / photograph*

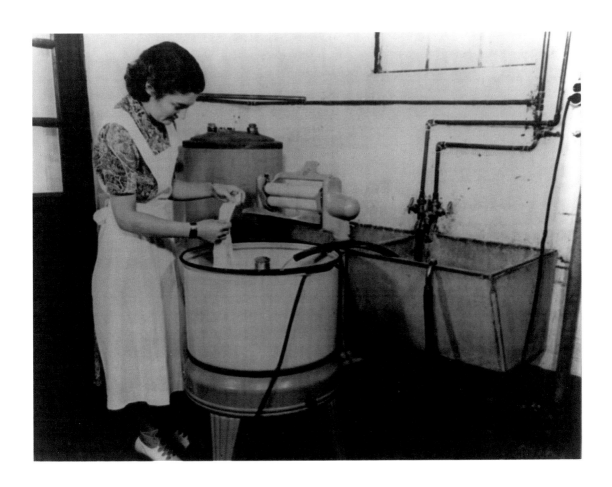

A woman using an electric washing machine:
part of a series depicting American rural life in
the mid twentieth century.
*Photographer unknown / Portrait of America,
No. 36 / 1940–46 / photograph / negative
12.7 × 17.8 cm*

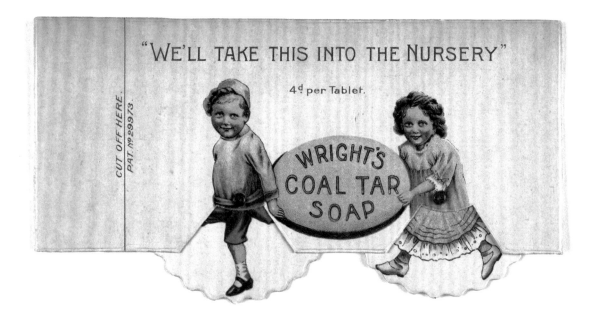

An early twentieth-century advertisement for Wright's
Coal Tar Soap. The children's legs are printed on
cardboard discs that can be rotated.
*W. V. Wright & Co. / Advertisement for Wright's Coal
Tar Soap / 1900s / print on cardboard / 8 × 15 cm*

areas of the United States. Electric washing machines appeared later, the first
patented in the United States in 1914. Commercial laundries and launderettes soon
followed, although the machines did not become popular as domestic appliances
until indoor plumbing became commonplace.[9]

The growth of commercial cleaning products and appliances coincided with
the rise of branding and advertising, another business that boomed at the turn of the
twentieth century. Advertisers played on housewives' fears, urging them to ever higher
standards of cleanliness and fostering ever greater anxiety about dirt. Such marketing
also usurped women's role as cleaning experts who carried with them generations of
wisdom and experience about how, when and what to clean, recasting them as now
lacking the 'scientific' knowledge necessary to protect their families. Advertising
advised women to turn to (male) manufacturers for advice, guidance and new products
to keep their homes clean and their families safe.

During the twentieth century, and particularly following the introduction of
television, advertising became an increasingly important arbiter of standards for
domestic cleanliness, and a key force in shaping ideas of domestic dirt. As women
were exhorted to wash their whites whiter and kill more germs dead, routines and
practices in household cleaning changed. Whereas in the past, cleaning was often
done in response to set routines, with tasks undertaken regularly on a daily, weekly
or annual basis, today cleaning is more often done in response to visual cues – a
floor will be cleaned because it looks dirty, not because it is the appointed time for

it to be cleaned.[10] As a result, practices such as 'spring cleaning' or the weekly wash are increasingly rare as houses and clothes are continually cleaned 'as needed'. Cleaning because things look dirty means there is no limit to the time and labour that could be spent, because there is always something that could be done to make our houses look cleaner. This is very good for cleaning-product manufacturers, but bad for women, whose work is now literally never done.

Women's work?

Throughout this chapter I have deliberately gendered the role of cleaner. Ever since housework has been distinguished from other labour, women have been responsible for the vast majority of it, and continue to be today. Cleaning and caring for homes and their inhabitants have been thought of as women's 'natural' roles for centuries. Women no longer adopt such roles unquestioningly, but change has been slow, and although Lenin wrote that 'no nation can be free when half the population is enslaved in the kitchen' as long ago as the early twentieth century,[11] it was only during the 1960s and 1970s that the women's liberation movement brought the relationship between housework and women's oppression to the fore.

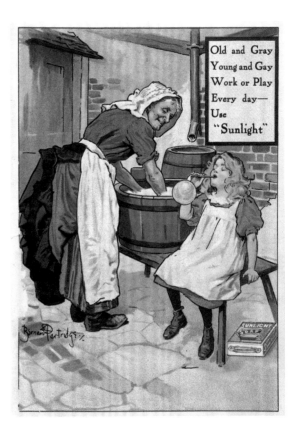

A 1920s advertisement for Sunlight soap.
B. Partridge / Advertisement for Sunlight Soap / 1920s / magazine insert

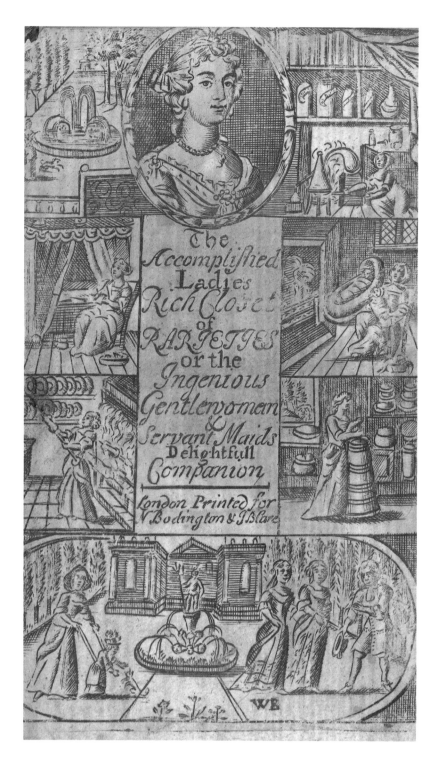

The Accomplished
Ladies
Rich Closet
of
RARIETIES
or the
Ingenious
Gentlewomen
&
Servant Maids
Delightfull
Companion

London Printed for
V. Bodington & I. Blare

WE

Various seventeenth-century
scenes depicting women
engaged in domestic work,
including looking after the
children and making butter.
*John Shirley / Frontispiece
for* The Accomplished Ladies'
Rich Closet of Rarities /
1691 / engraving

Feminists showed how important women's work in the home really was to society and started to challenge the assumption that women were naturally suited to doing housework. They argued that it was responsibility for housework which was frustrating women's chances of achieving equality with men.

Betty Friedan's *The Feminine Mystique*, published in 1963, blew open the myth that women were naturally happy homemakers. She showed that housewives in the United States were isolated and unhappy, prone to depression, sleepwalking through a never-ending round of cooking, cleaning and caring for others. In 1974 sociologist Ann Oakley published her seminal study *Housewife*, investigating the lives and work of housewives in Britain. Oakley found that British women were doing an average of 77 hours of housework a week and suffered from isolation and the stress of job fragmentation and speed-up at much higher levels than even assembly-line workers. Oakley's study was important because it clearly demonstrated that housework was indeed work, albeit work that is unpaid and socially neglected. She argued that traditional gender stereotypes and the social structures that maintain women's place in the home put pressure on women to become psychologically involved with housework and to seek satisfaction in doing it to ever-higher standards. Yet housework is intrinsically unrecognised and unrewarded with no possibility for personal growth or advancement. The work is isolating and modern developments aren't experienced as liberating measures, but rather have the effect of tying the housewife to her work.

Oakley argued that responsibility for cleaning and caring was at the heart of women's unequal place in society. She called on women to reject the housewife role and said that they should challenge their male partners to share the work, challenge the standards of housekeeping that they were expected to maintain and raise their children to fill gender-equal roles in future generations. Other feminists at the time also saw cleaning as a key element in women's unfair treatment, but rather than arguing that women should resist these tasks, they campaigned for housework to be remunerated. Their logic was that it was the unpaid nature of housework which was oppressive to women, not the tasks performed per se, therefore if women were paid for their work in the home they would gain financial independence from men and be shown respect by society. This line of reasoning was countered by other feminists who argued that paying women for housework would only entrench their place as housewives and put equal opportunities in the workplace even further beyond their reach.

While feminist campaigns to either abolish or financially reward housework might appear to have been unsuccessful, their legacy can indeed be seen today. Women still carry out the vast majority of housework, but fewer people would claim that this is their 'natural' role, and increasingly both men and women say they believe that household tasks should be shared. However, if men do housework they are most likely to take on shopping and childcare, and least likely to do cleaning. Women are still the people who have to deal with dirt.

Dirt, difference and inequality

Cleaning roles are not allocated simply by gender, but also by class, race and ethnicity. Working-class people and marginalised ethnic groups are often depicted to be inherently dirtier than those who are more privileged, and thought of as more

appropriate to do dirty work. Immigrants and members of minority ethnic groups are often abusively characterised as 'smelly' or 'dirty', hence not as clean as their neighbours. For at least two centuries white skin has implied cleanliness.

In the United States during the nineteenth century people with darker skins than Anglo-Saxons – that is, all African-Americans, but also Jews and southern Europeans – were often considered inherently dirty and inferior. Migrants arriving at Ellis Island from Europe in the late nineteenth and early twentieth centuries found that their initial welcome by the United States involved them being washed and disinfected. They quickly gathered that middle-class Americans put great store by personal and household cleanliness and that to fit in they would need to adopt their hosts' cleaning practices. English-language lessons for new arrivals included instructions on both domestic cleaning and personal hygiene, and immigrants soon learned that 'there was an American way to brush teeth, and an American way to clean fingernails, and an American way to air out bedding'.[12] Housewives in immigrant slum areas were visited by settlement workers, who checked on their cleaning practices and instructed them in the use of services and appliances they may not have seen before, such as mains water and flush toilets. The settlement workers also established model flats to demonstrate 'healthful housekeeping' and provided classes to help newly arrived migrants develop American sanitary habits. Adoption of these 'New World' ways was a key element to acceptance and success in the new country. Immigrants came under pressure from more established members of their own communities, as well as from middle-class culture more generally, to show through their standards of cleanliness that they were 'civilised' enough to become a part of American society.

African-Americans arriving in the same northern cities from southern US states were also subject to the inspections and teachings of social workers and educators,

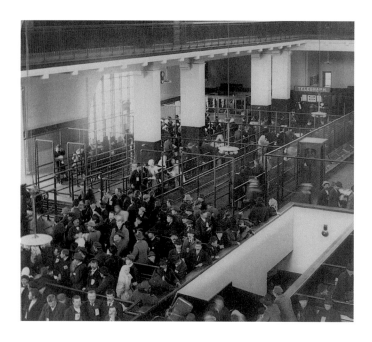

Immigrants to the USA queuing at the Ellis Island Immigrant Building in 1904 before being processed by border officials. *Underwood & Underwood / Immigrants Arriving at the Immigrant Building, Ellis Island / 1904 / stereograph*

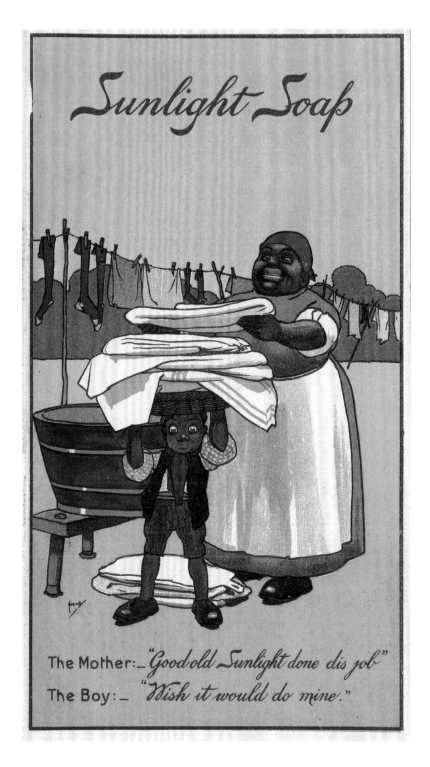

A 1920s Sunlight Soap magazine insert depicting a woman taking laundry down from the washing line and placing it on her child's head. *Lever Brothers Ltd / Advertisement for Sunlight Soap / 1920s*

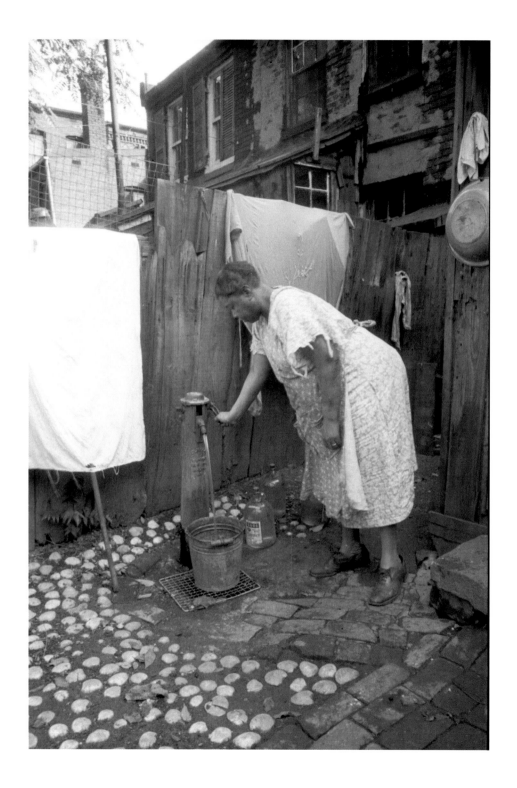

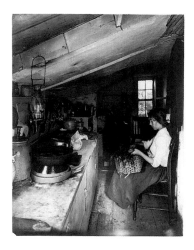

Opposite
A woman drawing water from an
outside water supply in a 1930s
slum area in Washington DC.
*Carl Mydans / Outside Water
Supply / 1935 / photograph
(35 mm film)*

Right:
A young domestic servant in
a small, cramped kitchen in
the early twentieth century.
*Jessie Tarbox Beals / Evelyn,
a Little Native Maid / 1909 /
photograph*

but, unlike white migrants, their portrayal as backward and dirty could not be easily escaped by learning particular washing and cleaning habits. African-Americans were exhorted to personal and domestic cleanliness by both the white and African-American middle class. Booker T. Washington, arguably the most influential African-American leader of the late nineteenth century, preached what he called the 'gospel of the toothbrush'. Washington taught that African-Americans should work their way up the social system in true American style. To be accepted, and to lead orderly lives, they should bathe every day and keep their clothes and housing spotless. In Chicago, the city with the largest African-American population in the north, volunteers from the Urban League – an organisation of the black middle class – went from door to door handing out leaflets, instructing migrants on cleanliness and respectable behaviour and urging them to 'use water freely'. Despite the good intentions of teachings that were meant to prevent the spread of disease as well as improve social standing, this advice could not address the problem of endemic racism that condemned many black Americans to sub-standard housing and living conditions. Areas that African-Americans were confined to often lacked paved streets, sewers, toilets or garbage collection, making attempts at household cleanliness both difficult and demoralising. Despite these poor conditions, rents were notoriously high, often being doubled when African-American families moved in. It is no surprise that between 1914 and 1926 Chicago's African-Americans died from tuberculosis at six times the rate of whites, yet they were still excluded from tubercular sanatoriums and so had no escape from the conditions that spread the disease.[13]

African-Americans were told that to be accepted they should adopt urban, middle-class standards of cleanliness, but this acceptance was not easy to come by. White European immigrants faced poverty and hardship in the urban ghettos, but for them there was the possibility of a way out and a chance to improve their lives, and certainly those of their children, if they could work hard enough and appear to be respectable. African-Americans knew that their skin colour limited their mobility and would restrict them to ghettos for generations. Adopting urban hygiene practices was not enough to overcome the entrenched racism that they faced, and African-Americans remained characterised as dirtier and less 'American' than whites.

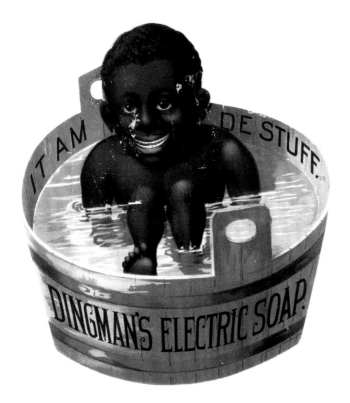

Cleaning up the global economy

One outcome of this imagined association with dirt is that African-American women
were presumed to be appropriate domestic servants, a pattern that has been repeated
throughout the world – women from denigrated groups clean up after the families of
the more privileged. Since the late nineteenth century, when other job opportunities
became available to working-class women, domestic work has been the occupation
for people without choices. Often these people are migrants, restricted by racism, lack
of local knowledge or visa type to the lowest-paid and lowest-status work.

Domestic service is often thought of as the classic Victorian occupation,
but in fact it has been growing rapidly throughout the world in recent years. In the
twenty-first century domestic service has become globalised. Tens of thousands
of (mostly) women leave their homes and countries each year to clean houses in
richer countries. Far from being boring, the dirt under your bed is now part of a
global-scale business.

Domestic workers tend to move from poorer areas to richer ones at global,
national and local scales and a whole range of systems and structures has emerged to
facilitate this movement and get domestic cleaning done for minimal cost. Governments
of countries that want to import low-wage domestic labour have created special visa
categories for these workers. Often these visas place tighter restrictions on workers
than visas granted to other groups. For example in Canada migrant domestic workers
are required to live in their employer's house and they have to be in Canada for at least

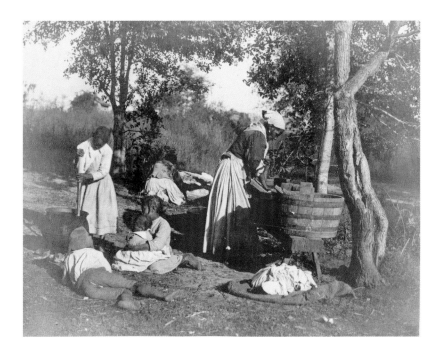

two years longer than other workers before they are given residency. In Singapore, as well as insisting that domestic workers live in, the government requires them to undergo regular pregnancy tests and bans them from having relationships with Singaporeans. In the United Kingdom, domestic servants are excluded from minimum working hours legislation and do not have the same rights to holidays, rest breaks or even minimum pay that other groups of workers have.

These government policies reflect the idea that domestic work is not the same as other work. Because domestic work is often done by unpaid female family members, cleaning and caring are not considered to be 'real' work, no matter how hard the physical labour involved or the amount of time it takes up. These beliefs help to keep wages low and make the function of domestic workers invisible. Domestic workers are treated differently from other workers, with many employers acting as though they themselves are dirty. It is common for domestic workers who live with their employers to be forced to drink from different cups, to use different plates or knives and forks, and not to be allowed to wash their clothes in the same washing machine or to bathe themselves in the same bathroom. Some are even made to wash with disinfectant.

Domestic workers are also subject to other forms of abuse at higher rates than other workers. Employers around the world beat, starve, imprison, sexually abuse, overwork and insult their domestic employees. In 2010 a couple in Saudi Arabia tortured their Sri Lankan maid by hammering hot nails into her hands, legs and head because she complained about her heavy workload. She stayed with the

The wife of a wholesale grocer in her kitchen in Middle
America, instructing her maid in domestic chores.
*John Vachon / The Wife of a Wholesale Grocer in Her
Kitchen with Her Maid / 1943 / photograph / negative
8.25 × 8.25 cm*

couple for five months and received no medical attention until she returned to Sri
Lanka, despite having 24 nails left in her body. This case is by no means unique and
domestic workers are particularly prone to abuse for a number of reasons. First, when
domestic workers live in, employers have immense power over them and can prevent
them from making friends or contacting welfare agencies who could possibly help if
they are being mistreated. Related to this, because it happens within the home, the
abuse is generally unseen and in many countries legal protections for workers inside
the home are weaker than for other groups. Also, while many have correct visas and
the legal right to work abroad, domestic workers' visas often mean that if the holder
leaves their employer, they must leave the country too – no matter how abusive that
employer is. Few domestic workers can afford to return home as they may owe money
for travel or employment agency fees and will also be supporting family members with
their wages. These circumstances have been likened to indentured servitude or
slavery, with growing concern from international bodies including the United Nations,
the European Union and the International Labor Organisation about the treatment of
migrant domestic workers.[14]

The stigma of working with dirt means that domestic workers find themselves
trapped within a vicious circle, which defines domestic cleaning as low status because
it is done by women, and women as low status because they deal with dirt. Migrant

women and women of colour are additionally caught in a cycle that characterises them as appropriate people to do dirty work, and thereafter stigmatises them because of their contact with other people's dirt. These workers experience the practical outcomes of contemporary feelings about domestic labour, facing low pay, exploitation and often abuse – all compounded by the low status that comes with working with dirt.

Conclusion

It seems that attitudes towards – and methods for dealing with – domestic dirt are complicated and not entirely logical. Dirt is not easily defined, it is not always one thing and not another, and we don't always agree on what is dirty and what is not. Yet our reactions to dirt in the home are strong and deeply emotional, and huge amounts of effort are put into cleaning dirt away.

Over time what we imagine to be 'dirt' has changed, in part as a response to new medical and scientific theories, but also in relation to changing social influences. In the eighteenth century, it might have been religious strictures that prompted women to display their virtue through the cleanliness of their houses, but by the twentieth century it was more likely to be television advertisers urging us to keep clean for fear of what the neighbours might think.

The ways we clean have also changed, both in how cleaning is organised and in terms of the tasks we do. For most people in developed countries, dealing with domestic dirt is no longer a matter of using home-made products and elbow grease. Instead, cleaning is bound up with our life as consumers and, while it still involves hard physical labour, it also depends upon appliances and industrial chemicals manufactured hundreds of miles from where they are sold and used by millions of households around the world. Few of us stick to the annual spring clean or the weekly wash; rather we clean dirt that we can see and worry that we have never done enough.

Even though it is easier to keep a house clean than it was in centuries past and it is not only the rich who can distance themselves from dirt, domestic cleanliness is still closely related to status. Within families, men now clean more than they did a generation ago, but women still clean more than men. Within societies, the poor clean more than the rich, and dealing with dirt has become a globalised trade in cheap labour. Domestic cleaning is now organised by flight paths and visa regulations, on-line interviews and international money transfers. Domestic workers, in their hundreds of thousands, service the lifestyles of the global rich, helping them to keep their distance from dirt. The most disadvantaged groups are still thought to be less clean than the privileged, and therefore suited to dealing with domestic dirt, and the proximity to this dirt still demeans the people who work to eradicate it.

Dealing with domestic dirt is not a simple thing. It involves a plethora of liquids, lotions, powders, brushes, cloths, electrical appliances, scientific knowledge, skills, techniques and experience. It draws on cultural knowledge and social understandings and is even part of global economic flows. It touches on deep emotions of love and care for family as well as fear and disgust. Cleaning up might seem like a routine and personal activity, a choice or a duty that just somehow always needs to be done. But dirt is far from mundane; it shapes our homes and our relationships, organises our time and links us to people throughout the world.

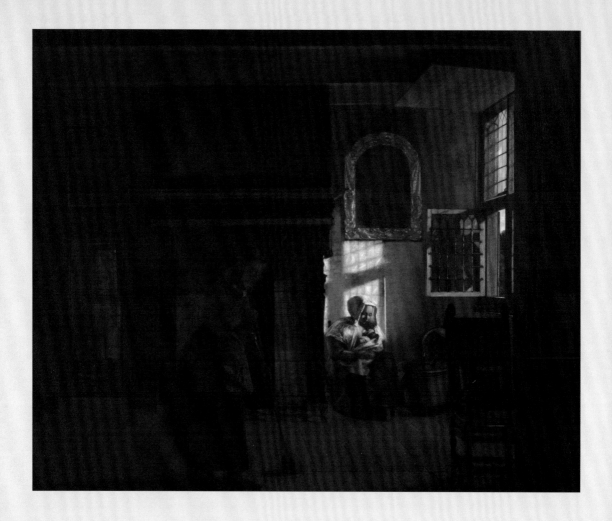

This seventeenth-century interior by Pieter de
Hooch depicts a woman tending a child by an
open window within a spotless domestic scene.
*Pieter de Hooch / A Dutch Interior / 1670–75 /
67.2 × 81.3cm*

In his 'Window' series, artist James Croak casts dirt
into the form of a window. Croak's work with dirt takes
up the material's status as both neutral and loaded, as
ubiquitous and also seldom used in creative practice.
James Croak / Window Series #1 / 1991 / cast dirt,
hanging bar / 177.8 × 88.9 x 16.5 cm

Above and right:
In his *Untitled (Bremen Carpet)*, Igor Eskinja uses household dust to create an installation reminiscent of a luxury carpet or rug.
Igor Eskinja / Untitled (Bremen Carpet) / 2010 / installation with home dust / 320 × 180 cm

Above and left:
Susan Collis's *Waltzer* raises the status of an everyday object (in this case a broom) by adorning it with valuable materials such as semi-precious and precious stones.
Susan Collis / Waltzer / 2007 / wooden broom, opals, turquoise, garnets, seed pearls, mother of pearl, black diamonds, white diamonds, fresh water pearls, coral, black onyx, marcasite / 127.5 × 37 × 11 cm

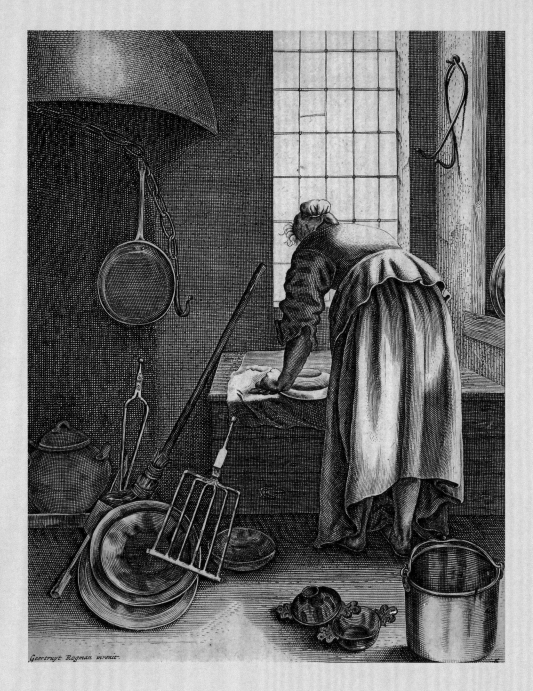

Unlike most Dutch interiors of the period, in which domestic order and propriety is depicted as quietly integral to the moral virtues of the household, Geertruid Roghman's remarkable engravings from the mid seventeenth century portray scrubbing, polishing and mending not as an obliging service but as hard physical labour.
Geertruid Roghman / Kitchen interior / 1648–50 / engraving

Pot-scouring, like sweeping and scrubbing, was a common subject
in representations of seventeenth century Dutch domestic interiors.
Copper and brass plates and bowls were much used, thoroughly
polished and often prominently displayed in the kitchen and around
the hearth – gleaming symbols of domestic propriety.
Hendrick Sorgh / Interior with Young Woman Washing Pots /
undated / oil on oak / 40.6 x 55.9 cm

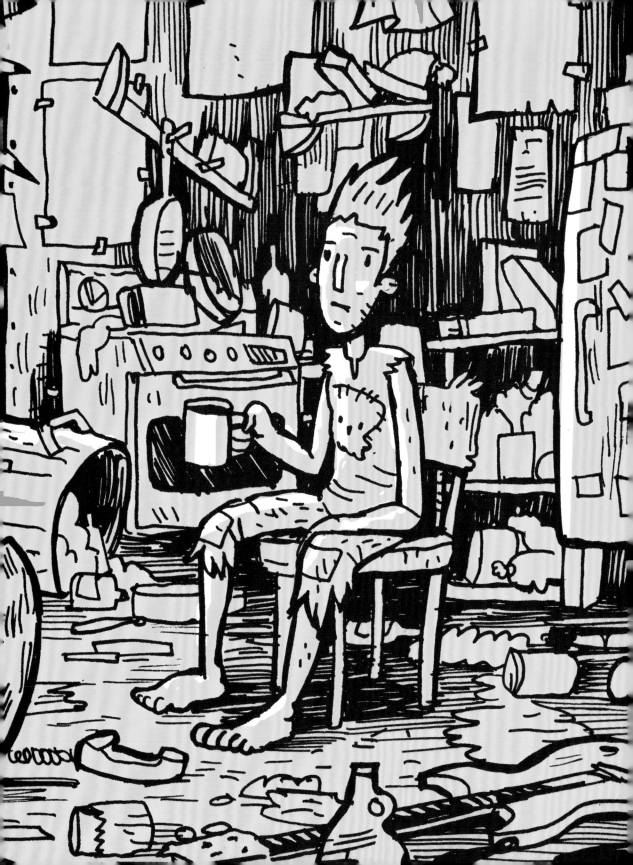

CLUB
CRUD

A GRAPHIC NOVEL

BRIAN RALPH

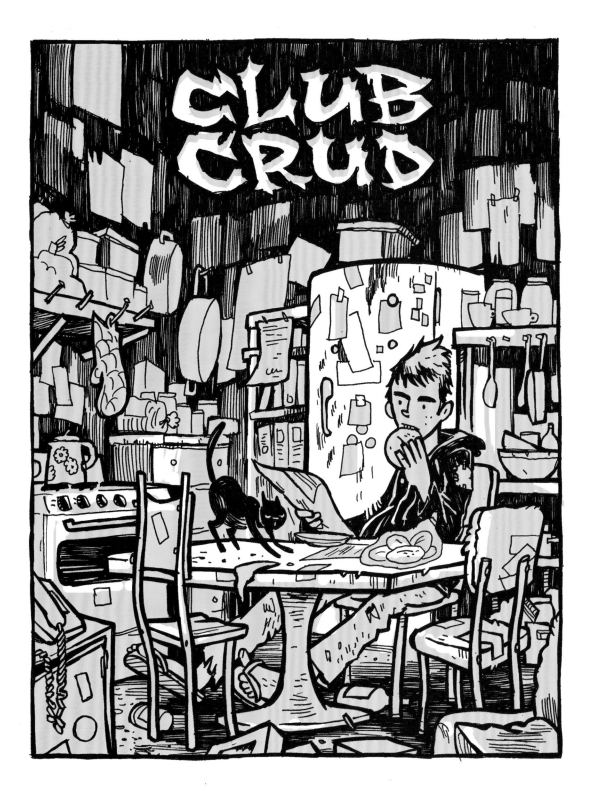

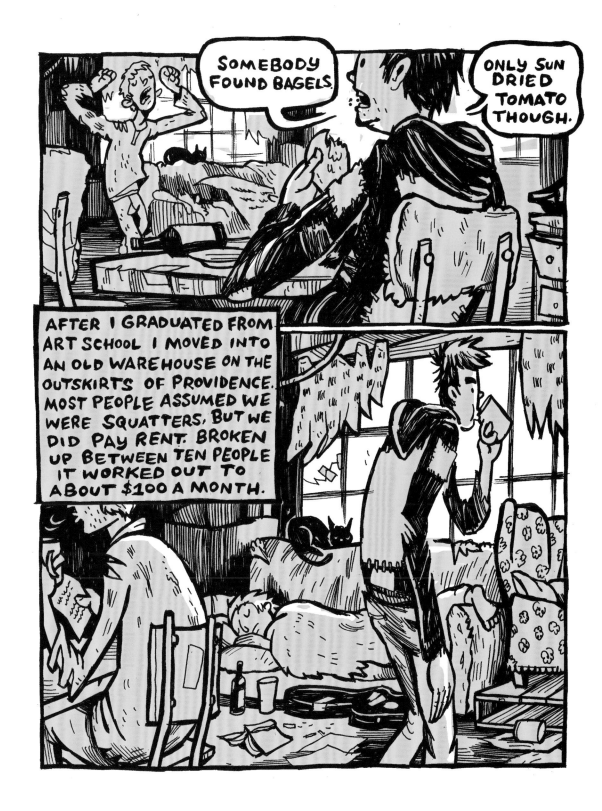

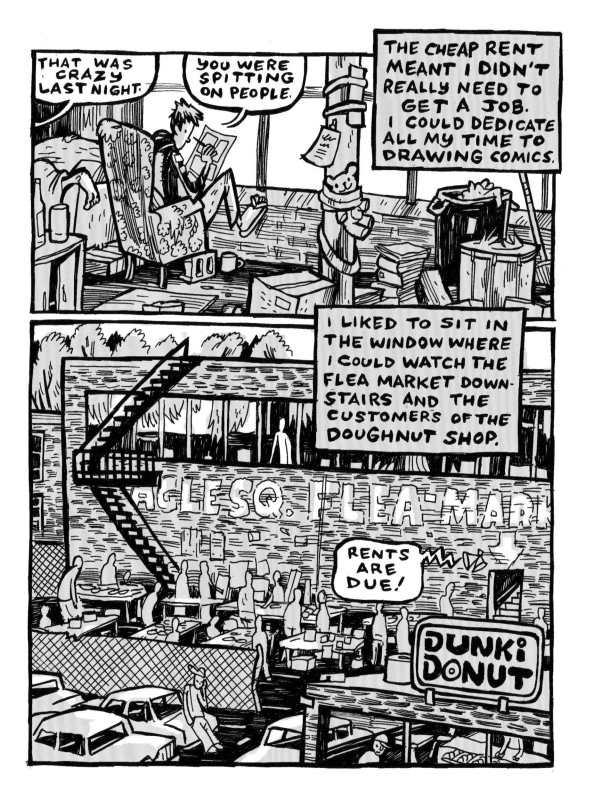

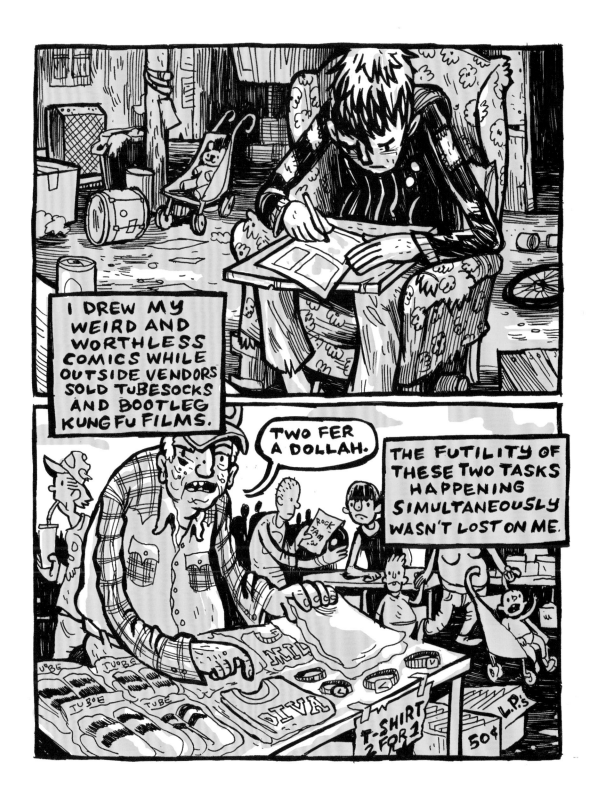

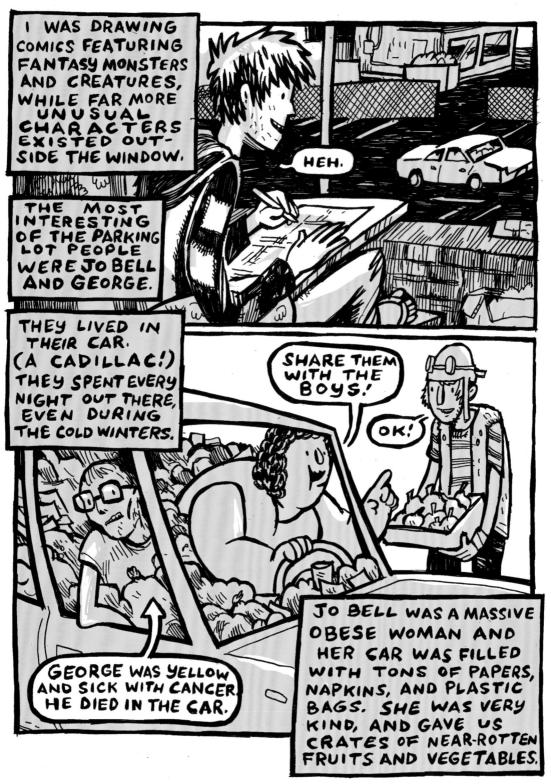

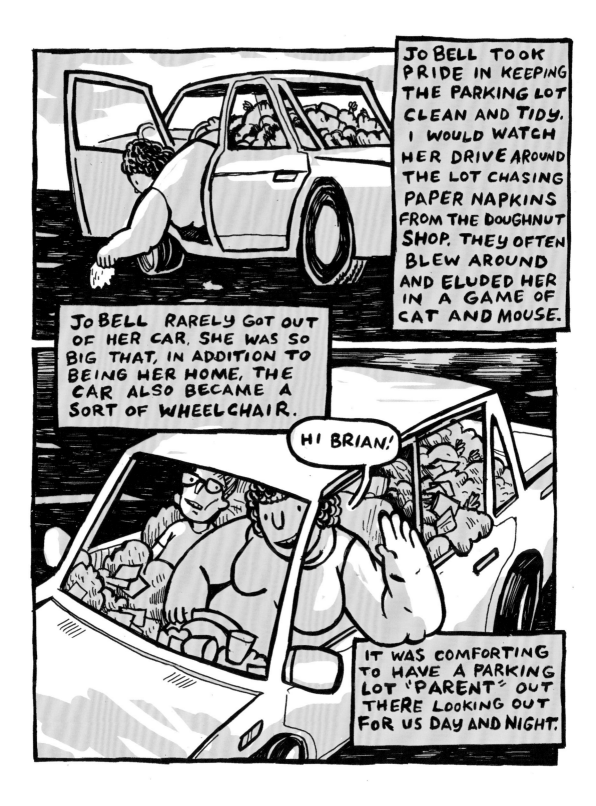

JO BELL TOOK PRIDE IN KEEPING THE PARKING LOT CLEAN AND TIDY. I WOULD WATCH HER DRIVE AROUND THE LOT CHASING PAPER NAPKINS FROM THE DOUGHNUT SHOP. THEY OFTEN BLEW AROUND AND ELUDED HER IN A GAME OF CAT AND MOUSE.

JO BELL RARELY GOT OUT OF HER CAR, SHE WAS SO BIG THAT, IN ADDITION TO BEING HER HOME, THE CAR ALSO BECAME A SORT OF WHEELCHAIR.

HI BRIAN!

IT WAS COMFORTING TO HAVE A PARKING LOT "PARENT" OUT THERE LOOKING OUT FOR US DAY AND NIGHT.

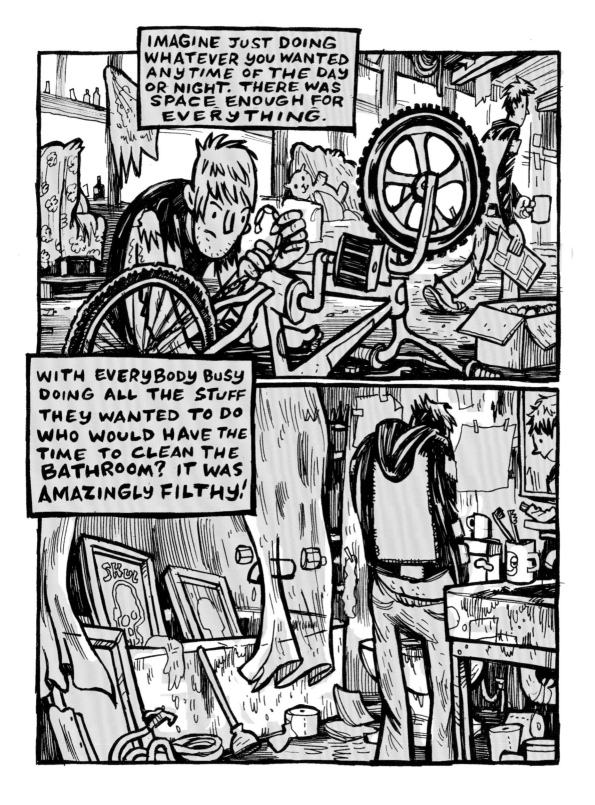

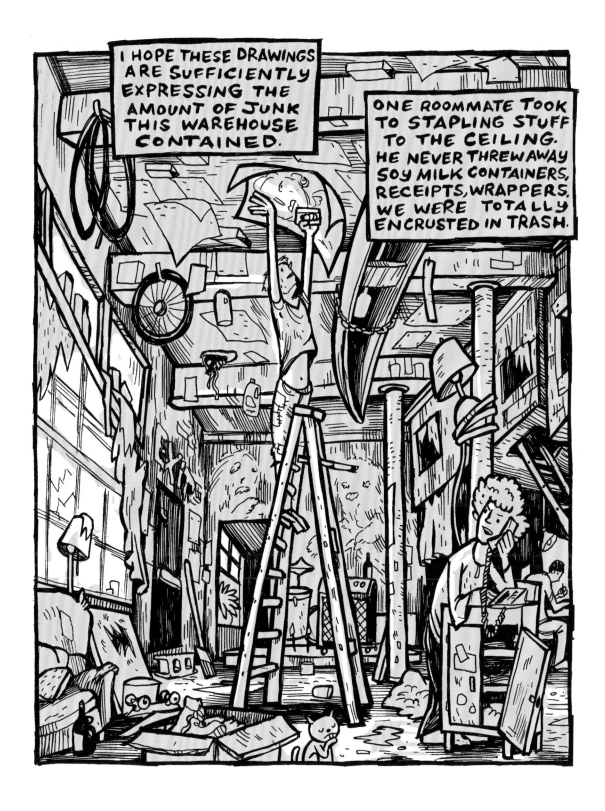

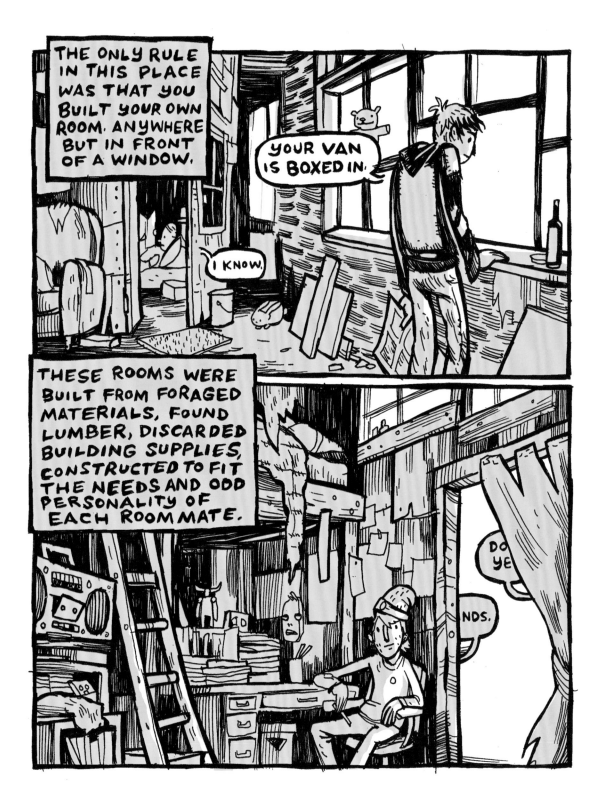

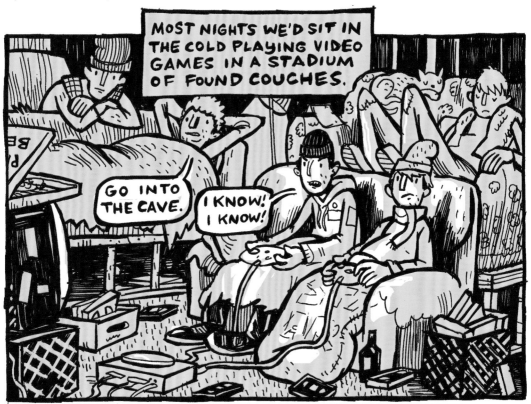

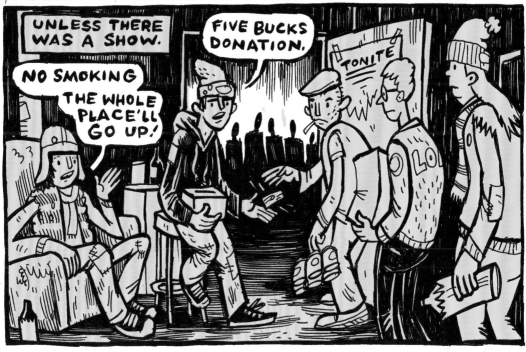

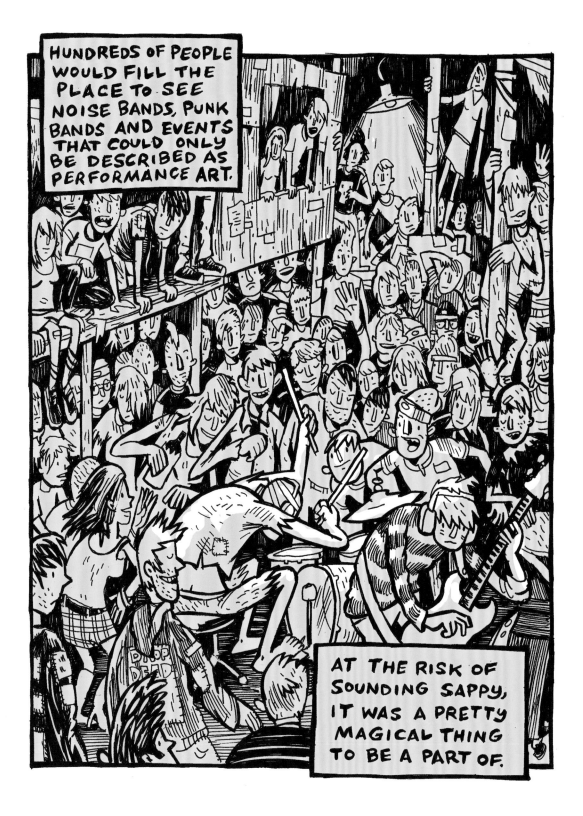

HUNDREDS OF PEOPLE WOULD FILL THE PLACE TO SEE NOISE BANDS, PUNK BANDS AND EVENTS THAT COULD ONLY BE DESCRIBED AS PERFORMANCE ART.

AT THE RISK OF SOUNDING SAPPY, IT WAS A PRETTY MAGICAL THING TO BE A PART OF.

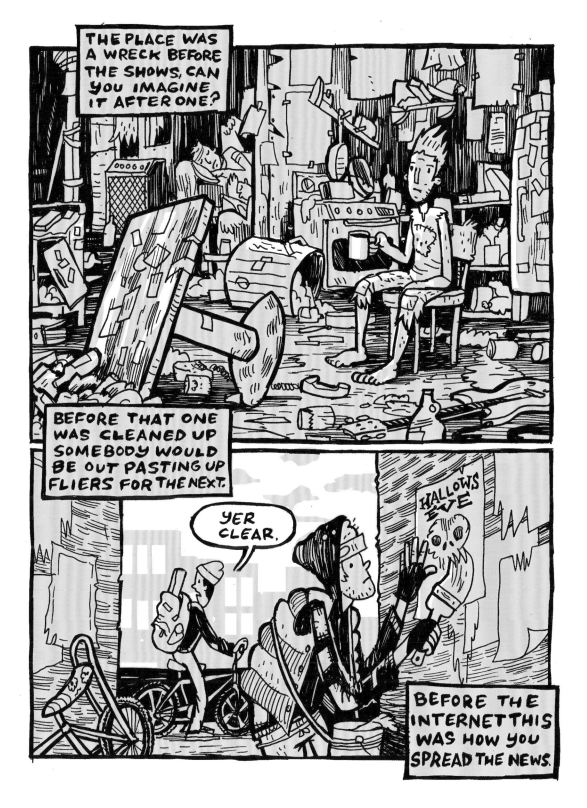

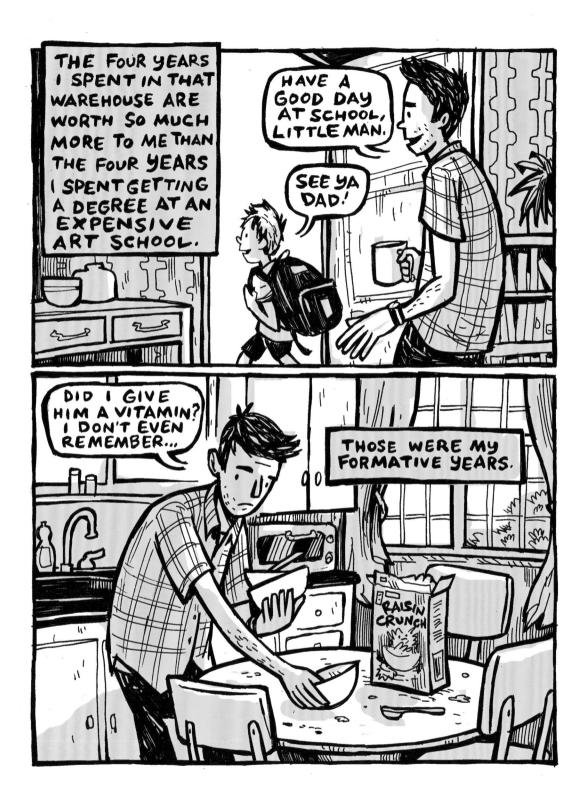

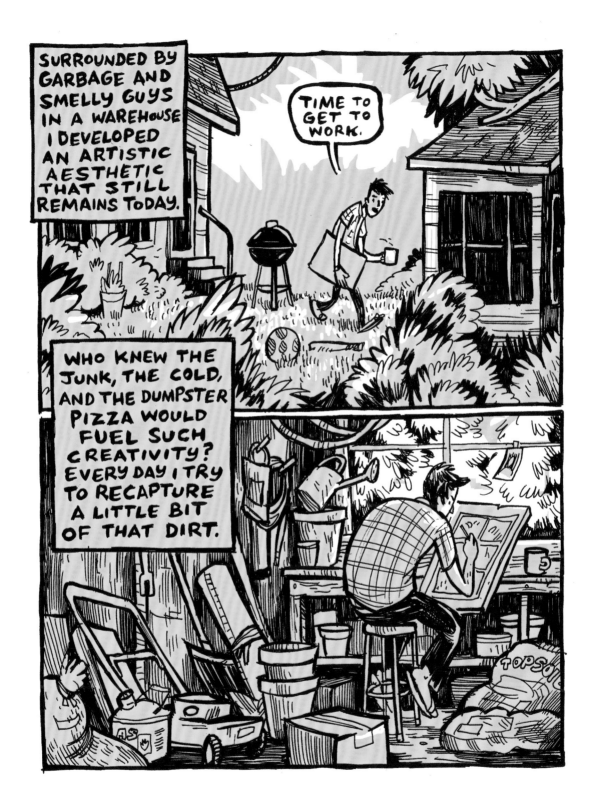

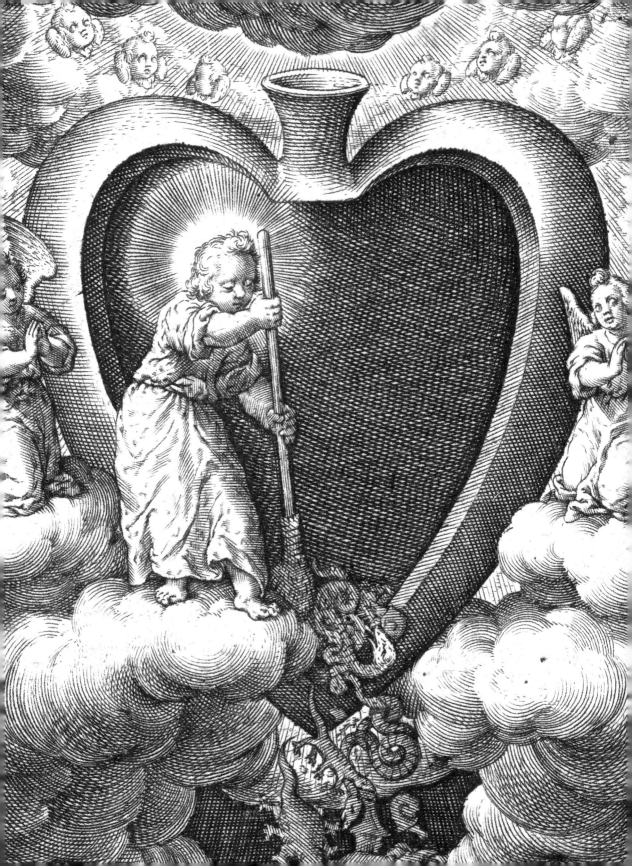

LEVITICUS
BE DAMNED

DIRT IN THE COMMUNITY

ELIZABETH PISANI

It's a Saturday morning in north London and I'm last down to breakfast again. That means that Andrew, the early rising housemate, will already have filched the best bits of the *FT*. Claire and David will be arguing over some damned thing in the *Guardian*, and it will fall to me to disguise my pyjamas under an old trench coat and go out for the croissants.

But no. Today I come down to the infinitely improbable sight of David reading the Bible. He is indeed arguing with Claire, who is deeply entrenched in that other holy tome: Prue Leith's *Fish Bible*. No sign of Andrew; it later emerges that he's upstairs on AskTheRabbis.com. What's behind this sudden access of holiness in our heathen home? We've invited an Orthodox Jewish friend to dinner, and had planned to serve monkfish with mangos as a main course. But are Orthodox Jews, dancing as they must around all the abominations listed in Leviticus, chapter 11, allowed to eat monkfish?

Yes, says Claire, because it swims in the sea. That's allowed. No, says David: monkfish is unclean. He flicks with unexpected familiarity to Leviticus 11:10. 'And all that have not fins and scales in the seas, they shall be an abomination to you,' he intones. And then, for good measure, Deuteronomy 14:10. 'And whatsoever hath not fins and scales ye may not eat: it is unclean unto you.'

Previous page:
The Christ Child is pictured sweeping a plague of reptilian monsters out of the believer's heart with a broom.
Antonie Wierix / Cor Jesu amanti sacrum / 1600s / engraving with etching / 7.8 x 5.6 cm

Below:
A study of fish from Sierra Leone, including monkfish and pilchard.
Artist unknown / Fish at Sierra Leone / date unknown / etching with engraving / 16 x 22.2 cm

I protest; monkfish have fins, don't they? Yes, but Prue says they're a type of shark. No scales, then. Andrew emerges with the definitive answer. It's there in bold on the Non-Kosher Fish List,[1] though judging by the qualified entry ('added by Rabbi Donneal Epstein in consultation with Dr Atz') there has been some discussion about it.

The prohibition on monkfish is part of the Bible's long list of dietary dos and don'ts. Creatures that chew the cud are clean, but only if they have a divided hoof. Birds are OK, with several specific exceptions that include eagles, ospreys and pelicans. Bats are out, of course, along with anything that moves on its belly.

Why should cows be clean but camels unclean, guinea pigs edible but rabbits an abomination? Some take a rather literal view; animals deemed 'unclean' are themselves unhygienic. They are bottom-feeders, filter feeders or just like to root around in muck acquiring parasites. But 'unclean' monkfish swim in the same waters as 'clean' mackerel and cod, and eat more or less the same things. A swan doesn't seem to me to be all that different from a goose, but one is OK and the other is not.

Maybe, then, we should go with the school of thought that deems foods 'unclean' not because they are bad, but rather because they are too good. 'The lawgiver sternly forbade all animals of land, sea, or air whose flesh is the finest and fattest, like that of pigs and scaleless fish, knowing that they set a trap for the most slavish of senses, the taste, and that they produced gluttony,' quotes Mary Douglas in *Purity and Danger*, her seminal work on the clean and the unclean.[2] Not for nothing is monkfish known as 'poor man's lobster'. (Of course, lobster is unclean too.) By the same logic, pelicans and bats, which are on the Leviticus abominations list, must be peculiarly yummy.

There are sundry other explanations – deeming some foods unclean is an attempt to fit in with existing religious traditions, say some. It's about trying to differentiate the new religion from past traditions, say others. It's completely random, or it's an expression of the ordering of the universe. Mary Douglas herself thinks that things are unclean if they don't fit perfectly the tidy box of their type: fish without scales are only half fish; birds that swim aren't proper birds; things that live on the land ought to walk, not slither on their bellies. But that still leaves owls and eagles, and they seem to be proper birds . . .

Perhaps, then, we should think of the unclean as a form of divine symbolism. The eighteenth-century Roman Catholic bishop Richard Challoner explained the monkfish mystery in a footnote to his famous revised English Bible: 'Fishes were reputed unclean that had not fins and scales: that is souls that did not raise themselves up by prayer and cover themselves with the scales of virtue.' That seems pretty far-fetched, but it turns on a central equation that seems to inform all of the putative explanations:

CLEANLINESS = VIRTUE

the inverse of which is

DIRT = WICKEDNESS

To restore ourselves to the path of righteousness, we simply need to clean up. Every religion has ritual cleansings that involve splashing water around, but few are as frequently cleansed as Muslims. Not content to require its followers to purify their souls five times a day in prayer, Islam demands physical purification before prayer, too. Not the easy-peasy Catholic 'dip-your-fingers-in-the-Holy-Water-and-make-the-sign-

of-a-cross' type purification, but the full head-and-four-limbs purification. And that's just for *wudu*, which is considered by most to be nothing more than a half-cleansing, compared with the full *ghusl*.

Whole books have been published on how to perform *wudu* correctly. They go into details about what to do with your comb-over (put the hair back in its natural place before washing), what sort of water you must avoid (water left by someone who has drunk wine) and what invalidates your *wudu* (passing water, leaking pus). But here are the basics from a handy-dandy guide for new converts to Islam.[3]
The bits in italics are optional. The rest is obligatory.

1. Making the intention (*niyyat*) in one's mind.
2. *Washing the hands two times*
3. *Gargling three times*
4. *Rinsing the nose three times*
5. Washing the face the first time *and then the second time*
6. Washing the right forearm the first time *and then the second time*
7. Washing the left forearm the first time *and then the second time*
8. Wiping the head with one finger *or with three fingers together*
9. Wiping the right foot with the right hand
10. Wiping the left foot with the left hand

That's a lot of cleansing; it suddenly seems a bit of a cop-out to be a Christian. Yes, I'm born with the stain of Original Sin. But I get cleansed of it in a quick half hour wrapped in a lace cloth as a baby. One jug of water at the baptismal font, followed by a boozy lunch for my parents and their mates, and I'm all purity again. *Wudu*, by contrast, is undertaken between one and five times a day (depending on the strength of your bladder and thus the frequency with which your previous *wudu* gets invalidated by peeing), and with the utmost seriousness. In some situations, no amount of cleansing is good enough. Women are excused from praying five times a day when they have their periods, on the grounds that menstrual blood and all it symbolises is just too filthy to be washed away by gargling three times and wiping the head with one or three fingers. The stain of a new life not achieved is a great religious unifier; most faiths regard menstruating women as unclean.[4] For one week a month, sometimes more, women are not allowed into mosque or temple (Hindu, Jewish or Buddhist), and are excluded from many a church, too. Predictably, the bombastic Leviticus regards women 'with an issue of blood' as an abomination. So much so that any cushion she sits on, any bed she lies on, becomes unclean. If you inadvertently plump down on a cushion thus sullied, you have to bathe and wash all your clothes, and still you'll be unclean until evening. Woe betide a man who lies with a bleeding woman and is stained with her flowers – the poor bloke is considered unclean for a whole week, and no amount of bathing can restore his dignity before that time is up.

Lots of ways to be unclean, then, but lots of cleansing going on. Why doesn't it translate into a greater respect for cleanliness in the public realm, I pondered recently, while trundling down the flyblown coastline of South Sulawesi. The people of South Sulawesi are among Indonesia's most pious Muslims, and the region's newly autonomous districts are competing with one another to demonstrate just how holy they are. As the population grunts and sweats a living out of collecting seaweed for sale to a Taiwanese agar jelly factory, the worthies of Takalar district have decided to invest their citizens' hard-earned taxes in motivational road signs. 'HAVE YOU

PRAYED YET?' I am asked, as I bump by in a bus sticky with sweat, half-eaten coconut candies and chicken droppings. 'OUR UNITY LIES IN GOD!' the next sign assures me. Then, squeezing along a potholed road between a town rubbish dump and a beach strewn with disued flip-flops, crushed plastic bottles and dog turds: 'CLEANLINESS BRINGS JOY TO THE IMAM'S HEART'. The gentleman sitting next to me spits into the aisle, then rubs the gob neatly into the floor with his foot.

Tragic commons – happy toilets

The 'cleanliness is next to godliness' mantra turns up in many a culture. But I'm by no means the first to note that there's often a gulf between the enthusiastic and frequent practice of ritual cleansing and a tolerance for dirt in daily life. Anthropologists working in Benin explain the mismatch as an active protest against corruption in government.[5] People are very keen to keep dirt off their bodies and out of their houses, but streets and public spaces are the government's responsibility. When city councillors spend more time cleaning out public coffers than cleaning up public spaces, people retaliate by adding to the piles of fetid rubbish that clog the streets. Councillors respond by accusing the population of ignorance and pig-headedness; no point spending money to keep inner-city slums clean, then. Funds that should be spent on sanitation drift off to personal bank accounts, people retaliate by adding to the piles of rubbish . . . and so it goes round.

For my own part, I think people who dump in public places what they wouldn't want dumped on their own doorstep are not so much agents of social protest as bit players in that well-worn human drama, the tragedy of the commons. If I dump rubbish in my yard, only I suffer. If I pick it up again, I get to enjoy that nice clean space all by myself. If I dump it in the town square, on the other hand, I suffer less, but lots of other people suffer with me. If I make the effort to tidy up the square, I do all of the work, but only benefit a little, and lots of people who didn't lift a finger to help profit from my work, too. That doesn't seem fair; I might just as well leave it there for someone else to deal with.

What would happen, though, if the government were to assume responsibility for cleanliness in public places? Ironically, such a society would be one in which individuals were least likely to leave a mess for the authorities to clean up. A society in which emptying chamber pots in the street, leaving beer bottles on the beach, peeing in lifts and sticking chewing gum onto the underside of bus seats is viewed as Jurassic behaviour. A nice, modern, corruption-free state with shopping malls agleam with marble and hospitals bright with polished steel. In such a place, cleanliness is the visual symbol of modernity just as dirt is shorthand for all that is miserable, backward, underdeveloped. Everybody knows that the kid with the grubby knees in the schooldays film is the pauper. Everybody knows that the guy with the soup stains on his tie and the greasy mackintosh is the loser, the sad sack, the 'dirty old man'. Those are images we want to avoid not just personally but as a society. So we launch cleanliness campaigns, fine people for dropping litter, celebrate the absence of dirt at every turn.

We'd become Singapore, that's what.

Singapore first showed symptoms of obsessive-compulsive disorder in 1964, when it banished cows and stray dogs from the city streets. Four years later, when its frequently re-elected benevolent dictator Lee Kuan Yew declared war on dirt with the first 'Keep Singapore Clean' campaign, he was quite clear that banishing dirt would lift the newly formed country from post-colonial backwater to paragon of modernity.

J.B.Hilaire Del.

MUSULMAN FAISANT·SON ABLUT

A.P.D.R.

Pl. 12.

J.B. Simonet, Sculp.

bdésth.

A seated Muslim man is attended by two male servants while he performs his ablutions (or *wudu*). These cleansing practices are undertaken by all followers of the Muslim faith before they enter a mosque or perform one of the five daily prayers. *Jean-Baptiste Hilaire, after J. B. Simonet / Musulman faisant son ablution / early 1800s / engraving / 17.4 × 25 cm*

'No other hallmark of success will be more distinctive than that of achieving our position as the cleanest and greenest city in South Asia. For, only a people with high social and educational standards can maintain a clean and green city,' he intoned. He banged on a bit about the tragedy of the commons, about people abdicating responsibility for cleanliness at their doorstep. But he wasn't content to push people over their doorsteps to remove dirt from the public realm, he pushed them right across other people's doorsteps, too. 'Singapore has become one home, one garden, for all of us,' Lee said. 'And the way any neighbour soils his home and breeds flies and mosquitoes has become your personal business.'

The city-state embraced the disinfected path to progress with gusto. On average, Singaporeans wash their way through more than twice as much soap in a year as their northern neighbours in Malaysia, and more than four times as much as the Indonesians to the south.[6] The 'Happy Toilets' campaign which runs a star rating system for public loos is surely a model for the world to emulate.[7] No country witnesses more frequent slapping of young hands and repetition of: 'Don't touch! Dirty, lah!' It has worked: when the death-to-dirt campaign was launched, 22 out of every thousand Singaporean babies died before their first birthday; that's about the same as in Botswana or Nicaragua today. Singapore's infant mortality rate has since been scrubbed down to the lowest in the world at two deaths per thousand births; in the United States and the United Kingdom rates are nearly three times higher.[8]

Life expectancy is one of our most common measures of 'progress'. If sweeping away dirt helps sweep away infant deaths, then by definition it is a measure of progress. So it's mildly ironic that all this not playing on the floor and washing with antibacterial soap is sapping immune systems and leading to increases in some types of disease. Singaporean school kids have become significantly more prone to eczema, and asthma among teenagers is up, too.[9] But other types of illnesses are also appearing among young people who live in the gleaming shopping mall that Singapore has become. In 2007 the state's first survey of childhood mental health found that one in eight kids had emotional or behavioural problems – about the same as in Western countries.[10] Interestingly, though, Singaporeans were much more likely to have 'internalising' problems – emotional constipation, basically – and much less likely to have 'externalising' problems: running around screaming and beating up other kids.

If allergies are sometimes the consequence of an excess of cleanliness, mental illness is sometimes the consequence of an excess of boredom. Singapore's obsession with removing all traces of physical dirt is clearly part of a self-conscious drive for modernity. Does that perhaps parallel the excision of other, more symbolic types of dirt and disorder – immoderate appetites for money, sex and power that make our lives and societies messy and chaotic, perhaps, but often the richer for it? I think so.

In praise of dirt

I'll concede that most cultures would agree with Lee Kuan Yew that dirt goes hand in hand with all that's undesirable. More than 150 years ago, in 'The Song of the Shirt', poet Thomas Hood portrayed a London seamstress thus:

With fingers weary and worn,
With eyelids heavy and red,
A woman sat, in unwomanly rags,
Plying her needle and thread –
Stitch! stitch! stitch!
In poverty, hunger, and dirt.

Poverty, hunger and dirt. Not exactly something to aspire to. And yet, more and more, we're turning to dirt as a sign of authenticity in our over-processed world. We go to farmers' markets with our jute bags and buy things that have a visible connection with their earthy origins. We want dirt on our spuds.

Beyond its association with a greener planet and bad facial hair, dirt has a glamorous side, a side that is equated with heroic strife, with towering effort, with gritty determination. Millions gather weekly to watch sweat-soaked demigods battle through the mud for some sporting trophy or other. As a rugby fan myself, I am slavishly devoted to seeing a glittering trophy being held aloft by a player properly caked in the mud of the chase. Many would say that team sports are a ritualisation of tribal warfare; do we have an underlying need to see the warriors-by-proxy covered in the dirt of the savannah in the same way that young Samburu men on the plains of northern Kenya smear themselves in ochre? Certainly, we expect our fictional commandos to be daubed with the grubby marks of battle. If I close my eyes and think of any screen warrior I see two

Two rugby teams in action.
Photographer unknown /
Rugby Game / 1983 / photograph

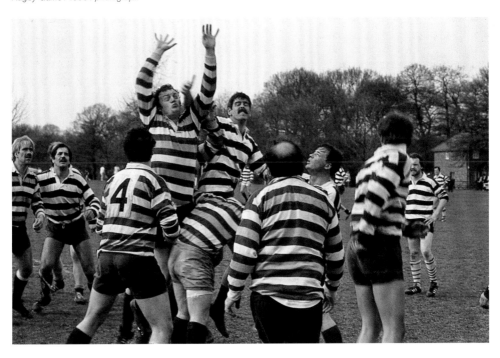

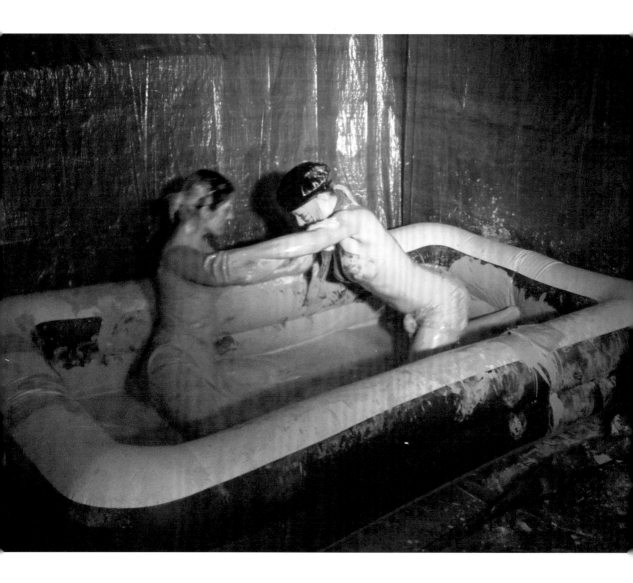

Although the first recorded mud-wrestling match
was between two male competitors, the sport has
become sexualised in recent years. It is now usually
performed by two women in a state of undress for
the entertainment of male spectators.
*Mud-shack, London / Mudwrestlers Match /
2010 / photograph*

things: a semi-automatic weapon and a muddy jawline. If I close my eyes and think of any real fighter I've seen, the frightened teenagers in army uniforms pursuing unseen terrorists in the hills of north-western Indonesia, for example, I still see the semi-automatic. Late in the day there's a fair bit of mud, too. But there is nothing remotely glamorous about it. It occurs to me that the fetishisation of earth and dirt as a sign of authenticity, of primal struggle, of heroism is an extraordinary luxury. It exists only in situations where people have the option of being clean. Where dirt on your potatoes, under your fingernails and in your drinking water is the status quo, all you want is Singapore.

That mud-as-glamour thing slid into a pit of silliness with the spread of mud-wrestling as a source of entertainment. The key feature of mud-wrestling is actually the absence of a feature: any clothing to speak of. Though the first recorded match was between two men, mud-wrestling has lately undergone gender reassignment. Good-looking girls slip-sliding across one another's near-naked bodies in a primeval slop of dirt that pretends to be a good, honest contact sport; at once wholesome and titillating. What's not to like? Mud-wrestling weds the heroic aspects of dirt with the dirty aspects of heroines – their sex.

Dirty sex?

In many cultures at any rate, sex is considered dirty. I'd like to say it was considered dirty in that glamorous, heroic-strife, towering-effort way that we accord to sporting and screen icons, but no. It's considered dirty in that furtive, slightly embarrassed, should-be-ashamed-of-yourself sort of way that makes you secretly wish you didn't enjoy it so much. Trying to think of attempts to make sex 'glamorous dirty' rather than 'shameful dirty', I come up with nothing better than those glossy ads in which women with smouldering eyes and bare backs throw come-hither looks at men in sharp suits. Men who always seem to go for the cigar and glass of cognac, in the end. In the high camp world of *The Rocky Horror Picture Show*, there's the iconic Janet-grows-up scene. Yes, she wants to be diiiiiiiiiirty, but at least she associates that with being thrilled, chilled and fulfilled. It's hardly mainstream glamour though, is it? Even thinking about sex is considered dirty: you never hear someone accused of having a 'dirty mind' because they are thinking about corruption, or bodily functions, or poor road drainage. But laugh at some fatuous double entendre and you're told to get your mind out of the gutter.

Is sex considered dirty because it's bad, or is it considered bad because it's dirty? After all, sex can be quite dirty. Sticky, mostly, though some practices generate more sheet-washing than others. It is probably no coincidence that some of the naturally muckier ways to have fun – anal sex, for example – are also the ones we're least keen to talk about. But does the stain of that dirt bleed into the stigma which we so generously attach to people who we know have anal sex – to gay men, principally? I know straight men who are made physically uncomfortable by the idea of having a doctor's finger up their anus, let alone another man's tackle. But I don't think it's the actual emissions in their various forms that account for the lingering pall of homophobia, any more than I believe the majority think of vaginal sex as something physically dirty. In fact, a lot of the things we think of as most sordid don't involve any physical contact between people at all: dirty old men in their macs at peep shows, sexual fantasies, pornography.

Countless volumes have been written about the social construction of sex in various cultures; the most striking thing about many of them is that it is possible to be so turgid and humourless about something as inherently fun as sex. A disproportionate

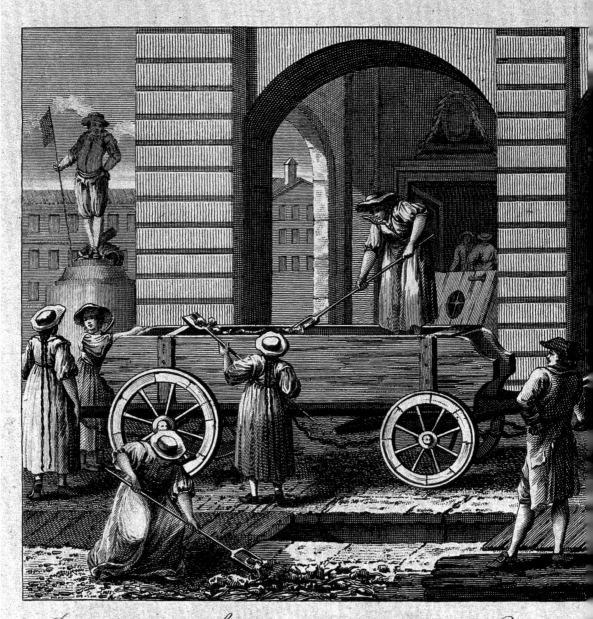

Punishment of PROSTITUTES in Switzerl
the Scavengers Cart.

Warren sculp.

by dragging

The arcades or covered promenades of late eighteenth century Bern are shown in the background as the shopkeepers open up their shops. In Bern, and throughout Switzerland, female prostitutes would be apprehended and sentenced to public punishment. Here, four women are harnessed to the scavenger's cart, and are compelled, on pain of the lash, to clean the city streets.
Warren / Punishment of Prostitutes in Bern, Switzerland, by Dragging the Scavengers Cart / 1790 / engraving / 12 × 17.6 cm

One of a group of four studio portraits of a man in women's clothing, apparently sent to the late nineteenth-century German psychiatrist Richard von Krafft-Ebing from Karlsruhe, Germany, in 1896. This would have been produced for the 'sitter' or someone associated with him, and then later sent to Krafft-Ebing as a representation of a particular perversion, by either a patient or more probably a fellow medical professional. *Photographer unknown / untitled / from the Richard von Krafft-Ebing Collection / 1896 / photograph*

amount of attention has been paid to sexual cultures in sub-Saharan Africa, though very rarely by African writers. The great explorer and reputedly great sexologist Richard Burton was one of the first to describe the sexual landscapes of the continent in any detail. Tragically, we lost most of those descriptions to the prudish bonfires of his arch-Catholic wife Isabel after his death, but he started a trend that allowed Victorians to take an interest in other people's sex lives under the guise of anthropology. What they found was that other people's sex lives were much more interesting that their own. In truth, virtually any variation on the dreary life-long-spouse-and-occasional-hooker-if-you-dare model would be more interesting than their own in that buttoned-up age. But the Civilising Forces of Colonialism were bent upon bringing everyone down to the lowest common denominator. The Victorians wrapped their sexual prudery up in the pages of the Bible – we don't call the set piece of vanilla-flavoured sex the missionary position for nothing. And they set about spreading it across cultures that had for millennia escaped any terrible divine vengeance despite embracing sex with the joyful enthusiasm it merits.

The Christianity stuck, and with it all the small-minded moralising about sex that we find in the junk mail that St Paul liked to send to unsuspecting Corinthians, Galatians, etc. But the cross-your-legs-and-think-of-heaven behaviours that the moralising implies did not stick. It is this mismatch between the echoey-Victorian public discourse about sex in some parts of Africa and the vibrant practice of this most fulfilling of human activities that has, in part, allowed the fatal but preventable HIV virus to infect an estimated forty million people in sub-Saharan Africa. That's

A 1990s German public health poster showing
two naked men. The caption reads: 'Conscious
life. Sexuality has a lot of possibilities: use his
imagination for hot safe sex. And a condom'.
*Will McBridie and Detlev Pusch / AIDS
Public Health Poster / 1990s / colour lithograph /
59.3 × 41.9 cm*

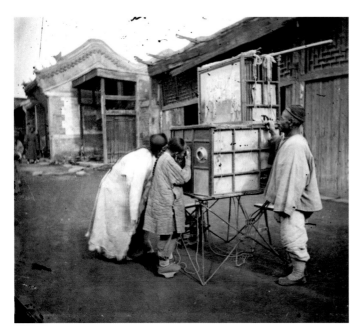

A travelling peep show in late
nineteenth-century Peking.
*John Thompson / Chinese Peep
Show / 1869 / photograph*

In this advertisement card, possibly for the
Moulin Rouge in Paris, a woman rides a
man like a horse, in an act of sexual roleplay.
*Photographer unknown / A Woman Riding
a Man / from the Richard von Krafft-Ebing
Collection / 1880s*

A matchbook produced for American
sailors during World War II, warning of
the dangers of sexually transmitted diseases
and encouraging the use of condoms.
D. D. Bean & Sons Co. / Matchbook / 1940s /
lithograph cover / 9.6 × 4.8 cm

Public health poster published by the US
Government Printing Office during World War II.
Leonard Karasakov / Public Health Poster,
Prostitution / 1944 / lithograph / 46.6 × 36.3 cm

A 1940s US public health poster depicting
a woman wearing a sandwich board
announcing she has venereal disease.
*US Navy Bureau of Naval Personnel /
'They Don't Wear Labels' Public Health Poster /
1948 / colour lithograph / 60.1 × 46.2 cm*

two-thirds of the world's infections in an area that accounts for just one in ten of its population.[11]

That brings me to one of the reasons that sex is considered 'dirty': it transmits disease, madness and death. These days, most other sexually transmitted infections pale by comparison with HIV. But syphilis, much easier to catch, was nearly as incurable until penicillin came along around the time of World War II. Like HIV, syphilis could strike you blind as well as make you mad before it went on to kill you. Its general horridness led to much not-in-my-back-yardness: the Brits, the Italians and the Germans called it the French disease. The French passed the buck back to the Italians. The Dutch called it the Spanish disease. For the Turks it was the Christian disease. Even the South Seas sent it back to a far-off origin; in Tahiti, syphilis was apparently known as the British disease. Like many prejudices, these are not entirely blind. Foreign seafarers cooped up on painfully slow sailing vessels with lots of other men often sought female company when they arrived at port. They were well placed to pick up a cargo of *Treponema pallidum* in one port and deliver it to the next.

By extension, some sex is dirtier than other sex; commercial sex is the dirtiest for heterosexuals, and whores are nothing less than vectors of disease. So goes the popular thinking. But it's not quite that simple. Almost by definition, if a sex worker is infected with a sexually transmitted disease, he or she was infected by a man, so can hardly be considered the source, origin, fountainhead of infection. And yet it's true that, if they are any good at their jobs, hookers bed more clients than clients bed hookers. Before condoms, that meant a prostitute was more likely than her client to be infected. Because there have always been many more clients than sex workers, the absolute numbers of infections can be very similar. And yet it's always been the sex worker, always the female sex worker, who is blamed for spreading the dirt. The image persists in the popular imagination even in places where condoms are the norm in commercial sex. In many countries, a woman who sells sex is no more likely to be infected with HIV than a client, a school teacher or a schoolgirl. But still we think of hookers as inherently dirty. And, of course, there's the money thing. As if sex isn't sordid enough in its own right, hookers add a grubby, transactional dimension . . .

Where are the dirty rich?

Money is something of a Janus issue where dirt is concerned. We often describe people as being 'filthy rich'. In some societies, and I'd put Britain close to the top of the list, money is considered inherently vulgar. Wealth is OK, as long as it grows from real dirt (soil, land, estates), preferably dirt that has been tramped down through the family and the hallowed halls of the House of Lords on generations of green wellies. But flash cash, cash earned through the unseemly work of making things or selling them, is somehow sordid. The dirty rich are superior to the filthy rich.

In the first decade of the twenty-first century, the Filths and the Dirts had a few little affairs. The progeny of the first crawled into the House of Lords on the coat-tails of their donations to the Labour Party. Because Labour ran the country at the time, they were allowed to nudge the Queen into shooing various generous Filths into the Lords, where they took their places alongside a dwindling number of wellie-booted peers and a lot of others who were there on their merits. This cash-for-honours scandal is not, you understand, to be confused with the cash-for-influence scandal that followed a couple of years later, in which a number of

members of the House of Lords bragged that they could deliver changes in the country's laws in exchange for a dollop of filthy lucre.

And filthy it can be – the black market is home to a trade in everything from heroin to other people's (nuclear) waste products. Supermodel Naomi Campbell was unintentionally accurate when, while giving evidence in a trial at the International Court of Justice, she dismissed diamonds given to her by warmonger Charles Taylor as 'dirty little pebbles'. The money that blooms fungus-like from the stolen art works, bloody diamonds and counterfeit cigarettes of the black market has to be washed clean to be usable. And, of course, an easy way to generate a bit of cash is through blackmail, which only works if someone has a dirty little secret. Those secrets are usually about one of two things. The first is sex. The second, with marvellous circularity, is money itself.

You can't blackmail someone by threatening to tell the world that they are rich, of course. They have to have come by their money by doing something slightly rotten, or by spending their money on something slightly rotten, or both. In the cash-for-honours/influence two-step it wasn't the money itself that was considered dirty, but the whiff of corruption that rose from it. And that in turn was the product of greed and hubris – two qualities at which some cultures turn up their noses more than others. In many places, ranging from the uber-capitalist United States to nominally communist China, we see Janus's other face. 'To get rich is glorious,' intoned Chinese leader Deng Xiaoping as he turned his back on his predecessor Mao Zedong. The sentiment was echoed from the other side of the political canyon: 'What I want to see above all is that this remains a country where someone can always get rich,' said Mr Deng's American counterpart, Ronald Reagan.

Americans didn't always think of money as synonymous with a virtue. In fact they more or less invented the concept of money laundering, both physically and figuratively. According to Lewis Lapham, who has a word or two to say about America's obsession with cash, the Pacific-Union Club (perched on the lofty social high ground of Nob Hill in San Francisco) cycles all coins through the kitchen for cleansing before they can be

Left:
The oil magnate and founder of Standard Oil, John D. Rockefeller, with his son in 1910.
Photographer unknown / John Davison Rockefeller with his son John D. Rockefeller Jr / 1910 / photograph

Opposite:
An early twentieth-century postcard depicting poor children from Croydon, near London, photographed against a studio backdrop.
Photographer unknown / Croydon, Raw Material / 1903 / postcard

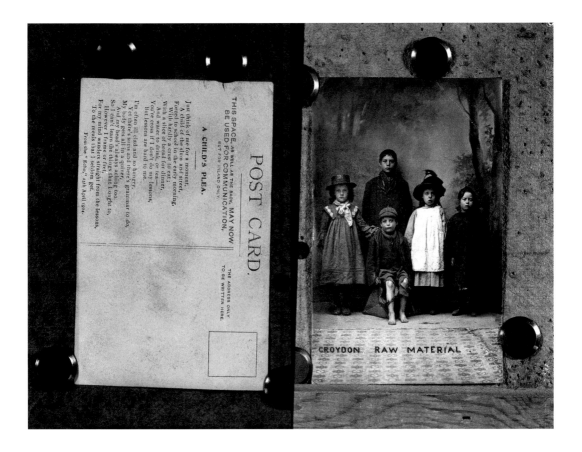

offered to members on a tray as change.[12] Lapham is among many to observe that the great American tradition of philanthropy blossomed out of the muddy slush funds generated by the robber barons of the nineteenth century – John D. Rockefeller and his ilk.

America = Opportunity = Wealth = Happiness. The equation was recited to me in a roundabout way by a twenty-something man with an indefinable accent whom I met in Boston in 2008, as he was working one of the three jobs that collectively allowed him to make ends meet. It was the night before the presidential election and the airwaves were frenzied with an excitement that I shared and he didn't. He'd only become an American citizen the previous May, and didn't think he'd bother to vote. 'For a while, I thought I'd vote for Obama. But then I heard he wanted to take money away from rich people and give it to poor people. If he did that, what would be the point of being an American?'

The indefinable accent had, it turned out, been shaped by a childhood in Albania. The sentiment it expressed was very American. There is nothing dirty or unacceptable about money in America. As in China, what's really unacceptable is to be dirt poor.

Dirty for art's sake

For Thomas Hood's hapless seamstress, poverty and dirt are inextricably entwined, and not in a good way. But as wealth breeds comfort, it also breeds perversity: rich societies have come to glorify both poverty and dirt as noble, artistic and ultimately desirable.

The term *Arte Povera*, 'Poor Art', wasn't coined until 1967; by that time a number of the Italian artists who embodied the movement had generated a fair few coins of their own by turning soil, dirty rags and other grubby objects into 'art'. Perhaps the most, ah, solid expression of that was Piero Manzoni's 1961 collection of canned excrement, elegantly entitled *Artist's Shit*. Manzoni produced 90 cans of shit, individually numbered but otherwise identical; 'CONTENTS 30 GR NET. FRESHLY PRESERVED. PRODUCED AND TINNED IN MAY 1961,' declare the labels in Italian, German, French and English.[13] Inevitably, the art attracted a lot of gumph about its inner meaning: everything that an artist produces is art, excrement is the most intimate expression of the artist's creation, etc., etc.

LE SAVETIER.

Opposite:
A cobbler connives in his beautiful wife's dalliance with a rich merchant – she plans to repay her husband's debts with sexual favours.
Jean-Baptiste Joseph Paterre / 1736 / Le Savetier / etching / 34.1 × 38.2 cm

Right:
In this early nineteenth-century Italian etching, a poor man is pictured picking up money spilling from a rich gentleman's pockets. The caption reads: 'Those who have money sow money.'
Giuseppe Piattoli / Chi n'ha ne semina / 1800s / coloured etching / 28.8 × 21.6 cm

XX.

Chi n'ha ne femina

Costui che in terra abbonda di Contanti, Senza pensare, che vi son tanti e tanti,
Li semina e li dona, a questo e a quello: Che non hanno la stampa entro il borsello

If the tins really do contain his shit, it means that Manzoni squeezed out over 2.7 kilos of excrement in the month of May – easily done, since the average for a healthy man with a diet heavy in bread is 407.7 grams a day, according to one pair of scientists who took the trouble to diligently monitor the faecal output of 1,000 healthy volunteers.[14] All that bowel action by Manzoni, if indeed it happened, was well worth it. At least one collector thought the artist's droppings were worth their weight in gold, exchanging 30 grams of 18-carat gold for one of the tins in 1962. In 2007, Sotheby's sold tin number 018 for €120,000.[15] Since 30 grams of gold was selling for about $35 in 1962 and $680, or €500, at the time of the Sotheby's sale,[16] it seems that shit, when properly conserved, labelled and elevated to the status of art, is a pretty good investment, outstripping gold by well over 2,000 per cent.

Manzoni was not, of course, the first scatological artist. He was preceded by the even more iconic Marcel Duchamp, whose 1917 *Fountain* is nothing less (and nothing more?) than a urinal, laid flat and signed. More recently, Britain's Tracy Emin declared the detritus of her life a work of art. Unwashed dishes, condoms and dirty underwear adorned her unmade bed; a scene uncomfortably familiar to many of us, albeit not one that we might choose to display to random strangers. This was dirt as part of the fabric of our lives; mundane, prosaic, banal – anything but artistic. If we assert that dirt is art, does that somehow make our lives less dreary, turning each of us into an artwork in the making?

It was not so long ago that the scented classes were proposing art as a way of uplifting the Great Unwashed. No one put it more clearly than Victorian clergyman Charles Kingsley. For him, the works of art hanging in the picture galleries and museums of London were nothing less than moral magnets, lifting the working man out of the gutter and carrying him closer to the divine: 'Believe it, toil-worn worker, in spite of thy foul alley, thy crowded lodging, thy grimed clothing, thy ill-fed children, thy thin, pale wife – believe it, thou too and thine, will some day have your share of beauty . . . That pictured face on the wall is lovely, but lovelier still may the wife of thy bosom be when she meets thee on the resurrection morn!'[17]

Barely more than a century later, and artists are pooing in tins for an appreciative world. It's a great subversion of an earlier vision of art as an expression of all that is most precious in life. Or is it? Perhaps the assertion that dirt, grime and trash have artistic value is in itself a way of elevating our tawdry lives towards some higher truth.

The artist Piero Manzoni created a work in 90 editions, said to contain his own excretion, and labelled 'Artist's Shit, CONTENTS: NET WEIGHT 30GR. FRESHLY PRESERVED. PRODUCED AND TINNED IN MAY 1961' in German, French, English and Italian.
Piero Manzoni / Artist's Shit / 1961 / sculpture/ tin can with paper wrapping, unidentified contents / 48 × 65 × 65 mm

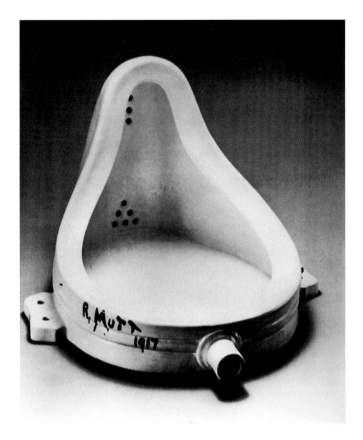

Return to dirt

The link between workaday dirt and the artistic, or indeed the sublime, goes back many millennia. The lotus is central to Buddhist iconography in large part because it is an object of incontestable aesthetic beauty, rising pristine from the mud. So should we be able to rise untainted from the sludge of life that surrounds us.

Dirt takes us back to religion, then. For all the ritual ablutions that we go through during our lives, many of us would do well to be less snooty about dirt. In most religions it was our origin, and in many it is our destination – dust to dust, ashes to ashes. Perhaps it is this that makes us so ambivalent about dirt in its many contexts. Sweat and bodily grime signal both poverty and heroic endeavour. Sex is dirty, but also fun and thrilling. Money is filthy, but also desirable. Paintings, sculpture, soaring architecture – all raise us above the grubby reality of our lives. Yet the rubbish with which our lives are strewn becomes an art form of its own.

Leviticus may think that giving birth to girls, sharing cushions and eating monkfish are abominations, but I think we should do more to celebrate the unclean. We could probably do without mud-wrestling, but life without sex, money, art and perhaps even monkfish would surely be abominable.

ARTHUR MUNBY AND HANNAH CULLWICK

Hannah Cullwick was the maidservant and later wife of the nineteenth-century British civil servant Arthur Munby. Munby had a well-known fascination with, and fetish for, working-class women and often travelled across industrialised cities in search of female labourers to interview and photograph. Munby met Cullwick on one such outing in 1854. The fetishisation of hard physical labour and domestic dirt-removing chores was, by all accounts, a central feature of the couple's relationship.

Arthur Munby / Portrait of Hannah Wearing Men's Clothes / 1861 / photograph / 6 × 9.2 cm

Arthur Munby / Portrait of Hannah as a Slave /
1862 / photograph / 2.7 × 5.2 cm

John Cooper / Portrait of Jane Brown, a Wigan Pit-Brow Girl /
1860s / photograph / 5.5 × 9 cm

Right:
H. Howle / Portrait of Hannah Cullwick / 1874 / photograph / 6 × 9.3 cm

Below:
M. Fink of Oxford Street / Hannah Scrubbing the Floor / 1860s / photograph / 10 × 8.6 cm

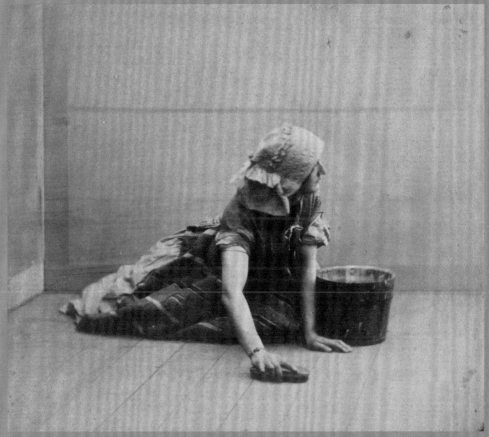

MODERNIST ARCHITECTURE

Modernist architecture in the 1920s and 1930s was characterised by a preoccupation with openness, transparency, sunlight and fresh air. As well as using new construction methods and materials, the 'new' architecture was promoted as airy, light-filled, clean, hygienic and healthy – in sharp contrast to the dark, heavy, stale and constricting spaces of the 'old'. Concrete, steel and glass were celebrated not only because they allowed for more efficient construction, but also because they encouraged straight lines and right angles, and therefore larger, less interrupted surfaces with fewer corners, nooks and crannies to clean.

White walls, generous rooms with floor-to-ceiling windows, sliding partitions, balconies and roof terraces all helped to blur the boundaries between inside and outside and to introduce light and air, creating a freer, healthier atmosphere. It is no coincidence that some of the most radical modern buildings in an otherwise architecturally conservative inter-war Britain are directly associated with health or healthy living: the Pioneer Health Centre, Peckham; Finsbury Health Centre; the De La Warr Pavilion, Bexhill-on-Sea. It wasn't just the architecture of these buildings that was 'modern'. The buildings were designed to serve and complement radical new approaches to community healthcare, or, in the case of the De La Warr Pavilion, to leisure time and community.

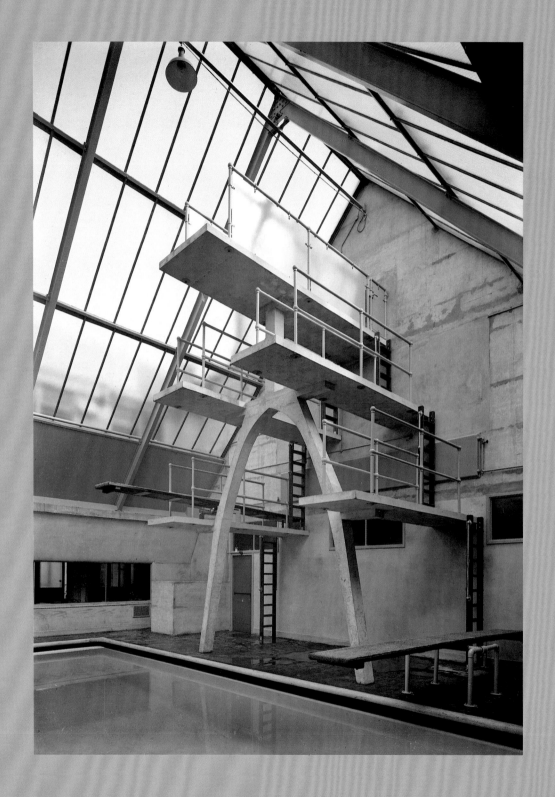

Previous page:
The Pioneer Centre in Peckham, south London,
designed in the 1930s by Sir Owen Williams, was
built as part of an initiative by the doctors George
Scott Williamson and Innes Pearse to investigate
the effect of environment on health care.
*Dell & Wainwright / Pioneer Health Centre
by Night / 1935 / photograph / 20.3 × 25.4 cm*

Opposite:
The diving stage in the Pioneer Health
Centre's swimming pool.
*Photographer unknown / Pioneer Health Centre:
the Swimming Pool Diving Stage / 1935 /
photograph / 20.3 × 25.4 cm*

Above:
Finsbury Health Centre in London, designed by
Berthold Lubetkin and Tecton: the entrance to the
building, and the patient waiting area. The centre
is an iconic example of 1930s early modernist
architecture in Britain.
*John Maltby / Finsbury Health Centre / 1938 /
photograph / 20.3 x 25.4 cm*

Finsbury Health Centre. The entrance to the solarium is pictured
here, featuring a health mural by Thomas Gordon Cullen.
*Dell & Wainwright / Finsbury Health Centre / 1938 / photograph /
20.3 × 25.4 cm*

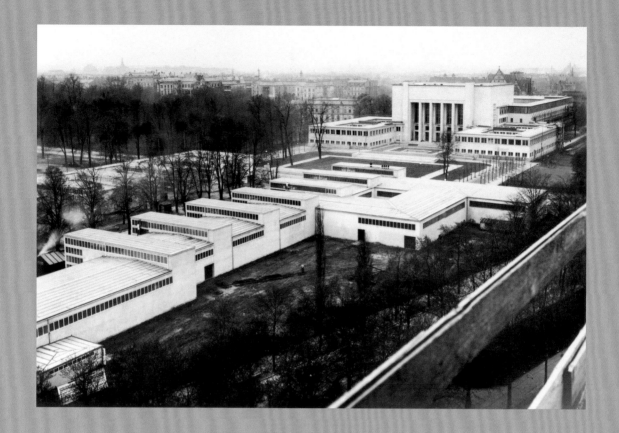

Above:
The Deutsches Hygiene-Museum and exhibition halls
during the Second International Hygiene Exhibition,
staged in 1930.
*Photographer unknown / Deutsches Hygiene-Museum,
Dresden / 1930 / photograph*

Opposite:
Inside the Deutsches Hygiene-Museum, showing the
Wandelhalle, a reception area outside the auditorium
on the top floor of the main block, located above the
museum entrance. Its huge windows look out onto
Dresden's largest public park, the Grosse Garten.
*Photographer unknown / Deutsches Hygiene-
Museum, Dresden / 1930 / photograph*

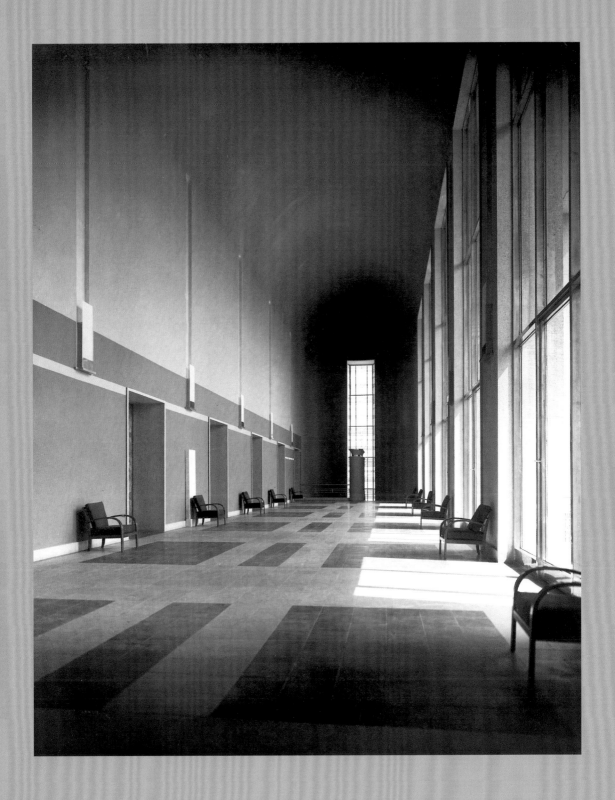

Official poster for the First International Hygiene
Exhibition staged in Dresden, Germany, during
1911. The exhibition was largely the brainchild of
the wealthy manufacturer Karl Lingner, and it led
to the founding of the Deutsches Hygiene-Museum.
*Franz von Struck / Poster for the First International
Hygiene Exhibition, Dresden / 1911*

Above:
The early twentieth-century artist Stuart Davis often took up aspects of packaging and advertising in his painting, elevating common or everyday subjects to the status of fine art, as evidenced by his *Odol*, depicting a popular brand of mouthwash. Karl Lingner, the driving force behind the founding of the Deutsches Hygiene-Museum, was also the owner of Odol, and made most of his money from mouthwash.
Stuart Davis / Odol / 1924 / oil on canvasboard / 60.9 x 45.6 cm

Overleaf:
A German airship advertising Odol in 1932.
Artist unknown / Parseval airship D-PN-30 with Odol advertising / 1932 / postcard

La med.ᵃ un'ora appresso l'invasione
del Cholera, e quattr'ore prima della morte

THE BLUE GIRL

DIRT IN THE CITY

ROSE GEORGE

n 1831, a ship arrived. The port was Sunderland; the ship's cargo is now unknown except for one small part. This small part, a micro-organism known now, but not then, as *Vibrio cholerae*, was expected. For months, Britain had watched as a deadly outbreak of cholera decimated St Petersburg, then Hamburg. The British knew cholera already, because it infected them every summer, because every day they were drinking water from the same rivers that their cesspools and privies were emptied into; no one connected upstream to downstream or cause with effect. But that British cholera was not considered serious. It caused dysentery and discomfort, but rarely death. In winter you caught a cold; in summer you caught cholera.

The cholera that arrived in Sunderland that year was a different kind. The British serving in India knew it from an outbreak there in 1817, when hundreds died. And Indians themselves knew it well enough to dedicate a church on the Ganges to *Ola Beebe*, Our Lady of the Flux. They feared its deadliness and the ferocity of its attack. This cholera, they knew, would drain you of most of your fluids, and if these fluids were not replaced it would make you vomit, give you agony, shrink your fingers into 'washerwoman's hands', turn your body skeletal, sink your eyes and turn you blue. By that stage, most probably, you'd be dead. Most terrifyingly, it could do all this between breakfast and supper.

The British tried to prepare for this 'approaching malady',[1] which they were now calling the continental or Asiatic cholera. They were an island people, but also a shipping nation, and they knew that diseases such as cholera travelled willingly and easily, that the island's surrounding waters could be barriers or carriers. Ships were quarantined for ten days on arrival and subject to inspections. Sailors had to wash clothes and bedding and air their quarters. But the 1830s were miasmatic times, when diseases were supposedly transmitted by bad air, or even bad character (a drunkard, one newspaper later wrote, had no chance of escaping the cholera). No mention was made of inspecting the sailors' drinking water or food, or the dirt under

A young Venetian woman is depicted before contracting the cholera, and after she has been afflicted with the disease, showing the characteristic 'blue' skin.
Artist unknown / Young Venetian Woman, aged 23, Depicted Before and After Contracting Cholera / 1831 / coloured stipple-engraving

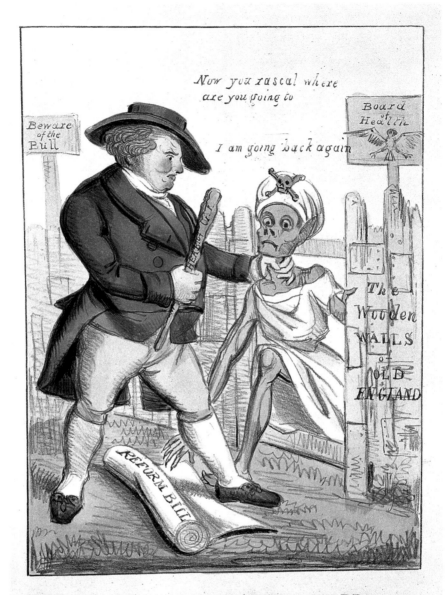

A nineteenth-century caricature of John Bull
defending Britain against the invasion of the
cholera from foreign ships.
Artist unknown / John Bull Catching the
Cholera / 1832 / lithograph / 25 × 19 cm

THE APPEARANCE AFTER DEATH OF A VICTIM TO THE INDIAN CHOLERA
WHO DIED AT SUNDERLAND

their fingernails, because no one understood then that the disease lived in excrement, and could be spread when that excrement travelled through water. Before we scoff at the miasmatic doctors who thought stench brought death, consider our own ignorance. Even today, when 2.6 billion people have no toilet at all, when diarrhoea kills a child every fifteen seconds, creating a death toll higher than TB, HIV/AIDS and malaria put together, we still talk of 'waterborne diseases' and 'dirty water' while rarely acknowledging that the diseases are travelling in excrement in that water, and that our defecation provides the source of that dirt. Delusion and denial, in the world of sanitation, are not only historical.

Despite the airing and the quarantine, cholera still arrived in Sunderland. On 17 October 1831, twelve-year-old Isabella Hazard went to church twice. She lived near the docks, and her housing was poor, but she was healthy that evening, until at midnight she took ill. The town's most eminent doctor, William Clanny, recorded her symptoms: 'Excessive vomiting and purging of a watery fluid attended with great prostration of strength and unquenchable thirst, eyes sunk in their sockets, features much altered, a deadly coldness over the surface of the body, with spasms of the lower extremities, the skin remarkably blue, so much so that the mother enquired "what made the child so black" as she termed it, pulse imperceptible, tongue moist but chilled and a total suppression of urine.'[2]

Isabella died the next afternoon, a blue girl.

The quarantine was increased along with the fear. A frigate, dispatched to patrol the harbour, enraged local merchants, whose coal trade was blocked. A public meeting in November published its 'decided and unqualified opinion' that the disorder 'which has created unnecessarily so great an excitement in the public mind throughout the kingdom [is not] Indian Cholera, nor of foreign origin, but that the few cases of sickness and death which have taken place in the town within the last six weeks have in fact been less in number than generally occurred and have arisen from that description of disorder hitherto known as "common bowel complaints", which visit every town in the kingdom in the autumn, aggravated by want and uncleanliness'.[3]

The *London Medical Gazette* was unimpressed, writing that 'the good people of Sunderland appear in no very favourable light. It seems very clear that the public

safety is in their estimation a very secondary object when brought into competition with the sale of coals.'[4] From the perspective of the twenty-first century, when banks steal our money and oil pollutes our oceans, the desire for uninterrupted commerce may seem less repugnant than the willingness of the good people of Sunderland – and every place that cholera visited next – to blame the outbreak on its bad people. The dissolute were bringing disease upon themselves.

And so it was, because the careful quarantine of the coastal regions did not extend inland: 702 people eventually died from cholera in Leeds, for example. At the height of the outbreak, vicars were burying the dead at all hours and in all weathers. For us, in our sanitarily plumbed and seweraged cities, cholera is cholera; an unremarkable noun describing a disease that strikes other, poorer people in Africa or Asia. For the spooked Victorians, the intruder at the door deserved a character. It was '*the* cholera', related to 'the plague' or 'the pox'.

In the story of cholera, most attention focuses on London, and on the genius of Dr John Snow, anaesthetist to Queen Victoria and the first man to understand that

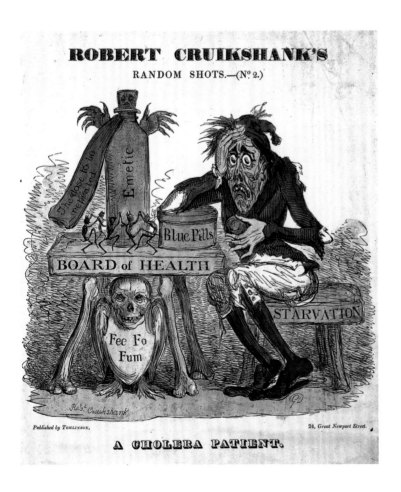

Opposite:
The corpse of a young woman who died of cholera in Sunderland during the 1830s.
Hodgson, London / The Appearance after Death of a Victim to the India Cholera 1832 / coloured lithograph

Left:
A caricature of a cholera patient experimenting with home remedies to prevent the development of the illness.
Robert Cruikshank / A Cholera Patient / 1832 / coloured etching

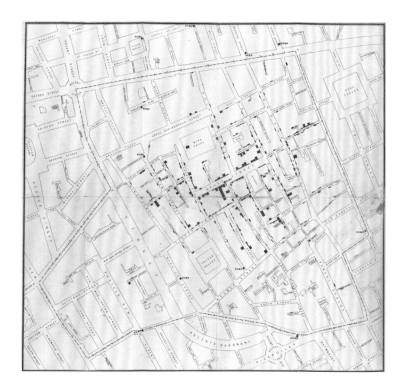

A map depicting the deaths from cholera in Broad Street, Golden Square and neighbouring areas of London from 19 August to 30 September 1854.
John Snow / Map Showing Deaths from Cholera in Broad Street and Surrounding Area / 1855 / 22 × 22 cm

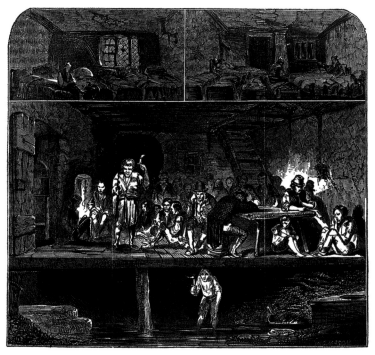

A lodging house in Field Lane, London, showing the poor and unsanitary conditions of low-income housing in the capital during the nineteenth century.
Hector Gavin / Lodging House in Field Lane / 1848

An 1860s public notice advising inhabitants
of the London East End districts of Limehouse,
Ratcliff, Shadwell and Wapping to boil all water
before use to prevent the spread of cholera.
*Board of Works, Limehouse / Cholera and
Water / 1866 / broadsheet*

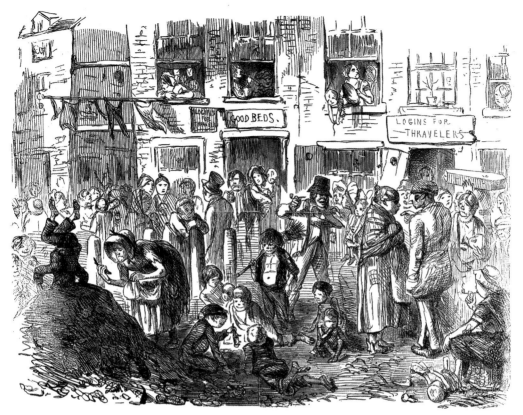

A COURT FOR KING CHOLERA.

cholera travelled in water, when he broke the Broad Street pump and watched the residents of his Soho neighbourhood die a bit less often as they drank less foulness. But twenty years before Snow started his 'ghost map', plotting the sites of disease outbreaks around Broad Street in 1854, a less lauded former military doctor named Robert Barker was doing his own mapping. Barker's exploration of Leeds took him to its darkest yards, enclosed by slum tenements, off its dirtiest streets. He listed a few:

> Bridge Street – in a most filthy state
> Baxter's Yard – most dingy, privies open
> Cherry Tree Yard – open privies, very bad
> Jack Lane – an offensive ditch nearby
> Orange Street – most wretchedly bad
> Micklethwaite's Yard – stones have to be put down to walk[5]

In Fleece Yard he found a pile of human excrement covering forty square yards, and three lanes that housed 386 residents who shared three privies. He saw the dirt, and he found the dirt suspicious, but he still didn't make the connection between dirt and water. Barker thought the pestilence came from air, as did the medical profession

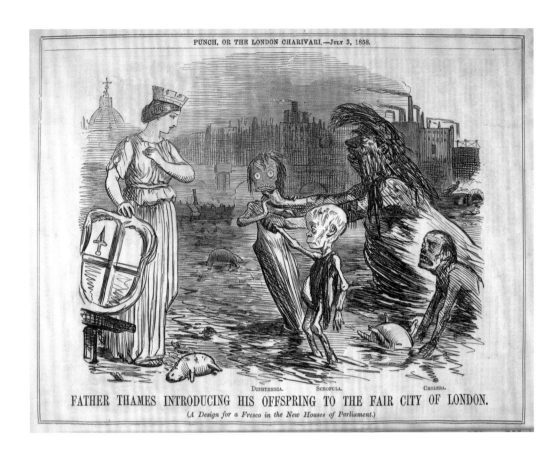

DIPHTHERIA. SCROFULA. CHOLERA.

FATHER THAMES INTRODUCING HIS OFFSPRING TO THE FAIR CITY OF LONDON.

(A Design for a Fresco in the New Houses of Parliament.)

Opposite:
A mid nineteenth-century caricature depicting the unsanitary and crowded conditions in London – conditions that facilitated the spread of cholera.
Punch / A Court for King Cholera / 1852 / 28 × 30 cm

Above:
In another caricature from *Punch* magazine, a filthy Father Thames presents his offspring, diptheria, scrofula and cholera, while around him the carcasses of dead animals float in the water and in the background factories belch out black smoke.
Punch / Father Thames / 1858

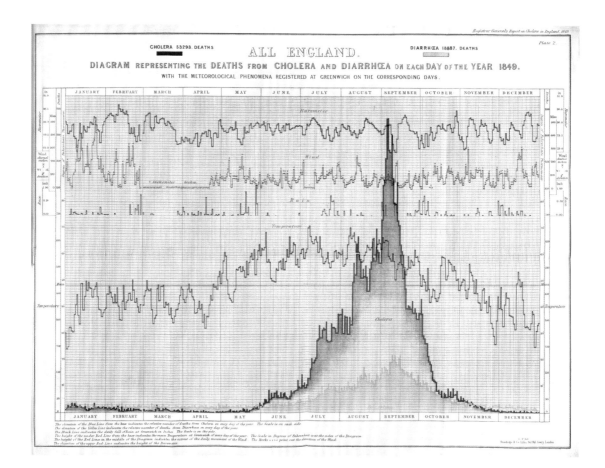

Above:
A graph showing the deaths from cholera and diarrhoea for the year 1849, with the corresponding days' meteorological activity recorded at Greenwich.
Great Britain General Register Office / Diagram Representing the Deaths from Cholera and Diarrhoea on each day of the Year 1849 / 1852 reproduction

Overleaf:
A map of Leeds from the 'Report on the Sanitary Conditions of the Labouring Population of Great Britain', indicating the areas of Leeds that were most affected by the cholera epidemic of 1832.
Edwin Chadwick / Sanitary Map of Leeds / 1842

in its entirety until John Snow proved them wrong (and even then many refused to accept the fact for decades). Eminent doctors slept with the door ajar so that good air could defeat the bad cholera. The miasmatic transfer of disease was a powerfully held belief, and there was much circumstantial evidence to uphold it. In London, it was widely believed that the construction of sewers had disturbed cemeteries, discharging foul air and causing cholera. The sewer system was indeed the culprit, not because of bad air, but because it carried infected sewage into the Thames, the capital's main source of drinking water. In 1853, even though the *Lancet* took full advantage of watery metaphors, it was still far off target. 'What is cholera? Is it a fungus, a miasma, an electrical disturbance, a deficiency of ozone, a morbid off-scouring of the intestinal canal? We know nothing. We are at sea in a whirlpool of conjecture.'[6]

Such fear produced rage. The urban dirty were enraged by urban dirt. They knew what they lived among and they protested when they could. When the journalist Henry Mayhew took a walk around the cholera districts of Bermondsey, a woman told him, with awful simplicity, that 'neither I nor my children know what health is'. Soon there were cholera riots as rumours spread that the disease came from a conspiracy by the higher classes to decimate the dirty, lower ones.

Fear explains some of the anger. Cholera was certainly deadly. It killed approximately 31,000 Britons in 1832, from a population of seventeen million. Although typhus, as John Snow wrote later, killed seven times as many, cholera was terrifying because its onset was rapid and inescapable. But cholera was terrible for another reason. Cholera loved cities. It thrived in crowds and close quarters, in places where people drank from the same river into which they deposited their excrement. It was perfectly at home with humans living closely together, unaware that their excrement was a powerful weapon of mass destruction, that their unknown infector could make such short hops and cause such rapid devastation and death.

Cholera still thrives in refugee camps and crowded, insanitary cities. The absence of cholera remains a World Health Organisation indicator of successful social development. Its presence demonstrates that a city is environmentally dysfunctional. Cholera means a city is not working. In 1851, a boy born in inner-city Liverpool had a life expectancy of twenty-six years. A country boy – from Okehampton in Devon, say – could expect to live to fifty-seven. Cholera, and all the other diseases brought by dirt, made the city a lethal place, a conglomeration of unhealth.[7]

England's great cities had several opportunities to learn lessons from cholera. The disease arrived periodically, and each time became more efficient at killing. A public health movement, led by the effective but unpopular Sir Edwin Chadwick, was responsible for the revolutionary Public Health Act of 1848, and the discipline of public health – the state deciding what is good for you – was created. In his introduction to Chadwick's *Report on the Sanitary Conditions of the Labouring Population of Great Britain*, M. W. Flinn wrote that cholera 'led as no other disease did . . . to immediate, vigorous administrative action'.[8]

This is partly true. Places were cleaned up, yet sanitation was not improved, and so the cholera kept calling. In Leeds, the night soil in Fleece Yard was removed, but privies remained insanitary, as did the stinking streams that people drank from. John Snow's work was dismissed and scorned. Cholera should have disturbed the middle class, because it was depriving them of labourers, but it did not.

Change finally came from smell, and ironically from the fact that the smell did not bring death. In 1858 London's cesspools – overflowing even more since flush

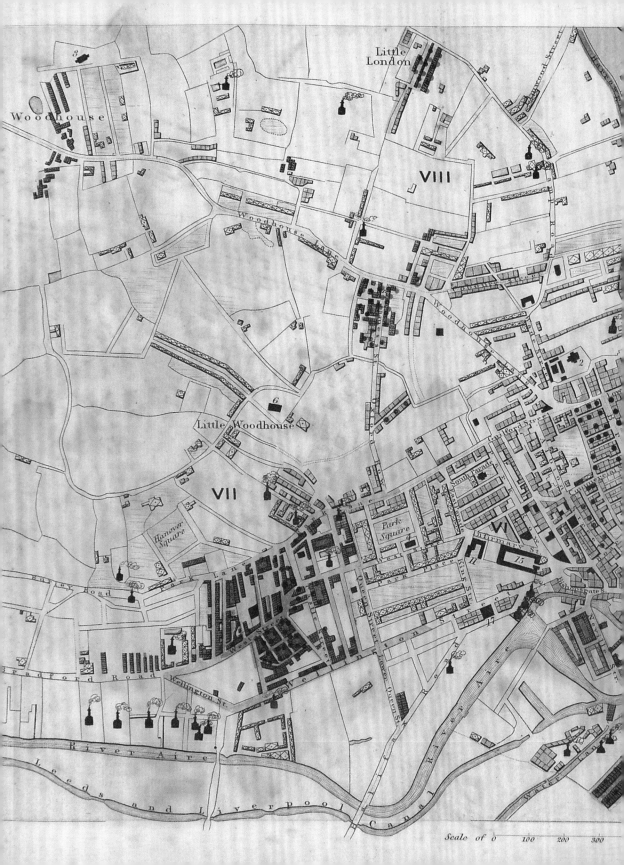

Little
London

Woodhouse

VIII

Woodhouse Lane

Little Woodhouse

6

VII

Hanover
Square

Park
Square

VI

Burley Road

Bradford Road

Wellington St.

River Aire

Leeds and Liverpool Canal

River Aire

Scale of 0 100 200 300

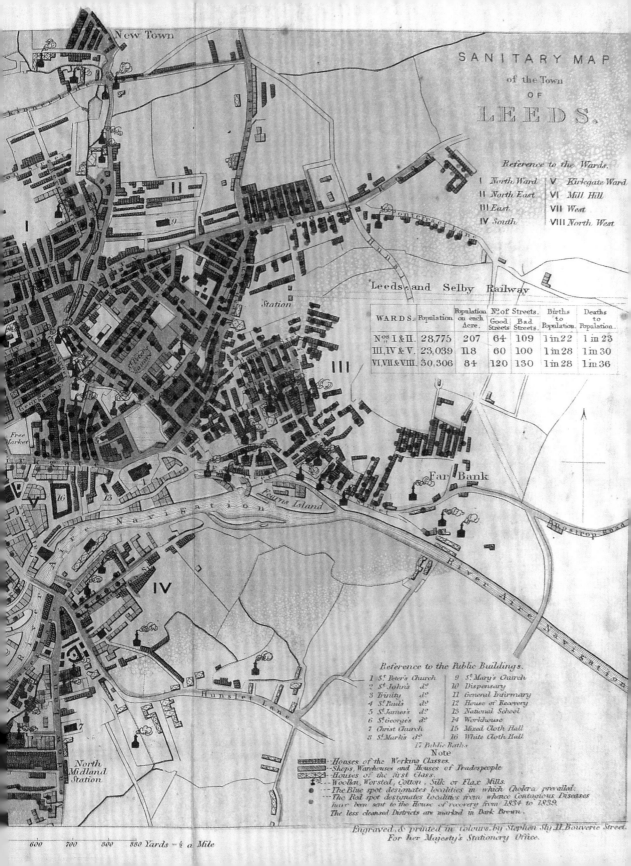

SANITARY MAP
of the Town
OF
LEEDS.

New Town

Reference to the Wards.

I North Ward V Kirkgate Ward
II North East VI Mill Hill
III East VII West
IV South VIII North West

Leeds and Selby Railway

Station

WARDS.	Population	Population on each Acre.	N°. of Streets.		Births to Population.	Deaths to Population.
			Good Streets.	Bad Streets.		
N°s. I & II.	28,775	207	64	109	1 in 22	1 in 23
III, IV & V.	23,039	118	60	100	1 in 28	1 in 30
VI, VII & VIII.	30,306	84	120	130	1 in 28	1 in 36

III

Far Bank

Fearns Island

Free Market

Apostrop Road

River Aire Navigation

IV

Hunslet Lane

North Midland Station

Reference to the Public Buildings.

1 St. Peter's Church 9 St. Mary's Church
2 St. John's d° 10 Dispensary
3 Trinity d° 11 General Infirmary
4 St. Paul's d° 12 House of Recovery
5 St. James's d° 13 National School
6 St. George's d° 14 Workhouse
7 Christ Church 15 Mixed Cloth Hall
8 St. Mark's d° 16 White Cloth Hall
 17 Public Baths

Note

Houses of the Working Classes.
Shops, Warehouses and Houses of Tradespeople.
Houses of the first Class.
Woollen, Worsted, Cotton, Silk or Flax Mills.
The Blue spot designates localities in which Cholera prevailed.
The Red spot designates localities from whence Contagious Diseases have been sent to the House of recovery from 1834 to 1839.
The less cleansed Districts are marked in Dark Brown.

Engraved & printed in colours by Stephen Sly, 11 Bouverie Street.
For her Majesty's Stationery Office.

600 700 800 880 Yards = ½ a Mile

toilets had become popular – discharged, as they had for decades, into the Thames. But the summer was hot, and the river ran past Parliament, and the stench was so terrible that the Palace of Westminster's curtains had to be dipped in lime chloride, and MPs who went out from the library to the riverside terrace to investigate the smell were forced to retreat, handkerchiefs over their noses. There was serious talk of moving Parliament to Richmond. That didn't happen, but legislation did, either because of the noise of public protest, or because the lawmakers had been overwhelmed, or because the stench was not in fact followed by a cholera epidemic, confounding the miasma theorists. With astonishing speed, laws were passed in eighteen days to authorise the 'Main Drainage of the Metropolis', to be overseen by Sir Joseph Bazalgette, Chief Engineer to the Metropolitan Board of Works.

Over the course of the following sixteen years, Bazalgette built 83 miles of interceptor sewers. There were already sewers in London; Henry VIII had enacted a Bill of Sewers, though it forbade them to be used for the disposal of human excrement. But the sewers led to the river, and the river provided drinking water, so Bazalgette built interceptor sewers to act as barriers. These sent the sewage elsewhere, still to the river but further out in its eastern reaches. To achieve this, he used gravity, ingenious engineering, magnificent pumps and 318 million bricks.

There are now 25,000 miles of sewers under London. Their size and scale vary widely; there are motorways and B-roads, alleys and ginnels. There are sewers that could hold a Mini, and those that are sized for rats. This change to main drainage was not entirely unopposed. The sewers were one thing, but Londoners still clung to their non-flushing privies. The city fought citizens who resisted its top-down sanitary measures, because the city knew best. Public health meant delivering your health to

the public; it meant governance. Mr Tinkler, a Wandsworth landlord, was a rare voice of objection. In 1857 he took his council to court because they wanted to install flush toilets in his rented-out cottages, while Mr Tinkler and his tenants were content with his traditional privies. Flush toilets were pointless, he said, 'when there was no sewer for the drains required by the notice to fall into'. Wandsworth said it would build a sewer in the fullness of time; Mr Tinkler said he would wait for that time and until then use his perfectly clean privy. Mr Tinkler won.

So far, so linear. The story of the cholera, of sanitation, and of our technological response to it, seems as straightforward as a sewer. There was cholera, then there was cleanliness. As clean as a flush. But the truth of how we treat our dirt, of how we live with it, past and present, is more slippery. You can glimpse this truth in an anti-city. You can glimpse it in a slum.

In the slum

We are urban humans now. At some point in the last couple of years the proportion of humans living in cities rather than in rural settings passed 50 per cent for the first time. In Bazalgette's day, 8 per cent of the UK population was urban. Today it is 80 per cent. This is by no means a bad thing. With sewers and sanitation, and hospitals and electricity, cities have become centres of health. It is far easier to get health-care in a city served with public health facilities and public transport than in a village served by red-earth roads and a twenty-mile walk from the nearest clinic. Cities give people life in two senses, longevity and energy, and they are greener, too, because those living there consume less (less fuel, in particular). The dark, grim, deathly city has been banished underground and out of sight.

And then you go to Mumbai. It seems a pleasant city, because of the sea and the breeze. It has spacious roads and graceful seafront buildings, and marvellous mangoes in season. It has hospitals and trains and a vast and congested road network. On one of these roads, leading to the airport, you will find, if you turn your head to the left, the slum of Shanti Nagar. How do you know it's a slum? It looks dense, but so does much of Mumbai. It is teeming, but so is India, with its billion people. The clue to the slum nature of Shanti Nagar is that little boy crouched by the roadside, because he is not crouching but squatting, and he is performing his daily toilet. You see him, and then examine the road more closely, and you realise that the dots you can see are faeces, and that they are everywhere.

UN-Habitat, the UN agency responsible for human settlements, defines a slum not by what it is, but by what it lacks: secure housing, dignity. I define a slum by its toilets, or, more accurately, by the fact that it rarely has any. After the success of *Slumdog Millionaire*, people often talked to me of the hideous latrine scene, when the young hero drops into a pit of shit, and they are incredulous that people live that way today. And I tell him that I have seen those beach latrines, at Juhu slum, and that they are right to be incredulous, for not only would a five-year-old boy never be entrusted with such a lucrative business opportunity as a latrine, but the latrine itself is a luxury that few slum dwellers would ever be able to aspire to. In Shanti Nagar, and every place like it, sanitation is for other people.

And there are dizzying numbers of places like it. Slums scare because of their size and the speed at which they can grow. Some mud or cement and a zinc roof, and

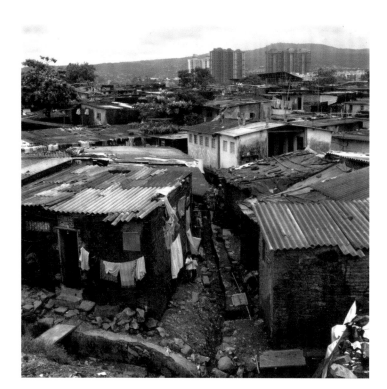

Left:
A scene from a large slum near Mumbai,
with waste-water flowing in a trench
close to makeshift housing.
*Photographer unknown / Scene from a
slum in Mumbai / 1970s / photograph*

you have a slum house. A shanty town can rise up in a week, as people are pushed to the city by poverty, drought or other natural disaster, and their desperation has the force of a wave. Some of the slums I visited in Mumbai have been there fifty years. They can be dated to a certain drought in Madhya Pradesh in 1942; or to floods in Orissa in the 1970s. I met people who were born and still live in the slum, like Mr Shankar, who used to run a restaurant in Shanti Nagar until the place flooded – slums are usually built on bad land – and people stampeded and the restaurant was wrecked by water and panic. Mr Shankar runs the local humanist association and once organised slum-wide protests against the lack of netting and fans to combat malaria. Yet he has never protested about those children squatting on the road, or about the fact that there are under a hundred toilets for a population of several thousand, which amounts to the same as nothing. He found my interest in toilets quaint, and took me on a tour. The slum was filthy. Sometimes I had to use stepping stones to rise above the muck. Open drains smelled and loomed off every corner. The alleyways were dark and narrow, and I was grateful for the kind hands that reached out to save my head from sharp roof edges. But filth is not the only character of the slum.

Some of the land is worth more per square metre than middle-class Mumbai apartments. There are hovels and shanties, but also two-storey apartments with lockable doors. Some slum dwellings have flush toilets, as shown in the documentary *Q2P* by Mumbai film-maker Paromita Vohra. In it, a slum toilet-builder called Sheikh Razak proudly shows to the camera the toilet he has just built, saying, 'like an apartment where there's a kitchen, bedroom, bathroom. People see that and they want the

same for themselves. They can't have all that so they get the big necessity, a toilet.' And Vohra then shows how this big necessity is plumbed into nothing, but discharges its sewage directly into the *nala*, or open drain, to join the rest of the foul, dark mess that slithers through it, if it slithers at all.

Mr Shankar didn't have a toilet. His family of six lives in a single room the size of a parking space. That was one shock; the other was the extreme cleanliness of it, as if the front door opened into a Narnian wardrobe, and outside Mr Shankar and his family will consent to live in filth, but inside they will not. The city, of course, has always been about the good governance of public and private; of impressing the individual with the common good. And nothing is more expressive of this intricate, intimate relationship than sanitation, for what is more personal than defecation, and what is more deadly for the common good than the fifty-odd communicable diseases that travel in it? Defecation is an individual matter, but its repercussions are plural and deadly.

A wooden building set out over the river, used as a public toilet in Bonthe, Sierra Leone, in 1911. A century later, latrines of this sort are still common in unplumbed areas around the world.
Photographer unknown / Public Toilet in Bonthe, Sierra Leone / 1911 / photograph / 8.4 × 14.1 cm

Shanti Nagar may look like a thousand other slums, but Shanti Nagar is unusual, because it is organised. There is a slum-wide water committee, for example. Families pay a monthly fee, and in return they get clean water. The water has to be bought in, because of another unwritten rule regarding slums: even if a city is overrun with them, even if the city is more or less all slum, the city authorities will rarely do anything that might imply the slum is sanctioned – things such as providing household water, gas, or electricity. Nothing that could imply land rights. Nothing that acknowledges the slum as legitimate. All cities try to keep the things and people they would prefer to ignore invisible. Street cleaners, garbage workers, sewermen; they disappear behind the high-visibility vests that ironically hide them from view.

India takes this quest for invisibility further by ignoring a whole sub-caste of people. Manual scavengers, the lowest sub-caste of the Dalit – the untouchables – are doubly untouchable because they are forced to have contact with human shit, because they must clean dry latrines (often two bricks a squatting distance apart and nothing else) with their bare hands, and carry the contents in a leaking basket on their heads. In doing this, they become polluted (though the extreme sexual violence against Dalit women shows that, as with most societal taboos, everything is relative). Most manual scavengers work in rural areas, but not all. They still clean all of India's trains and tracks, and have been found working in its high courts, though scavenging is illegal.

So water will not be provided to the residents of Shanti Nagar, and they must pay for it, up to five times what other city-dwellers pay. They queue up for it once a day, bringing old chemical drums to carry it in, waiting for the water to arrive through pipes that have no taps, because the water is either there or it is not.

They pay for it because they see the need for it. Everyone knows that you die without water. But like the miasma-theorists in nineteenth-century London, they cannot see that they die without sanitation, too, even when their children get diarrhoea weekly, until the bout that kills them. There is cholera today, sometimes in India, and often in Africa, just as there was in England in 1831, but what killed most of London's toddlers then, when one in two didn't live beyond five, and what kills the children of Mumbai's slums now, is boring, banal diarrhoea. Diarrhoea results in malnutrition – the best indicator of hygiene standards – because how can a child keep down food when bacteria are shoving it through the body as fast as they can? Poor sanitation is the invisible killer behind malnutrition, and behind polio (vaccinations have to be given again and again to a child with diarrhoea for them to have any effect).

So why are there not enough toilets in diarrhoea-ridden Shanti Nagar, when there are mosquito nets to counter malaria, a disease that kills far fewer? Because you can see a mosquito but you can't see bacteria. And because of that Narnia effect between private and public. Too often, promises of public toilets in Indian slums are held up as temptation to voters by eager politicians. The National Slum Dwellers Federation explained this process best:

> Each [political] system has its own particular agenda, its own donor constituency and its own attitudes towards slums: government slum improvement systems which pay for expensive contractor-built latrines but no maintenance; political organisations that do toilets only for particular castes; engineers who do only high-tech ferro-cement wonders that poor people are scared to enter; Rotary Clubs which bestow 'fully-tiled facilities' but don't provide water connections or follow-up maintenance to go with them; rival charities which do aqua-privies

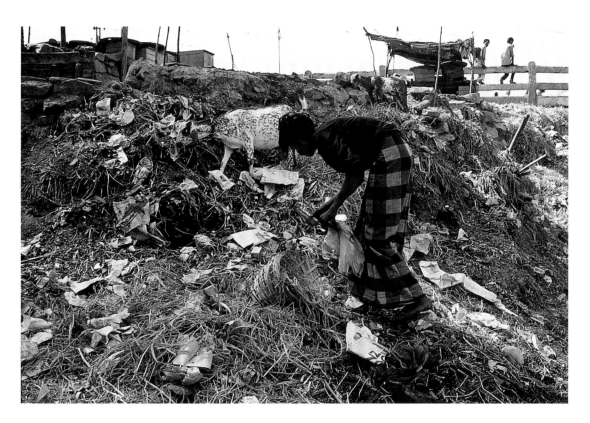

A man and a goat scavenging
in a communal rubbish dump
in a slum near Delhi.
*Photographer unknown /
Rubbish Dump, Delhi Slum /
1970s / photograph*

for Jesus; and appropriate-technology types who concoct elaborate biogas latrines with noble dreams of turning feces into cooking fuel.[9]

I saw some of these top-down toilets in Mumbai. They are rudimentary concrete blocks. The doors have gone and the taps haven't worked for years. There is no maintenance and no ownership. And I saw other toilets that were different, because they are built from the bottom up. One is run by a caretaker named Mr Sattar. He had a careful ledger recording how many families have signed up (310 households). His subscribers provide sufficient income to keep his toilet facilities clean; to buy enough water; to employ attendants and cleaners; and to install a fish-tank to entice people in. (I found this mesmerising after two days of slum-walking, and after forgetting what it feels like to breathe clean air or walk on something other than muck.) Sattar told me that the genesis of his toilet had not been easy: people had to be persuaded to pay to do something that they had been doing for free. The most powerful argument in favour was convenience. Other toilet entrepreneurs have used different methods: the Kenyan businessman

David Kuria has built toilet blocks in the vast slum of Kibera that include barber shops and nail bars, and he has had them opened by Miss Kenya. When he wanted to open a snack bar, 'people told me no one would ever buy food near a toilet. Now the snack bar always has queues.'[10] Others in India have health clinics attached. One community toilet organisation has paid for its own ambulance, in instalments.

UN-Habitat classifies a slum as having 'intolerable housing conditions'. Of course this is true, because there is no privacy. They are usually on bad, flood-prone land that no one else has claimed. I will not defend them. But the slums keep the city working. They provide its cleaners and housekeepers; drivers and white-collar professionals. I saw several men in suits walking through Shanti Nagar, on their way to jobs as university lecturers or primary school teachers. Slums are a springboard into the city for first-timers. They are not ideal, but they don't have to be so bad. Asia's largest slum, Mumbai's Dharavi, has small industries that produce $800 million of turnover a year.

Slums are more complicated than they appear. They are not entirely bad; they contain elements that are energetic and vital, even with the disease and the sexual violence and the half-hour walk to the toilet block where you can't sit for more than a few minutes before someone is knocking on the door. Slums fascinate me

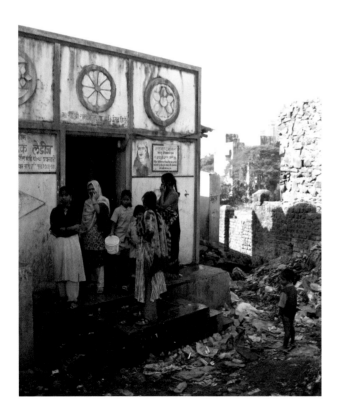

Women queuing up to use Mr Sattar's public pay toilet in the slum of Shanti Nagar in Mumbai. *Rose George / Shanti Nagar Pay Toilet / 2006 / photograph*

because of the place they are assigned in our consciousness, where they are given the role of the anti-city, a contrast to the clean and ordered, sanitary, sewered places that we live in. There, all is chaos; here, all is order and civility. That is mistaken.

In 2006 I took a road trip through rural China. By the end, I had just about got used to something that was, on first encounter, profoundly shocking: in rural China, public toilets have no doors. I don't mean that their doors are missing or damaged, but that they are built without them. I asked everyone I met about it. An agricultural scientist, an ex-pat banker, a charity worker, my translator: they were all surprised to be asked, because they had never considered the question. But it was more striking that they all took my question about doors to be a veiled question about something else. The scientist, clearly at our meeting on Party business, took offence, huffing, 'We do have doors. We are civilised, you know.' Someone else said, 'The closer you get to Beijing, the more doors you will find. We are not backward any more.' I was surprised that they had taken such umbrage. I had never asked about civilisation. I didn't think the Chinese were backward, just different. The best answer I got was from the ex-pat banker. Even when toilets have doors, she said, her Chinese colleagues wouldn't shut them. They would carry on with their conversations, doors open. 'They just aren't bothered.'

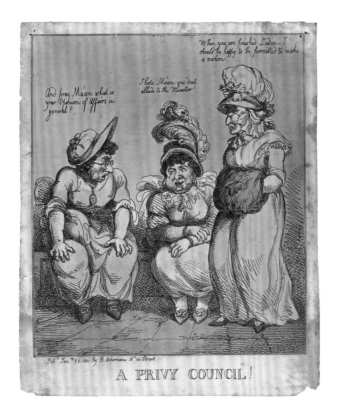

A PRIVY COUNCIL!

Three early nineteenth-century women in fine clothing and hats, having a discussion while sitting on a latrine.
R. Ackermann / A PrivyCouncil! / 1801 / etching with watercolour / 31 x 25.2cm

I'm often asked about the worst toilet I've encountered (it was a Chinese pit latrine with maggots). But those doorless toilets are the most memorable, because they illustrate perfectly the intimate and intricate relationships between privacy, civility and sanitation, relationships that can be as surprising as that fish tank in a Mumbai slum.

The time bomb of sanitation

Humans have had rules about hygiene for as long as there have been rules. In the Bible, Deuteronomy 23 specifies instructions for defecation. The Israelites should 'have a place outside the camp and go out there, and you shall have a spade among your tools, and it shall be when you sit down outside, you shall dig with it and shall turn to cover up your excrement'. Hygiene was holy, but it was also a means to survival. In the palace at Knossos, Crete, there were rudimentary toilets, as there were in the ancient cities of the Indus valley, whose citizens 2,000 years ago had latrines that are better than those of their descendants today, who often have no toilet at all. In that great country of gleaming Bangalore software centres and 10 per cent annual growth, 70 per cent of Indians have no sanitary facilities beyond a roadside or a bush.

Those 'bare bottoms, doing what they must', in the words of Indian journalist Chander Suta Dogra, prove a curious point. Sanitation is relative, and its standards are not constant. One day, I visited Crossness in London, one of the city's major sewage treatment works. It is a large and capable place, dealing with millions of gallons of sewage every hour, but its showpiece is ELSI. The East London Sludge Incinerator, towering above the treatment beds and anaerobic digesters, is a shiny silvery monument to technological progress, its roof an undulating swoosh. I see in it an unerring confidence in the modern city's ability to eradicate dirt, as if it had always been like this. But even a hundred years ago, our attitudes were different. There are still outhouses in the United Kingdom with family holes for parent and child to defecate together. Until the nineteenth century, when the flush toilet was sufficiently developed and clean to be allowed indoors, and when rising incomes provided privacy, defecation was often both communal and public. There are doorless public toilets throughout Western history, from lavish Roman public latrines, with friezes and marble floors, to commodes in thrones for seventeenth-century monarchs such as Louis XIII, who defecated in public and ate in private. The palace of Versailles was one great toilet, where aristocrats urinated in corridors and defecated in the gardens. I like to think of that because it punctures the assumption that the paradigm of modern sanitation is immutable, and has always been so. But that is wishful thinking. Even in a city that can afford to build ELSI, sanitation has not always been there, and – if things don't change – might not be there or properly functioning for much longer.

That silvery shiny sludge incinerator at Crossness stands near a historic part of the Thames. Near here, in 1866, 631 people died in the river after their steamer was hit by a dredger. Even then sewage was routed here to be dealt with, but the 'treatment' was simply to discharge it unprocessed into the river. *The Times* published furious editorials: 'There can be no doubt that at the period when the collision occurred, the Metropolitan sewers … were pouring forth their daily contribution of millions of gallons of water loaded with all the filth of a great city.' One survivor said many of the deaths could have been due 'to the poisonous state of the water'. Another said that 'for taste and smell it was something [he] could hardly describe'.[11]

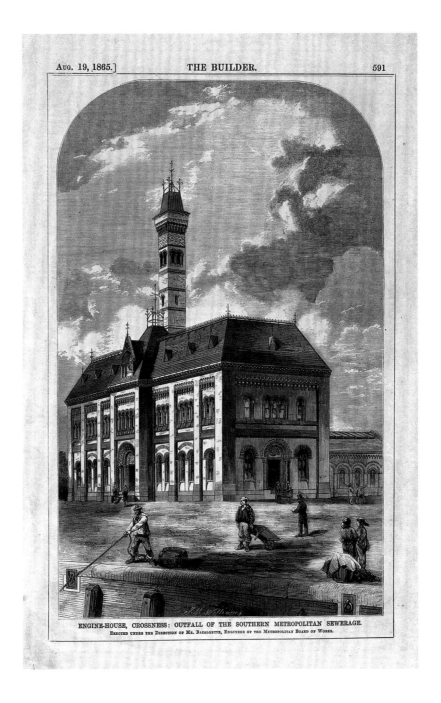

ENGINE-HOUSE, CROSSNESS: OUTFALL OF THE SOUTHERN METROPOLITAN SEWERAGE.
ERECTED UNDER THE DIRECTION OF MR. BAZALGETTE, ENGINEER OF THE METROPOLITAN BOARD OF WORKS.

The engine house at Crossness and the
southern metropolitan sewerage outfall.
*John Mayhew Williams / from The Builder /
1865 / wood engraving / 27 × 16.9 cm*

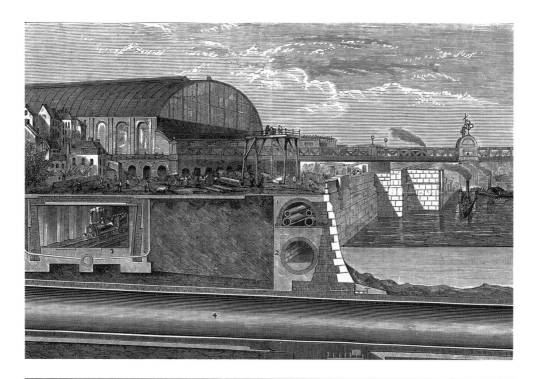

Those outfalls were eventually removed and Crossness and Beckton, its sister plant on the north bank of the river, were built to Bazalgette's design during the 1860s to deal with the great city's filth. Crossness is impressive now, for its size, for what it does – not only removing dirt from the water but making it clean enough to drink – and for its location, just a couple of miles east of Woolwich. It may have been distant once, but the city has grown to meet it, and the city doesn't like that. A flusher (sewer worker) I once met thought people who bought houses near sewer works must have been drunk at the time, but I sympathise with them. How can today's city dwellers know what filth really is, when they are so shielded from the processes of cleansing, and the dirt they produce is removed so quickly with a simple flush?

Crossness still has its original Victorian pump house, where powerful engines worked to move the sewage when gravity could not. On display is an illustration of its opening ceremony, which was conducted by Edward, Prince of Wales. Guests included Prince Edward of Saxe-Weimar, the Duke of Cambridge, the Lord Mayor of London and various archbishops. Our current Prince of Wales has an impressive interest in sewage and sanitation, having installed a reed-bed at Highgrove House to naturally cleanse the royal sewage using sunshine, bacteria and water. Even so, and even though the Dutch Prince of Orange sits on a high-level UN sanitation committee, I can't imagine Prince Charles opening a sewage works, nor guests more usually found in *Tatler* in attendance.

To be fair, those house-buyers' ignorance of the modern wastewater system is inevitable. Visiting London's sewers, for example, is difficult. Thames Water takes weeks to persuade, and a senior flusher is required as a guide. The first sewer I descended into, in the hours around midnight, used to be the Fleet River. It provided a shock, but only for its lack of smell. The next, on Gray's Inn, was different. This was a Bazalgette sewer, but the spiral staircase designed for access, formed from some of those 318 million bricks, was impassable. Its steps were inches deep in fat, the accumulation of every takeaway meal, every frying pan rinsed in the kitchen sink, every thoughtless pouring of oil into the sewer network. There it was, grey and solid and defiant. On one occasion the flushers of Thames Water spent six weeks removing a wall of fat that was blocking the sewers under Leicester Square. Another had to be removed near Westminster. Standing round that sewer entrance in Gray's Inn, the flushers let rip. They hate fat, because it gets into your pores. You can remove the smell of shit – they are extremely clean men, with gleaming white teeth – but you can't stop the fat emerging later, when you are showered and pristine yet you still smell like chips. Both these walls of fat had to be attacked with high-pressure hoses

Opposite, above:
A section of the Thames Embankment in 1867 showing the underground railway, the low-level sewer, the Metropolitan District Railway and the pneumatic railway.
Artist unknown / Section of Thames Embankment / 1867 / wood engraving / 14 × 21 cm

Opposite, below:
Workers inspecting the sewage pipes in the subway under Charterhouse Street in London during the early twentieth century.
Walter Besant / Sewage pipes under London / 1909

and brute force. Both incurred overtime. One flusher bought a new car with his earnings. A 'fat-mobile'. 'But it was disgusting,' he said. 'And the worst thing was Big Ben. Those bloody chimes.'

London's flushers hold a precious knowledge. Thames Water does not know the full extent of its sewer network, and it does not have comprehensive maps, so the knowledge is in the heads of the workers who maintain them. The final sewer I went down, on Clerkenwell Road, had not been visited for fifteen years. The city is built upon arteries and networks that are mysterious. One flusher took notes on every sewer he entered. He told me that when he retired, he was taking his book with him. That day will come soon, for he is near retirement age, and his colleagues, all of whom are over forty, will not be long in following. Already they are tiny in number. There are only around forty for the whole network. Compare this with New York's sewer system, which extends for 6,600 miles and is maintained by 300 or so full-time flushers. Paris, with its own lowly 1,312 miles, has 284 *égoutiers*. So few men – they are overwhelmingly men – to stand between the metropolis and disease. There is no doubt that they are the defenders: London's last cholera outbreak was in 1866, a year after much of the sewer network came into operation, and it occurred in east London, in an area where the works had not been completed. Four thousand people died in a month, all customers of the East London Water Company, whose drinking water filters proved to be fictitious and whose reservoir at Old Ford was uncomfortably close to the River Lea, into which east London's privies still emptied. Once all the sewers were working, cholera left London and has not yet been back.

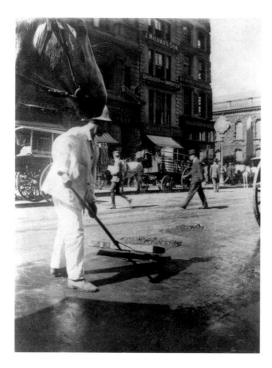

A Department of Sanitation employee sweeping a New York street in 1910. *George Grantham Bain / New York City Sanitation Department Employee / 1910 / photograph*

So these intrepid flushers, with their labouring-class names – Kev, Dave, Keith – are the city's guardians, as much as the city's police or its firefighters are. But they are accorded none of the respect shown to others by affectionate nicknames. New York has its Finest (police) and its Bravest (firefighters). Even prison officers are its Boldest. New York's flushers – whose work has probably reduced child mortality more than any other, more than penicillin or modern medicine – remain unrecognised. They are not even seen. As I stood around an open manhole with London's flushers, sometime after midnight, a full bus went past. We were wearing hard hats and crotch-high waders, and standing around a hole. But no one looked. No one was curious. No one connected that hole with the flush of their toilet, and with their increased lifespan. Why should they? The success of city sanitation is evidenced by its removal from conversation. We talked about our shit when we couldn't escape it; when women had to wear high heels to walk above it in the street; when Samuel Pepys went down into his cellar and found the contents of his neighbour's privy had filled it, and he was not surprised.

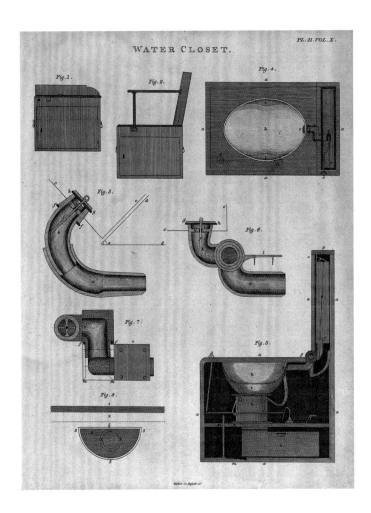

Eight early illustrations of water closets
and pipework designed to reduce smell
and mess from sewage waste.
*Mutlow and Russell / Water closets
and pipework / early 1800s / engraving /
23.6 x 18 cm*

A US public information poster advertising a home sanitation unit, depicting an outhouse in a picturesque setting.
Illinois State Department of Public Health / Public Information Poster, Sanitary Unit / 1941 / silkscreen on board

The flush toilet, invented by Queen Elizabeth I's godson John Harington in the 1590s, but only popularised by Joseph Bramah two centuries later, provided a luxury. Its S-bend eradicated smell. It also eradicated sanitation from conversation, and that is damaging, because conversation includes questions, and the assumption of the modern city that its paradigm of waterborne waste treatment is unquestionable; but it cannot be questioned when sanitation provokes only silence.

In 2009 the American Civil Society of Engineers rated the nation's sewer infrastructure as D minus.[12] New Jersey senator Frank Lautenberg referred to it as 'a ticking time bomb'.[13] Most city sewers, here, there and anywhere there are sewers, are old. All face two major threats: bad weather and the relentless demands of the city itself.

Bazalgette was a man of foresight. He knew cities grew, and so he built in extra capacity. But the sewers he designed for three million must now serve three times as many. Bazalgette lived in a time where there was no shame in being a 'sanitarian'. It was also an age in which a public toilet was regarded as a public necessity rather than a convenience, and necessities were amply met by lavish and plentiful marble-tiled establishments with copper piping and uniformed attendants. So there were schemes in abundance for the sewage of the Metropolis.

The noted agriculturist Justus von Liebig declared a sewer network to be a criminal waste of good fertiliser, and calculated that wasting useful fertilising solids by mixing them with water would lose London £4 million a year.[14] A puzzled Karl Marx remarked that 'London could find no better use for the excretion of four and one half million human beings than to contaminate the Thames with it at heavy expense.'[15] Alderman Mechi, another sewage doctor, took inspiration from the new system of town-supplied gas and imagined a future in which 'each farmer will turn on the tap and supply himself with town sewage through his metre [sic] according to his requirements'.[16] Yet more good gentlemen proposed schemes that they had heard of being in use on the Continent: sewer networks that separated household and industrial sewage flows from surface water, or anything that fell from the sky. When the Metropolitan Board of Works was considering these proposals regarding how to deal with the excrement of the capital, it made the wrong choice. The sewers would be the combined variety, taking street-water and sewage together, so saving money. That was the decision of the Board, and the Board got it wrong.

Similar errors were made worldwide. Consequently, the sewer networks of major cities today, taxed by population growth and a lack of capacity, can be overwhelmed by just two millimetres of rain falling in an hour. When it rains, and the storm tanks are overflowing, and the sewage is coming at a swimming-poolful a second, they do what they are designed to do: open the sluice gates and flush it into the nearest river or sea. In August 2004, when many areas of the UK received double the expected amount of rain, 600,000 tonnes of raw sewage entered the Thames. This was not unusual; combined-sewer overflows happen weekly. But this volume was exceptional, and 10,000 fish died from the overload of sewage nutrients which destroyed the delicate balance of their river ecosystem. Newspapers called it the Lesser Stink, and Thames Water used a defence I have heard often since then: 'If we don't discharge this sewage, it will flood your basement.' New York unleashes the equivalent of 800 swimming pools of sewage into its waters in the average week.[17] In California, citizens can check online when sewers overflow. At 1 p.m. on 16 March 2009, for example, 51,000 gallons of sewage were discharged at Orange Avenue, Redding. The reason given summed up the inconvenient truth of modern-day sanitary networks: 'Rainfall exceeded design'.[18]

The invincible sewers of our sanitary cities depend on the discharge of raw sewage. Does it matter? A California study calculated that sewage discharges were causing 1.2 million gastrointestinal illnesses a year and costing the state $51 million in annual healthcare costs.[19] But it is not cholera, and we do not die of it in our flushed and plumbed world, so the cracks are overlooked.

The sociologist Erving Goffman wrote that living together in proximity required 'civil inattention'.[20] The ability to ignore is instrumental to successful communal living. Civil inattention is fundamental in a public toilet, where the privacy is never auditory, and sounds cannot be stopped. It must be fundamental in cities such as London that have closed 40 per cent of their public 'conveniences' in ten years, because there is no public protest. Standing around that hole in a street at midnight with the flushers, I realised, as passers-by ignored us, that modern city people are no different from the Indians who don't see their untouchables. And our sightedness is as short. Cholera is the red flag that alerts to a dysfunctional city, but it should not be the only one. Even without blue girls, or children dying from diarrhoea, we should question our perfect sanitation solution, and at least wonder whether it needs evolution.

The city has grown to meet Crossness, but the city is also growing over the earth in a way that damages the sanitary infrastructure that keeps it functioning. With a combined sewer system, rainwater should have somewhere to go other than the sewer. It should be able to escape to groundwater or aquifers. When homeowners in modern cities pave their gardens, tarmac their driveways, they block surface water's escape route. This is an obvious fact, yet a lesson that has only just been learned. London now requires any would-be pavers to apply for planning permission. Federal buildings in the US are installing 'green roofs' to give the water some leeway. In the United States, where, according to data from state environmental agencies and the Environmental Protection Agency, 9,400 of the country's 25,000 sewage systems reported discharging untreated or partly treated sewage and hazardous chemicals into rivers and lakes,[21] there is a dizzying shortfall between what is financially promised to upgrade sewers and what is needed ($10 billion was allocated for waste-water infrastructure nationwide; but $36 billion dollars is needed in New York state alone).[22] In London, the time bomb is being addressed as it was addressed in 1858: by ambition and technology. A 'super-sewer' will run under the Thames, to accommodate all those overflows. It will cost £2 billion and take years to complete. And one day it will not be enough, either.

In 1910 American President Teddy Roosevelt told a group of Buffalo businessmen that 'civilized people should be able to dispose of sewage in a better way than putting it into drinking water'.[23] Water is being wasted (mostly on agriculture) while the world dehydrates. In Bazalgette's time it was the best carrier for filth. Today it is an expensive and precious one. And so perhaps the modern city should in fact look at those slums and at all the world's people unserved with even basic sanitation, because that is where the expensive, energy-consuming, wasteful waterborne treatment model is truly a pipe dream. More inventive solutions must be found, and there are many, even if they aren't new. An Arborloo for an African farmer who has land to spare, and who doesn't mind composting his family's excreta, then planting a banana tree in it. (Human waste can be a perfectly good fertiliser, as the Chinese have believed for four millennia. They claim it makes for crunchier apples and stickier rice.) A community toilet block that is loved because it is paid for, and thus cared for. There is plenty that Mumbai's Mr Sattar and his fish tank could teach the local authorities in England, so fond of shutting down toilets when pennies are pinched. There is plenty that the uncivilised anti-city can teach the flushed and plumbed city, if only it would listen.

Present-day internal views of the Crossness Pumping Station, built by Sir Joseph Bazalgette, in south-east London.
Matthew Wood / Crossness Pumping Station / 2010 / photograph

Thames Water supervisors inspect the
interior of a London sewer in the early 1900s.
*Thames Water / Supervisors at Thames
Water on Site Inspection / 1910 / photograph*

Labourers working on the tunnel
front at the Southern Outfall Sewer
in London in the early 1900s.
*Thames Water / Workers on the
Tunnel Front / 1900s / photograph*

Workmen in the yard of the Number 2 Pit at
Rotherfield Street, London, location of the
North Eastern Storm Relief Sewer, in the 1920s.
Thames Water / NESR Sewer / 1922 / photograph

Two workmen at the Eltham Relief Sewer on Eltham
Palace Road in London in February 1939: they are
624 feet from the centre of the shaft, at 6.45 p.m.
Thames Water / Eltham Relief Sewer / 1939 / photograph

ANGELA PALMER

The following street scenes document artist Angela Palmer's journey in 2007 to Linfen in China's Shanxi province, reportedly the most polluted place on earth. The project began when the artist had a dream that she visited the most polluted place on earth, and the cleanest place on earth, wearing an identical floating white outfit. Palmer awoke and resolved to undertake the project. She spent a week in Linfen, a city at the heart of China's coal-mining industry, and then a week in Cape Grim at the northwest tip of Tasmania, a place continually 'cleaned' by blasts of winds from the Roaring Forties. Palmer brought back her white outfits, along with photographs, film, water and air samples, all of which she exhibited at her Breathing In exhibition at the Wellcome Collection in London during 2009.

Artist Angela Palmer opens a glass flask to capture the air of Linfen in China's Shanxi Province.
Angela Palmer / Breathing In / 2007 / photograph / 29 x 42 cm

Above:
A man scavenges in a local rubbish
dump used by residents of Linfen.
*Angela Palmer / Breathing In / 2007 /
photograph / 29 × 42 cm*

Opposite:
An elderly man sits outside his home in Linfen.
*Angela Palmer / Breathing In / 2007 /
photograph / 29 × 42 cm*

A man flinches from the dust in his eye in
the heavily polluted area of Linfen, Shanxi
Province, heartland of heavy industry in China.
*Angela Palmer / Breathing In / 2007 /
photograph / 29 × 42 cm*

A man in Linfen leaving his home, which
is encrusted with airborne pollutants.
*Angela Palmer / Breathing In / 2007 /
photograph / 29 × 42 cm*

TO LOVE
A LANDFILL

DIRT AND THE ENVIRONMENT

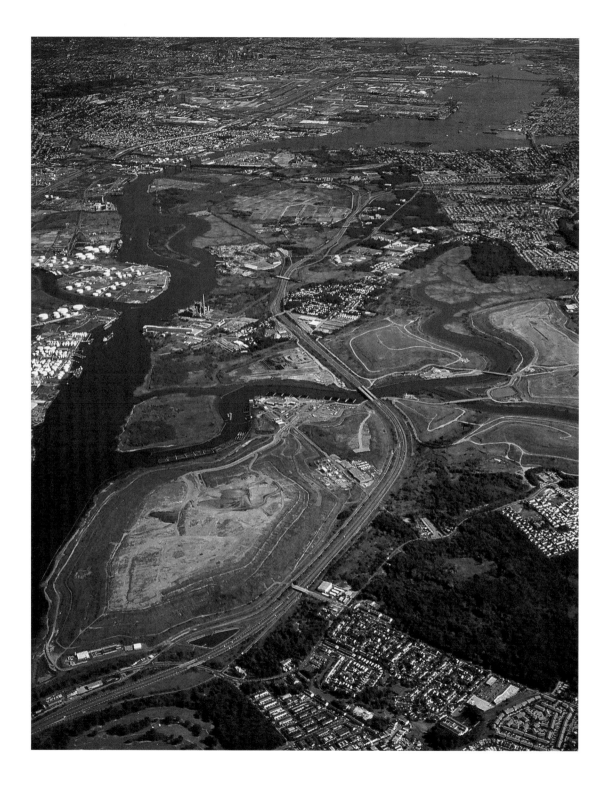

The landfill can be understood as a social space where discarded material is collected and contained, but also where cultural meaning may accrue and human relationships may be forged or understood.

The idea of the landfill as a common, socially meaningful, space is by no means a recent proposition. In 1850, the minor English poet and critic Richard Hengist Horne wrote a vivid and sensitive study of the community surrounding the Great Dust Heap at Gray's Inn Road in London in his 'Dust, or Ugliness Redeemed', reproduced here in an abridged form. Those same themes of community, value and meaning in the landfill are taken up more than 150 years later by the US anthropologist Robin Nagle in her discussion of the relationship between the city dump and the community it sustains. Taken together, these two texts reflect our ambivalent relationship with the idea of the landfill, as both a shared repository for waste and a place of shared social significance.

Previous page:
The transformation of Fresh Kills landfill to Freshkills Park will see haul roads such as these, previously used for transporting waste to various fill sites, re-purposed as park lanes for recreational activities such as cycling and running.
Photographer unknown / Freshkills Park / 2010 / photograph

Left:
An aerial view of the west shore of Staten Island, separated from New Jersey by the Arthur Kill.
City of New York / Aerial View of the West Shore, Fresh Kills / 2010 / photograph

DUST; OR
UGLINESS REDEEMED

R. H. HORNE

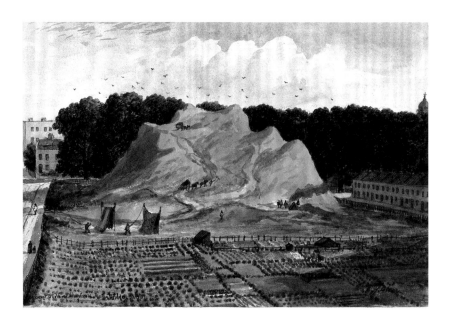

On a murky morning in November, wind north-east, a poor old woman with a wooden leg was seen struggling against the fitful gusts of the bitter breeze, along a stony zigzag road, full of deep and irregular cart-ruts. Her ragged petticoat was blue, and so was her wretched nose. A stick was in her left hand, which assisted her to dig and hobble her way along; and in her other hand, supported also beneath her withered arm, was a large rusty iron sieve. Dust and fine ashes filled up all the wrinkles in her face; and of these there were a prodigious number, for she was eighty-three years old. Her name was Peg Dotting.

About a quarter of a mile distant, having a long ditch and a broken-down fence as a foreground, there rose against the muddled-gray sky, a huge Dust-heap of a dirty black colour – being, in fact, one of those immense mounds of cinders, ashes, and other emptyings from dust-holes and bins, which have conferred celebrity on certain suburban neighbourhoods of a great city. Toward this dusky mountain old Peg Dotting was now making her way.

Advancing toward the Dust-heap by an opposite path, very narrow, and just reclaimed from the mud by a thick layer of freshly broken flints, there came at the same time Gaffer Doubleyear, with his bone-bag slung over his shoulder. The rags of his coat fluttered in the east wind, which also whistled keenly round his almost rimless hat, and troubled his one eye. The other eye, having met with an accident last week, he had

covered neatly with an oyster-shell, which was kept in its place by a string at each side, fastened through a hole. He used no staff to help him along, though his body was nearly bent double, so that his face was constantly turned to the earth, like that of a four-footed creature. He was ninety-seven years of age.

As these two patriarchal labourers approached the great Dust-heap, a discordant voice hallooed to them from the top of a broken wall. It was meant as a greeting of the morning, and proceeded from little Jem Clinker, a poor deformed lad, whose back had been broken when a child. His nose and chin were much too large for the rest of his face, and he had lost nearly all his teeth from premature decay. But he had an eye gleaming with intelligence and life, and an expression at once patient and hopeful. He had balanced his misshapen frame on the top of the old wall, over which one shrivelled leg dangled, as if by the weight of a hob-nailed boot that covered a foot large enough for a ploughman. In addition to his first morning's salutation of his two aged friends, he now shouted out in a tone of triumph and self-gratulation, in which he felt assured of their sympathy –

'Two white skins, and a tor'shell-un!'

It may be requisite to state that little Jem Clinker belonged to the dead-cat department of the Dust-heap, and now announced that a prize of three skins, in superior condition, had rewarded him for being first in the field.

He was enjoying a seat on the wall, in order to recover himself from the excitement of his good fortune.

At the base of the great Dust-heap the two old people now met their young friend – a sort of great-grandson by mutual adoption – and they at once joined the party who had by this time assembled as usual, and were already busy at their several occupations.

A Dust-heap of this kind is often worth thousands of pounds. The present one was very large and very valuable. It was in fact a large hill, and being in the vicinity of small suburb cottages, it rose above them like a great black mountain. Thistles, groundsel, and rank grass grew in knots on small parts which had remained for a long time undisturbed; crows often alighted on its top, and seemed to put on their spectacles and become very busy and serious; flocks of sparrows often made predatory descents upon it; an old goose and gander might sometimes be seen following each other up its side, nearly midway; pigs rooted around its base – and now and then, one bolder than the rest would venture some way up, attracted by the mixed odours of some hidden marrow-bone enveloped in a decayed cabbage-leaf – a rare event, both of these articles being unusual oversights of the Searchers below.

The principal ingredient of all these Dust-heaps is fine cinders and ashes; but as they are accumulated from the contents of all the dust-holes and bins of the vicinity, and as many more as possible, the fresh arrivals in their original state present very heterogeneous materials. We cannot better describe them than by presenting a brief sketch of the different departments of the Searchers and Sorters, who are assembled below to busy themselves upon the mass of original matters which are shot out from the carts of the dustmen.

The Great Dust-Heap at King's Cross, London, next to Battle Bridge and the Smallpox Hospital, in 1837.
E. H. Dixon / The Great Dust-Heap / 1837 / watercolour painting / 18.8 × 27.4 cm

The bits of coal, the pretty numerous results of accident and servants' carelessness, are picked out, to be sold forthwith; the largest and best of the cinders are also selected, by another party, who sell them to laundresses, or to braziers (for whose purposes coke would do as well); and the next sort of cinders, called the breeze, because it is left after the wind has blown the finer cinders through an upright sieve, is sold to the brick-makers.

Two other departments, called the 'soft-ware' and the 'hard-ware', are very important. The former includes all vegetable and animal matters – everything that will decompose. These are selected and bagged at once, and carried off as soon as possible, to be sold as manure for ploughed land, wheat, barley, &c. Under this head, also, the dead cats are comprised. They are generally the perquisites of the women Searchers. Dealers come to the wharf, or dust-field, every evening; they give sixpence for a white cat, fourpence for a coloured cat, and for a black one according to her quality. The 'hard-ware' includes all broken pottery, pans, crockery, earthenware, oyster-shells, &c., which are sold to make new roads.

'The bones' are selected with care, and sold to the soap-boiler. He boils out the fat and marrow first, for special use, and the bones are then crushed and sold for manure.

Of 'rags', the woollen rags are bagged and sent off for hop-manure; the white linen rags are washed, and sold to make paper, &c.

The 'tin things' are collected and put into an oven with a grating at the bottom, so that the solder which unites the parts melts, and runs through into a receiver. This is sold separately; the detached pieces of tin are then sold to be melted up with old iron, &c.

Bits of old brass, lead, &c., are sold to be molted up separately, or in the mixture of ores.

All broken glass vessels, [such] as cruets, mustard-pots, tumblers, wine-glasses, bottles, &c., are sold to the old-glass shops.

As for any articles of jewellery – silver spoons, forks, thimbles, or other plate and valuables, they are pocketed off-hand by the first finder. Coins of gold and silver are often found, and many 'coppers'.

Meantime, everybody is hard at work near the base of the great Dust-heap. A certain number of cart-loads having been raked and searched for all the different things just described, the whole of it now undergoes the process of sifting. The men throw up the stuff, and the women sift it.

'When I was a young girl,' said Peg Dotting –

'That's a long while ago, Peggy,' interrupted one of the sifters: but Peg did not hear her.

'When I was quite a young thing,' continued she, addressing old John Doubleyear, who threw up the dust into her sieve, 'it was the fashion to wear pink roses in the shoes, as bright as that morsel of ribbon Sally has just picked out of the dust; yes, and sometimes in the hair, too, on one side of the head, to set off the white powder and salve-stuff. I never wore one of these head-dresses myself – don't throw up the dust so high, John – but I lived only a few doors lower down from those as did. Don't throw up the dust so high, I tell 'ee – the wind takes it into my face.'

'Ah! There! What's that?' suddenly exclaimed little Jem, running as fast as his poor withered legs would allow him toward a fresh heap, which had just been shot down on the wharf from a dustman's cart. He made a dive and a search – then another – then one deeper still. 'I'm sure I saw it!' cried he, and again made a dash with both hands into a fresh place, and began to distribute the ashes and dust and rubbish on every side, to the great merriment of all the rest.

'What did you see, Jemmy?' asked old Doubleyear, in a compassionate tone.

'Oh, I don't know,' said the boy, 'only it was like a bit of something made of real gold!'

A fresh burst of laughter from the company assembled followed this somewhat vague declaration, to which the dustmen added one or two elegant epithets, expressive of their contempt of the notion that they could have overlooked a bit of anything valuable in the process of emptying sundry dust-holes, and carting them away.

'Ah,' said one of the sifters, 'poor Jem's always a-fancying something or other good but it never comes.'

'Didn't I find three cats this morning?' cried Jem, 'Two on 'em white 'uns! How you go on!'

'I meant something quite different from the like o' that,' said the other; 'I was a-thinking of the rare sights all you three there have had, one time and another.'

Before the day's work was ended, however, little Jem again had a glimpse of the prize which had escaped him on the previous occasion. He instantly darted, hands and head foremost, into the mass of cinders and rubbish, and brought up a black mass of half-burnt parchment, entwined with vegetable refuse, from which he speedily disengaged an oval frame of gold, containing a miniature, still protected by its glass, but half covered with mildew from the damp. He was in ecstasies at the prize. Even the white cat-skins paled before it. In all probability some of the men would have taken it from him, 'to try and find the owner', but for the presence and interference of his friends Peg Dotting and old Doubleyear, whose great age, even among the present company, gave them a certain position of respect and consideration. So all the rest now went their way, leaving the three to examine and speculate on the prize.

These Dust-heaps are a wonderful compound of things. A banker's cheque for a considerable sum was found in one of them. It was on Herries & Farquhar, in 1847. But banker's cheques, or gold and silver articles, are the least valuable of their ingredients. Among other things, a variety of useful chemicals are extracted. Their chief value, however, is for the making of bricks. The fine cinder-dust and ashes are used in the clay of the bricks, both for the red and grey stacks. Ashes are also used as fuel between the layers of the clump of bricks, which could not be burned in that position without them. The ashes burn away, and keep the bricks open. Enormous quantities are used. In the brickfields at Uxbridge, near the Drayton Station, one of the brick-makers alone will frequently contract for fifteen or sixteen thousand chaldrons of this cinder-dust, in one order. Fine coke, or coke-dust, affects the market at times as a rival; but fine coal, or coal-dust, never, because it would spoil the bricks.

As one of the heroes of our tale had been originally – before his promotion – a chimney-sweeper, it may be only appropriate to offer a passing word on the genial subject of soot. Without speculating on its origin and parentage, whether derived from the cooking of a Christmas dinner, or the production of the beautiful colours and odours of exotic plants in a conservatory, it can briefly be shown to possess many qualities both useful and ornamental.

When soot is first collected, it is called 'rough soot', which, being sifted, is then called 'fine soot', and is sold to farmers for manuring and preserving wheat and turnips. This is more especially used in Herefordshire, Bedfordshire, Essex, &c. It is rather a costly article, being fivepence per bushel. One contractor sells annually as much as three thousand bushels; and he gives it as his opinion, that there must be at least one hundred and fifty times this quantity (four hundred and fifty thousand bushels per annum) sold in London. Farmer Smutwise, of Bradford, distinctly asserts that the price of the soot he uses on his land is returned to him in the straw, with improvement also to the grain. And we believe him. Lime is used to dilute soot when employed as a manure. Using it

pure will keep off snails, slugs, and caterpillars from peas and various other vegetables, as also from dahlias just shooting up, and other flowers; but we regret to add that we have sometimes known it kill or burn up the things it was intended to preserve from unlawful eating. In short, it is by no means so safe to use for any purpose of garden manure, as fine cinders and wood-ashes, which are good for almost any kind of produce, whether turnips or roses. Indeed, we should like to have one fourth or fifth part of our garden-beds composed of excellent stuff of this kind. From all that has been said, it will have become very intelligible why these Dust-heaps are so valuable. Their worth, however, varies not only with their magnitude (the quality of all of them is much the same), but with the demand. About the year 1820, the Marylebone Dust-heap produced between four thousand and five thousand pounds. In 1832, St George's paid Mr Stapleton five hundred pounds a year, not to leave the Heap standing, but to carry it away. Of course he was only too glad to be paid highly for selling his Dust.

But to return. The three friends having settled to their satisfaction the amount of money they should probably obtain by the sale of the golden miniature-frame, and finished the castles which they had built with it in the air, the frame was again infolded in the sound part of the parchment, the rags and rottenness of the law were cast away, and up they rose to bend their steps homeward to the little hovel where Peggy lived, she having invited the others to tea, that they might talk yet more fully over the wonderful good luck that had befallen them.

An edited extract from the article first published
in *Household Words*, 13 July 1850

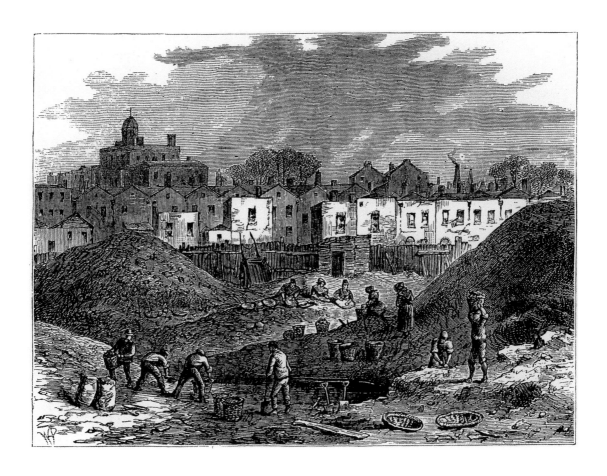

Male and female workers scavenging at
the dust heaps in Somers Town in London
during the mid nineteenth century.
*Artist unknown / The Dust Heaps, Somers
Town / 1836*

LAID TO REST

Dust is everywhere; it is part of us and the smallest of visible particles. Inspired by the commercialisation of waste in Victorian London, from the dust heaps of Gray's Inn Road to the engineering achievements of Joseph Bazalgette's sewage system, *Laid to Rest* will transform dust collected from houses, businesses and institutions into 500 commemorative bricks. The Victorian dust heaps were monuments to the invisible, and provided a major source of income. One of the industries to be born out of the heaps was London brick making: ash, cinders and rubbish from the heaps were mixed with the mud of nearby brick fields to produce the humble brick.

Each brick made as part of *Laid to Rest* will contain specific dust from the contributing household, business or institution. Imprinted on each brick will be information cataloguing its transformation from the barely visible to the palpable. A growing stack of bricks will be incorporated into the Dirt exhibition at the Wellcome Collection, and whilst on display a series of events will take place around the stack: a mythical marching band, The Brick-Keepers, will consecrate the bricks and the process of their making by combining choral incantations and ritual dance in a tribute to the overlooked and forgotten. The project will culminate in a horse-drawn procession and the burial of the bricks, returning them to the earth from where they came.

Laid to Rest is a project by Serena Korda, commissioned by the Wellcome Trust in association with UP Projects, and is part of the Wellcome Trust's Dirt season.

Opposite, above:
Serena Korda with
bricks for *Laid to Rest*.
*Michael Andreae / January
2011 / photograph*

Opposite, below left:
Serena Korda at H. G. Matthews's
brick yard, Buckinghamshire.
*Michael Andreae / January
2011 / photograph*

Opposite, below right:
Serena Korda stamping
bricks at the H. G. Matthews
brick yard, Buckinghamshire.
*Michael Andreae / January
2011 / photograph*

Right:
Serena Korda collecting dust for *Laid
to Rest* in a launderette, Chalton Street,
Somers Town, London.
Alice Carey / January 2011 / photograph

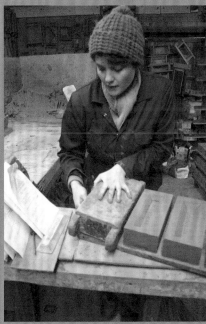

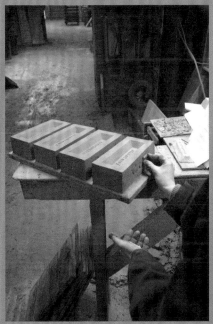

On 22 March 2001, New York City marked the end
of an era when the last barge ever to carry garbage
to Fresh Kills landfill set sail from Queens.
Robin Nagle / Last Barge / 2001 / photograph

THE HISTORY AND FUTURE OF FRESH KILLS

ROBIN NAGLE

Landfills as commons

Most people do not choose to spend time at active landfills. Livestock are not put out to pasture there, crops are not raised, game is not hunted, picnickers do not ward off ants, runners do not sweat, children do not gambol. A landfill is generally seen as an unfortunate answer to solid-waste disposal problems. It is not understood as a commons – that is, a land or similar resource shared by and for the benefit of a community – though its function as the repository of unwanted material goods is essential to the well-being of the metropolis that relies on it.[1] Often considered a blight, it is also a space to which all residents contribute, a 'social sculpture'.[2] The artificial geography of a landfill is created by all, shared by all, and has the potential to be transformed after closing into something that all may use and enjoy.

Moreover, a landfill reveals unexpected details about the society that creates it. 'The urban physiology of excretion,' notes social historian Alain Corbin, 'constitutes one of the privileged means of access to social mentalities.'[3] He was referring to sewage disposal, but the sentiment applies just as well to solid waste. That landfills are the disposal method of choice for much of the USA reflects a particular set of relationships between citizens, municipalities, environmentalists, material culture, moral and aesthetic sensibilities, and the science of solid waste management.[4]

Landfills let us get rid of our debris but also keep it indefinitely. Contrary to popular belief, much of our buried trash does not decompose.[5] When choosing between a landfill and an incinerator (or a 'waste-to-energy facility', as they're now called), a landfill is allegedly safer because incineration is thought to cause unacceptable air pollution. The off-gassings of methane and other volatile organic compounds at many landfills, however, are often greater threats to air quality. Since landfills are usually sited far from crowded population centres, they allow the illusion that there is a distant, disconnected place to 'throw away' rejectamenta. In the United States, with its vast open spaces, it seems impossible to run out of places in which to deposit refuse. In part because of this, source reduction – generating less trash in the first place – is not seriously explored.

Fresh Kills landfill in New York City is an excellent example of these trends and assumptions. Historically significant and politically volatile, the site has always been a commons, whether or not it was ever formally recognised as such. Here I will consider how a dump or landfill can serve as a commons, and explore the unique role Fresh Kills plays in New York's well-being.

First, to contextualise the challenge, it is helpful to illustrate how solid waste has vexed us for centuries. After that I explore the parameters of commons, briefly review Fresh Kills' history, and finally investigate some of the social implications and cognitive difficulties of allowing a landfill the role of a commons. I argue that if

we cannot appreciate a landfill as a common resource, our understanding of our larger culture is incomplete.

Garbage through time

Garbage, in the form of rejected and discarded material remains, has been part of human civilisation since our first days as hominids and perhaps even before.[6] The transformation of garbage into a large-scale problem, however, had to wait for us to move from hunting/gathering groups and agrarian communities into early urban sites. Although not uniquely urban, garbage presents particular challenges to city dwellers.

Rubbish in ancient Troy, for example, was simply dropped on the floors of homes or tossed in the streets. In approximately 2500 BC the city of Mahenjo-Daro in the Indus river valley had rubbish chutes, trash bins, a drainage system and a scavenging service. The Babylonians had cesspools, drains and a sewage system. The Israelites took a big step toward improving hygiene when Mosaic law directed Jews to remove their waste and bury it far from living quarters.[7]

The first municipal dumps known in the Western world were organised by the Athenians, who also enacted what may have been the world's first anti-litter ordinance. The Romans had more trouble coping with sanitation, and by the time the population of Rome reached its zenith of a million and a half inhabitants, there were unprecedented health and pollution problems. But at least the Romans had their baths and a version of a sewer. Europe forgot these niceties for nearly a millennium after Rome fell.

Indeed, the filth of Europe in the Middle Ages and in the Renaissance is difficult to imagine. King Philip II of France ordered the streets of Paris to be paved in 1184 because he was sickened by the smells emanating from the garbage-soaked mud. It didn't help much. 'This town is always dirty,' wrote one visitor to the City of Light in the late 1500s, 'and 'tis such a dirt, that by perpetual motion is beaten into such black unctuous oil that where it sticks no art can wash it off . . . It also gives so strong a scent that it may be smelt many miles off if the wind be in one's face.'[8]

London was as rank as Paris. In 1347, 'two men were prosecuted for piping ordure into a neighbour's cellar – it says a great deal about the general smell of London at the time that this economical device was not discovered until the cellar began to overflow'.[9] The flow of the Thames was regularly impeded by trash and untreated sewage.[10] Sanitary conditions in Europe remained relatively awful until the Industrial Revolution, which 'produced the most degraded urban environment the world had yet seen . . .'[11]

In New York, street-side trash collecting was legislated in the 1650s, but it happened only sporadically, and much waste was simply dumped along the city's shore. This proved a popular solution to the problem of too much trash and too little space. Even in the 1600s, real estate was a hot commodity in New York, and much of urban life centred on the downtown waterfront. Merchants were eager to build on crowded spaces, and dumping helped create more land onto which they could expand. In Manhattan, below City Hall, 33 per cent of the land is built on 'street sweepings, ashes, garbage, ballast from ships, dirt and rubble from excavated building sites, and other forms of solid waste dumped along the shore'.[12] Some parts of lower Manhattan have been filled three blocks out from the original shoreline.[13]

By the turn of the twentieth century, new fill opportunities were greeted enthusiastically. 'The possibilities of this reclamation are almost boundless,' boasted

John McG. Woodbury, the commissioner of the city's Department of Street Cleaning (precursor to the Department of Sanitation). 'The lowlands on Jamaica Bay,' he noted, referring to a broad network of marshes and islands on the city's south-eastern edge, 'afford an almost unlimited supply of dumping ground.'[14]

The trash of New York, and of many other American cities, has created thousands of acres of shared space that would not otherwise exist. The contours of New York differ irrevocably from their configurations before Europeans arrived, both inland and along the shore. About 20 per cent of contemporary Manhattan, Brooklyn, Queens and the Bronx is landfill. Archaeological evidence suggests that even before the arrival of the Europeans, the indigenous residents dumped refuse along the water's edges; discerning an 'original' shoreline for the city would be virtually impossible.

There is little public memory of the source of so much land. Few people realise that both of New York's airports are built on fill, as are the foundations of the Triborough, George Washington, Verrazano, Whitestone and Throgs Neck bridges. Numerous New York parks (Great Kills in Staten Island, Orchard Beach in the Bronx, Battery Park in Manhattan) were wetlands or water before they were filled.

Fresh Kills will someday be one of those spaces. A Department of Sanitation Annual Report from the 1950s bragged that Fresh Kills was the greatest land reclamation project ever attempted. This unlikely claim is being made real with current work to transform the formerly pungent geography into one of the largest green spaces within the borders of New York City.

Until the late 1980s, Athey wagons such as these were used to haul rubbish from barges to the landfill's active bank, or tipping point, at Fresh Kills.
Photographer unknown / Athey wagons at Fresh Kills Landfill / 1980s / photograph

Invented commons

Its status as a future park is not the only reason Fresh Kills qualifies as a commons. Social arrangements that bring a commons into existence, or that recognise and protect certain resources as commons, are in continual flux. The idea of a commons challenges notions of private property, prosperity, and who has rights to define and control communal well-being. Historically, the term 'commons' was most often applied to shared open areas of land used for agricultural purposes. The word is still in everyday use in England, where the commons were sources of grazing pasture, game, fish, and fuel wood for hundreds of years, until enclosure laws enacted during the eighteenth century forbade access (a process that was repeated throughout much of Europe). Resulting hardships among the peasantry included starvation and inspired violent reactions, which in turn provoked Draconian responses from the state. The punishment in Britain for removing the boundary markers of newly enclosed commons was death.[15]

A cheerier model of a commons is the grazing pasture sometimes pictured at the heart of colonial New England towns. Careful husbandry meant that it was available in perpetuity, or at least until advancing modernities made livestock a cumbersome possession for townsfolk. Public parks often replaced those older commons; now humans occupy space once dedicated to large ruminants.[16] Grazing cows would be a rare sight in such places today, though the Sheep's Meadow in New York's Central Park hosted its namesake until 1934, when parks officials, fearing that the woolly mammals would end up on dinner plates made empty by the Great Depression, removed them.

More contemporary examples abound. In the USA, the Clean Air and Clean Water Acts of the 1970s were explicit recognition that those basic elements constitute shared resources that must be safeguarded, transforming them from unmanaged (and thus exploitable) to managed (and thus at least potentially protected) commons.[17] The Georges Bank, a once-plentiful fishing ground off the north-east coast of the United States, was for centuries an unmanaged commons; today it suffers serious depletion after unbridled overuse. Biodiversity in some of the planet's last tropical rainforests inspires nations like Brazil to guard them from northern powers that would investigate. Such efforts impose a shelter on these wild commons but also place them at risk, since science that would strengthen the cause of preservation is rebuked with the same energy as attempts at exploitation.

Next to these illustrations, a landfill seems a lowly and unlikely commons.[18] But it serves, in the sense of a resource set aside by the community for its shared use, to enhance the greater good. Without a functioning landfill or some other way of ridding itself of debris, no metropolis can survive.

A landfill commons is humble in part because of the stuff that makes it. Garbage imposes technical, environmental, social and cognitive challenges that unite and commemorate the culture that creates it. Household rubbish in particular underscores the problem of trash as intimate, perpetual, and despised. It is intimate because there are few activities that occupy us in any given 24-hour period, except perhaps sleep, that do not generate garbage. Thus our refuse reflects our simplest, most mundane behaviours as well as our more celebrated moments. It is perpetual because, if we partake of contemporary life at what I call average necessary quotidian velocities, there are few ways to stop its creation.[19] And trash is despised for many reasons, the simplest of which is its conglomerate power to disgust. A single mouldy orange peel is not so

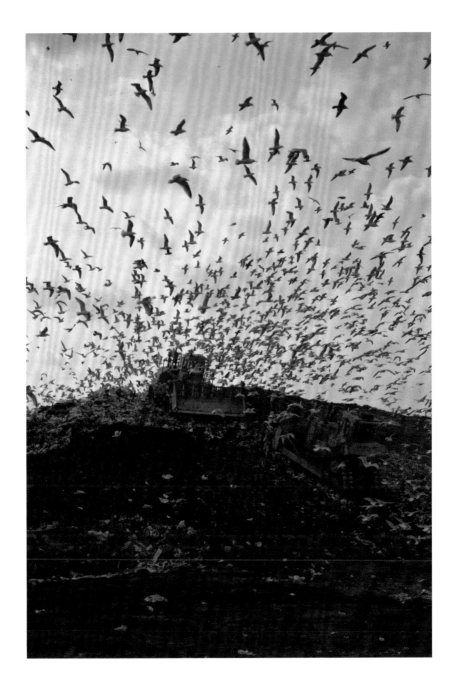

Seagulls surround a tractor at work on
an active fill site at Fresh Kills landfill.
*Diane Cook and Len Jenshel / Fresh Kills
Landfill on Staten Island, New York City /
1992 / photograph*

gross, especially if it's my own mouldy orange peel, but a bucket of rotting fruit from who knows what source can elicit strong negative reaction.[20]

Trash invites a willing ignorance that is nicely revealed in our vehemently vague language of discard. We don't 'put' it away, which would imply that we save it for later use.[21] Rather, we 'throw' it away, and the 'away' is comfortably undefined – but it is often a landfill. As the last stop for our discards, landfills force commonality on our material traces, whether or not such commonality existed before. They hold startlingly accurate records of the people who form them, and unlike the people, they endure. 'If I were a sociologist anxious to study in detail the life of any community,' wrote Wallace Stegner, 'I would go very early to its refuse piles . . . For whole civilisations we have sometimes no more of the poetry and little more of the history than this'.[22] 'The artifacts that will fully represent our lives are safely stored within mega-time-capsules, which we call landfills,' concurs archaeologist William Rathje. 'It is these anonymous, random remains that will tell our story to the future . . .'[23]

Landfills unite objects. They also sometimes unite citizens. In municipalities without garbage collection, they bring together residents who must travel to their landfill (or, in days gone by, to their dump) to discard trash. They often provide formal or informal recycling centres, where rejected but still useful possessions are claimed by new owners. Some landfills, or dumps, provide entertainment. When I was a child growing up in a small town in northern New York State, we went to ours on summer evenings to sit in the car with the windows rolled up and the headlights focused on the pits of trash, watching bears forage for food. We usually met neighbours who had come for the same attraction. But even more significant connections can occur. Nuptials were celebrated at the Bethel, Maine transfer station – formerly known as the town dump – on 1 September 2003. The location made sense to the newly-weds because it was where Rockie Graham, a conscientious recycler, met her husband, Dave Hart, a new employee at the facility. Townsfolk contributed to their honeymoon fund with bottles and cans to be redeemed for nickels.[24]

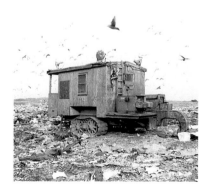

Left:
The job of the bank supervisor at Fresh Kills landfill was to monitor operations at the active bank, or tipping point, of the landfill. The active bank changed from day to day, so the office would be moved on tractors to the active site.
Photographer unknown / Bank Supervisor's Office, Fresh Kills / late 1980s / photograph

Opposite:
A Payhauler (left) and a compactor (right) at work on Fresh Kills landfill in 1991.
Photographer unknown / Landfilling at Fresh Kills / 1991 / photograph

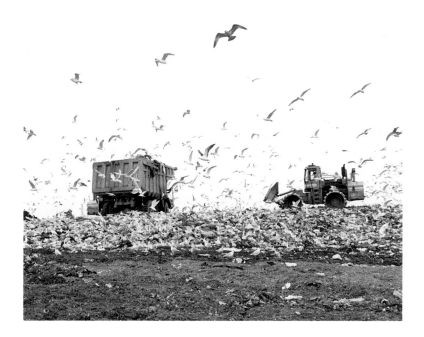

Fresh Kills: landfill

Fresh Kills is a rich example of a landfill as commons, which its history – especially its recent and future history – suggests. In part because of its audacious scale, it is a commons not only for the city that created it but also for the larger civilisation that the city represents.

Before it was a landfill, Fresh Kills was a series of inlet marshes, woods and meadows nestled into the middle western edge of Staten Island, separated from New Jersey by a narrow strip of water called the Arthur Kill. ('Kill' derives from the Dutch word for 'creek' and place names that include it, like the Catskill Mountains, are traces of a long-gone colonial legacy.) Indigenous artefacts estimated to be nearly 10,000 years old were discovered there. To the north, Linoleumville (now a neighbourhood called Travis) was founded around the country's first linoleum factory, built in 1882 by British inventor Frederick Walton. In its heyday, the factory employed more than 200 workers. By the early twentieth century, nearby hamlets included Kreischerville to the south (now Charleston), where locally mined clay was made into bricks and drainpipes.

Fresh Kills provided treasures for locals. Old women roamed the marshes harvesting herbs, wild flowers, grapes for jelly, and watercress. Italians came for mushrooms and mud shrimp. In the fall, truck farmers harvested salt hay with scythes, while Jewish elders and rabbis cut carefully chosen willow twigs for Succoth.[25]

Early in the 1900s, through a breathtaking piece of political legerdemain, the city established a reduction plant at Fresh Kills. Dead horses, other offal and rubbish were to be boiled down into grease, fertiliser and glycerine. The contractor who built the plant promised that odours would not be a problem, but it was regularly filled past capacity. Garbage and carcasses rotted in uncovered barges for months at a time. The odours – the very ones that city officials had promised wouldn't exist – were nauseating. Public outcry was immediate and loud, but the plant was not closed until the mayor who approved it lost his bid for re-election.[26]

Two decades later, in 1938, city planner and infamous autocrat Robert Moses wanted to build a bridge that would further his grand scheme to lace the New York region with highways. Fresh Kills' many bogs and swamps seemed the ideal place to fill for the bridge's foundations. As city parks commissioner and chairman of the Triborough Bridge Authority (among other titles), Moses already commanded the dumping of city trash to create the foundations for highways, bridges, and parks all over the city; Fresh Kills was merely one more place to fill in, to make 'taxable'.[27]

It took a while, and the Staten Islanders did their best to thwart the plan,[28] but dumping started on Fresh Kills in 1948; soon complaints were sounding from every neighbourhood. Moses assured irate residents that he only needed three years to fill the land. In 1951, however, he urged the mayor to allow more time. 'The Fresh Kills project cannot fail to affect constructively a wide area around it,' he reported that year. 'It is at once practical and idealistic.'[29]

By 1954, Fresh Kills covered 669 acres. Five years later, the city proposed extending its life by fifteen years. In 1965, when pressed about a closing date, officials demurred, claiming none could be set. By 1966, the landfill consumed 1,584 acres. A planning report in 1968 proposed a ski resort once the landfill's slopes were finally capped, but this surprisingly creative notion did not count on the perpetual presence of methane gas, a heat-generating by-product of decomposing organic matter.

By the early 1970s, other landfills in the city were closing, and Fresh Kills received almost half the city's refuse. In 1980, the state's Department of Environmental Conservation (DEC) charged the city with environmental violations because Fresh Kills had been built and expanded without linings, gas-retrieval systems, or leachate-recovery plans, among other problems. By then the landfill was so far from compliance with existing regulations, most legislated after it was opened, that it was technically illegal. The same charges against the city were made again in 1985, when Fresh Kills was receiving almost 22,000 tons of garbage every day – nearly all of New York's trash. Tipping rose to an all-time high of 29,000 tons a day by 1987.[30] By then the landfill employed 650 full-time workers, representing eighteen different unions.

In 1990, for the third time, the state's DEC cited the city for violations at Fresh Kills, but this time the charges included a tight schedule for bringing the landfill into compliance. In 1991, Edgemere landfill in Queens closed. Incinerators were already in decline as public protest against them grew, and the city's last three closed in the early 1990s.[31] Fresh Kills became the city's only option for disposing of household waste.

In 1995, Staten Island officials sued. Fresh Kills, they argued, violated the city charter's 'fair share' provision of the federal government's Clean Air Act. At the same time, the state legislature entertained bills mandating the landfill's closure by 2002. A few months later, the governor, the mayor and the borough president announced that the landfill would close by the end of 2001, a goal signed into law in June 1995. There was no alternative garbage management plan in place. The closing date was mostly arbitrary, but it let conservative mayor Rudolph Giuliani pay a debt. Staten Island, the

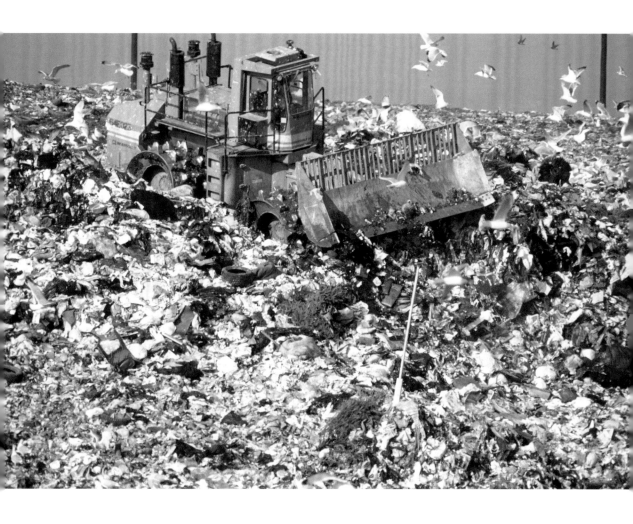

Workers move garbage at
Fresh Kills landfill in 1990.
*Stephen Ferry / Tractor at Fresh
Kills Landfill / 1990 / photograph*

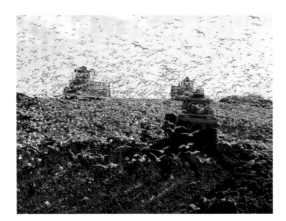

least ethnically diverse and most conservative borough in New York, had awarded him huge margins of victory in both his mayoral bids. Without an overwhelming majority there, it is unlikely that he could have carried his first or second election.[32]

Because the decision to close the landfill was political (despite the sound arguments of the Staten Island lawsuits), knowledgeable sources scoffed that it would not be shut down. There was no other place to put the trash and no coherent plan to find one. Despite predictions, however, and months ahead of schedule, the last tugboat pushing the last barges set off from a marine transfer station in Queens on a rain-drenched Thursday in late March 2001. When it arrived five hours later, the last building block of an extraordinary piece of architecture, constructed across more than half a century, was loaded into Payhaulers and sent up the hill.

Fresh Kills is one of the largest landwork structures in the history of humankind and for years was the largest landfill in the world. It spans nearly 2,200 acres, about two and a half times the size of Central Park. It comprises 6 per cent of the land mass of Staten Island, and until a methane retrieval system was initiated in 1998 it generated 6 per cent of the nation's and fully 2 per cent of the world's methane. It is criss-crossed by fifteen miles of roads and bridges. It cannot be seen in its entirety from the ground, but only from the air; in fact, it is visible from space to the naked eye.[33] It holds approximately 108 million tons of trash and still has an estimated 80 million tons of remaining capacity.[34]

The city's municipal garbage is now exported upstate, out of state, out of the region. For the first time in its history, New York has no place for its own trash. The cost of exporting has pushed the New York Department of Sanitation's annual budget above the one billion dollar mark. Rudy Giuliani's successor, mayor Michael Bloomberg, announced a twenty-year Solid Waste Management Plan that includes using the city's existing marine transfer stations, which are to be retrofitted to accommodate the necessary technology, to compact trash into containers. These will be loaded onto barges and shipped to transfer stations in New Jersey and elsewhere, and then sent to landfills. The city must also ramp up its recycling efforts; new processing facilities are planned in several locations.

The Solid Waste Management Plan was fiercely debated for several years before it was approved in 2006, and it still has big gaps, but one thing is certain: the garbage will keep coming. And regardless of pressures in the future that might advocate reopening Fresh Kills, at least one section of the landfill will never again receive trash.

Fresh Kills: memorial ground

One of the many arresting features of Fresh Kills is its view of lower Manhattan. Sketched delicately against the horizon, the city's skyline seems a hazy Oz from the landfill's austere hills fourteen miles distant. Workers on Fresh Kills watched both planes hit the World Trade Center on 11 September 2001 and saw the buildings fall. They knew what was coming. Even before official word arrived, they started readying Section 1/9, the largest and last-closed face, for the new loads. There was no other space in the city that was big enough and – just as importantly – that could be sealed off and secured for the ensuing criminal investigation and retrieval operations.

The first wreckage arrived by truck in the early hours of 12 September, but the Department of Sanitation soon had out-of-commission barges back in action and opened several marine transfer stations within days. At the height of the operation, more than a thousand people representing nearly twenty-five different city, state and federal agencies worked around the clock at The Hill, as it was now more tactfully known. A ceremony marking the end of the sorting process took place on 15 July 2002. By early August, the last piles of bent I-beams and tangled reinforcement bars were heading to recyclers.

The idea of leaving any of the World Trade Center material at Fresh Kills compounded stunned public disbelief and incomprehension in the days immediately after the attacks. Initial reports suggested that debris would be sifted at Fresh Kills and then taken elsewhere for burial, and city officials were careful to make no commitment about where the wreckage might finally end up. But it was gradually clear that it would be too costly to move the million-plus tons a second time, and Fresh Kills became the final resting place.

One of the workers sifting the rubble suggested that a memorial to the attack victims become part of Fresh Kills' future. He said he was glad that the remains of the

buildings were staying inside the borders of the city. Outrage was immediate. 'I really do believe that for the sake of their souls and their families, to have the "Dump" be a Memorial is a disgrace,' wrote one woman on the local newspaper e-mail forum that evening. '. . . Please don't even consider such an idea of this sort, the dump is the "DUMP."'

'I agree with you,' replied another, 'who in the world came up with that idea? a garbage dump as a memorial to the HEROS!!! [sic] my God what were you thinking?'[35]

But one person intimate with Fresh Kills had a different reaction. 'One can view with horror the decision to place what I consider sacred material on top of something profane,' wrote Nick Dmytryszn. 'I do not.'

Dmytryszn is the environmental engineer for the Staten Island borough president's office and thus has been a long-time student of the landfill. He continued:

> This section of landfill is scheduled, as per the law, for final closure. In simple terms, closure involves first placing down *clean* soil, followed next by an impermeable barrier, to be then all covered with another thick layer of *clean* soil. Thus what was enacted to protect the environment is now very relevant in protecting and respecting the final resting place of so many of our dead. Fresh Kills has now become a part of the landscapes of every American.[36]

Fresh Kills: a new commons

Such divergent perspectives point to the volatile politics of memory that already marked Fresh Kills. It serves as an immense, inadvertent museum, with countless objects preserved until the future possibility that they are excavated, scrutinised, maybe even catalogued and displayed. It is a monument to what sociologist Wayne Brekhus calls the 'unmarked' material relations of everyday life.[37] But now it also serves as a memorial to profound tragedy.

It became both museum and memorial by default. We had nowhere else to put our trash, and never worked much to diminish its quantity, so in our need for the 'away' of throw-away society, we invented Fresh Kills. We had nowhere else to put the wreckage from the World Trade Center, so out of necessity for space and security, we transformed Fresh Kills – a name too horrific to say in the days immediately following the attacks – into The Hill (even as the Trade Center site was called Ground Zero and, later, The Pit).

But these seemingly contradictory functions are not so surprising. Since its inception, Fresh Kills has commemorated many things. Its existence allowed the citizens of New York to live at breakneck speed without having to change consumption habits or consider that the 'away' is always a real place. From its start until its closure, it represented not only the prevalent solid-waste disposal technologies of the day, but it also helped advance the science of landfill design. Measures taken to bring the landfill into compliance with federal law in the mid-1990s required the Department of Sanitation to create complex engineering and infrastructural interventions on an unprecedented scale; many of these are now gold-standard choices for disposal operations around the world.[38] Today, as Freshkills Park, it continues to be a centre of significant innovation as environmentalists work to build an ecology rich with plant and animal life.[39]

It is made of four huge heaps of objects we classed as untouchable, consigning them to uniformed workers who took them 'away'. Now it is also forever linked to the history of a horrific event. We reject the former, masses of things that we decided to

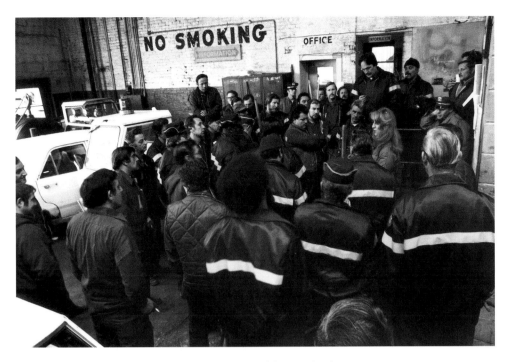

As part of her *Touch Sanitation* performance, Mierle Laderman Ukeles started each day at the early morning roll call in a different sanitation district, inviting the workers to participate by saying, 'I am not here to study or to watch you. As a maintenance artist, I am here to *be with you*, to thank you for keeping New York City alive.'
Mierle Laderman Ukeles / Touch Sanitation Performance: Sweep 7, Staten Island, 6:00 am Roll Call, 1977–80 / photograph / 152 x 229 cm

separate from ourselves. We passionately embrace the latter, memories of victims who could have been any of us. The biography of Fresh Kills always pointed to lives lived fully, richly, even to excess, and now that biography includes the remains of a violence excessive beyond comprehension.

Anthropologist Mary Douglas reminds us that the sacred and the profane are both segregated from the larger society; both are marked by special places and require particular behaviours.[40] Landfills are designated locations for things we no longer want and that can therefore qualify as profane. Often a landfill can be forgotten once it is covered over and turned into something else – a golf course, say, or a park. But landfills like Fresh Kills are too big to ignore, and so they pose a continual cognitive dissonance. They betray the lie of the 'away'. They confront us with part of the real physical cost of the way we organise our material lives.

Whether or not we acknowledge some of the more difficult lessons of a landfill, it is a geography with much to teach. Mierle Laderman Ukeles, artist-in-residence for New York's Department of Sanitation since 1977, knew Fresh Kills intimately while it was still a landfill. In 1989 she was commissioned to contribute to its ongoing transformation and has been deeply engaged in that work ever since. Through a variety of media, with a consortium of city agencies, and for a range of audiences, she is realigning public understandings of what Fresh Kills was, how it came to exist, and what it can become.

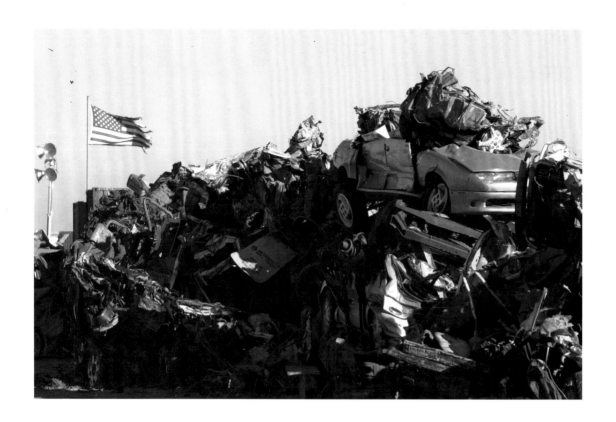

More than 1,200 vehicles destroyed
in the World Trade Center attack in 2001
are piled in heaps at Fresh Kills landfill.
Susan Watts / Crushed and Charred Civilian
Vehicles at Fresh Kills Landfill / 2002 / photograph

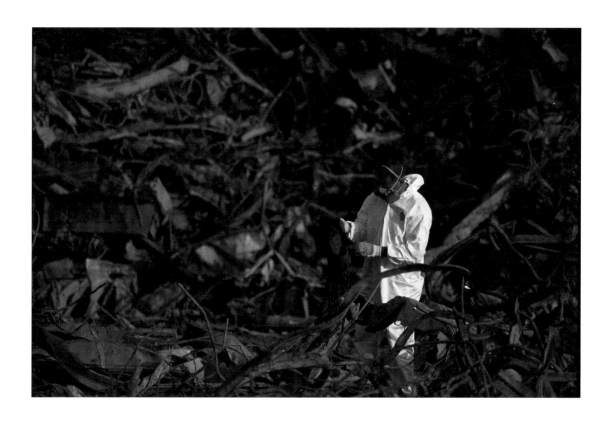

An FBI agent wears a protective suit and gloves
as he examines debris from the World Trade
Center attacks at the Fresh Kills landfill, looking
for evidence, property and the remains of victims.
*Michael Falco / Fresh Kills Landfill with Debris
from the World Trade Center / 2001 / photograph*

Ukeles proposes new and radically compassionate understandings of our relationship with this land. She reminds us that Fresh Kills was created collaboratively by every person whose discards rest within it. She invites us to consider that the connections we have with our material world are already wider than we know; whether or not we recognise it, we are forever bound to landscapes like Fresh Kills.

Ukeles does not work alone. A group of dedicated Department of Parks and Recreation staffers is focused exclusively on Fresh Kills; a fundamental part of their mission is a concerted and creative public outreach campaign. James Corner Field Operations, the landscape architecture firm selected as the site's planning and design consultant in 2003, has been crafting 'a new paradigm of creativity and adaptive reuse'.[41] And the Department of Sanitation, which built the underlying infrastructure across half a century knowing that one day it would become public space, continues to help navigate the dynamic geography of a closed landfill.

No one can heal land that has been claimed for a landfill; Fresh Kills will never again be the salt marsh that it was before 1948. No one can restore any city that has suffered cataclysmic attack to a present in which that event didn't happen; New York will never be the same as it was before 11 September 2001.

We can, however, accept Ukeles's invitation to acknowledge what landfills allow us, to recognise ourselves within them, and to see them for the futures they help create, not just for the pasts in which they were difficult spaces. We can acknowledge the visionary efforts of the teams at Parks, at Field Operations, and at Sanitation to reconfigure Fresh Kills. And we can celebrate the fact that, when landfills are closed, we have the chance to bring our most thoughtful efforts to their future by not forgetting what is in them, nor who shaped the hills where children can gambol, runners can sweat, picnickers can ward off ants, aching citizens can mourn – where we can create a commons for all to cherish.

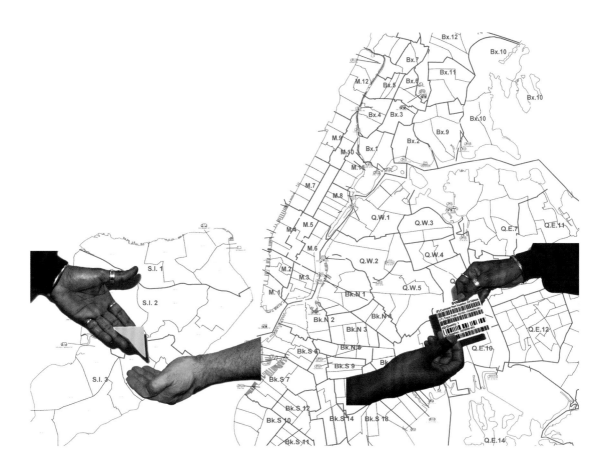

Mierle Laderman Ukeles' 'Public Offerings Made By All Redeemed
By All' proposal aims to transform the social meaning of the new
Freshkills Park site through asking some of the millions of New
Yorkers who contributed over 150 million tons of garbage to Fresh
Kills Landfill to contribute a small object of value to permanently
reside on the site in an act of renewal and respect.
*Mierle Laderman Ukeles / Public Offerings Made By All Redeemed
By All / 2000–2011 / detail of one donor citizen out of one million
releasing an offering and receiving a barcode receipt from the city*

The view from the South Mound of Freshkills Park,
facing north-east, July 2009.
Robin Nagle / Freshkills Park / 2009 / photograph

NOTES

EVACUATION AND REPAIR: DIRT AND THE BODY

1 'Ama ginu nemegere' ('May Ama [God] make your house dirty'). Dogon blessing from Mali.

2 On primate ancestry see D. E. Wilson and D. M. Reader (eds.), *Mammal Species of the World*, 3rd edn (Baltimore: Johns Hopkins University Press, 2005). Health policy anthropologist Valerie Curtis argues for a new 'natural history of hygiene' – 'as an animal behaviour, the proper domain of hygiene is biology, and without this perspective attempts at explanation are incomplete': V. A. Curtis, 'Dirt, disgust and disease: a natural history of hygiene', *Journal of Epidemiology and Community Health*, 61:8 (August 2007), 660–64.

3 For a good introduction see Jonathan Miller, 'Self-help', in *The Body in Question* (London: Jonathan Cape, 1978), 106–41; also Frank MacFarlane Burnet, *The Integrity of the Body* (Cambridge: Cambridge University Press, 1962); more generally see Colin Blakemore and Sheila Jennett (eds.), *The Oxford Companion to the Body* (Oxford/New York: Oxford University Press, 2001).

4 William Ian Miller, *The Anatomy of Disgust* (Cambridge, Mass.: Harvard University Press, 1997); Lyall Gordon, *Jacobson's Organ and the Remarkable Nature of Smell* (London: Allen Lane, 1999); Michael D. Stoddart, *The Scented Ape: The Biology and Culture of Human Odour* (Cambridge/New York: Cambridge University Press, 1990).

5 See Mary Douglas, *Purity and Danger: An Analysis of the Concepts of Pollution and Taboo* (London: Routledge & Kegan Paul, 1966/Ark, 1984); Andrew Shail and Gillian Howie, *Menstruation: A Cultural History* (Basingstoke/New York: Palgrave Macmillan, 2005); L. Dean-Jones, *Women's Bodies in Classical Greek Science* (Oxford: Oxford University Press, 1994).

6 See Stephen Kaplan and Rachel Kaplan, *Cognition and Environment: Functioning in an Uncertain World* (New York: Praeger, 1982); Jerome H. Barkow, Leida Cosmides and John Tooby (eds.), *The Adapted Mind: Evolutionary Psychology and the Generation of Culture* (New York: Oxford University Press, 1992).

7 See Robin Dunbar, *Grooming, Gossip and the Evolution of Language* (London: Faber & Faber, 1996), and *Primate Social Systems* (London: Croom Helm, 1988). The classic study is Desmond Morris's *The Naked Ape: A Zoologist's Study of the Human Animal* (London: Jonathan Cape, 1967). See also D. Morris (ed.), *Primate Ethology* (London: Weidenfeld & Nicolson, 1967), including J. Sparks, 'Allogrooming in primates: a review', 148–75. On the discipline of animal ethology see P. J. Bowler, *The Environmental Sciences* (London: Fontana, 1972).

8 W. C. McGrew and C. E. G. Tutin, 'Chimpanzee tool use in dental grooming', *Nature*, 24 (16 February 1973), 477–8. See also Marc Abrahams, 'Dental flossing – even a monkey could do it', *Education Guardian*, 27 May 2010, on monkeys using dental floss (and human hair as dental floss).

9 Most of the work that has been done concentrates largely on hair customs, with some work on tattooing and body art – perhaps because both are highly photogenic.

10 Ernst H. Kantorowicz, *The King's Two Bodies: A Study in Medieval Political Thought* (1957; Princeton: Princeton University Press, 1981). Eighteenth-century French court rituals were extensively analysed by Norbert Elias in *The Court Society*, trans. Edmund Jephcott (Oxford: Blackwell, 1983). See also Sandra Cavallo, *Artisans of the Body in Early Modern Italy* (Manchester: Manchester University Press, 2007); Anne Somerset, *Ladies in Waiting: From the Tudors to the Present Day* (London: Weidenfeld & Nicolson, 1984).

11 On health patterns in the early modern period see Margaret Pelling, 'Appearance and reality: barber-surgeons, the body, and disease in early modern London', in L. Beier and R. Finlay (eds.), *London 1500–1700: The Making of the Metropolis* (London: Longman, 1986). For the twentieth century see Margaret

Stacey, *The Sociology of Health and Healing: A Textbook* (London: Unwin Hyman, 1988); Mildred Baxter, *Health and Lifestyles* (London/New York: Tavistock/Routledge, 1990).

12 On Greek balneology see René Ginouvès, *Balaneutiké: Recherches sur les bains dans l'antiquité grecque* (Paris: Editions E. de Boccard, 1962). Nit-picking 'in bed, by the fire, at the window or on a shoemaker's bench . . . [or] in the doorway' was recorded in the Inquisition documents studied by Emmanuel Le Roy Ladurie in *Montaillou: Cathars and Catholics in a French Village 1294–1324* (London: Penguin, 1980), 141. Outdoor medieval public baths were recorded in numerous contemporary illustrations, most notably by Dürer; see Virginia Smith, *Clean: A History of Personal Hygiene and Purity* (Oxford: Oxford University Press, 2007), 168–80. En-suite latrines were usual in knightly houses by the medieval period, with or without a bathroom. On internal arrangements in noble houses, see Mark Girouard, *Life in the French Country House* (London: Cassell, 2000), and the many boudoir pictures in Françoise de Bonneville, *The Book of the Bath*, trans. Jane Brenton (London: Thames & Hudson, 1998).

13 See generally H. S. F. Saggs, *The Babylonians: A Survey of the Ancient Civilisation of the Tigris-Euphrates Valley* (London: Folio Society, 1999). See also Dennis Dutton, *The Art Instinct: Beauty, Pleasure and Human Evolution* (Oxford: Oxford University Press, 2009); Ellen Dissanayake, *Art and Intimacy: How the Arts Began*, 2nd edn (Seattle: University of Washington Press, 2000). See also Smith, 'The Cosmetic Toilette', in *Clean*, op. cit., 44–73.

14 B. L. Strassmann, 'The evolution of endometrial cycles and menstruation', *Quarterly Review of Biology*, 71:2 (June 1996), 181–220; Sharra L. Vostral, 'Masking menstruation: the emergence of menstrual hygiene products in the United States', in Shail and Howie, *Menstruation*, op. cit., 243–58; see also William Buchan, *Domestic Medicine* (1769; 2nd edn 1785), ch. 48, 'Diseases of women'.

15 On concerns about 'basic' bedside nursing see, for example, Simon Cooper, Leigh Kinsman, Penny Buykx, Tracy McConnell-Henry, Ruth Endacott and Julie Scholes, 'Student nurses show poor skills in treating deteriorating patients', *Journal of Clinical Nursing*, 19:15–16 (August 2010), 2309–18; 'Why can't we see what is right in front of us?', www.nursingtimes.net, 30 November 2009.

16 Francis Beckett, 'An unsentimental education', *Independent on Sunday*, 19 March 1995, 2; Emily B. Hager, 'Forget vampires, these bloodsuckers bite', *New York Times*, 12 September 2010, reporting on a bedbug plague in New York.

17 B. M. Spruijt, J. A. R. A. M van Hoof and W. H. Gispen, 'Ethology and neurobiology of grooming behaviour', *Physiological Review*, 72:3 (1992), 834–9; see also Sparks, 'Allogrooming'.

18 The importance of what was then known as 'primitive' and 'animal' medicine was in fact strongly promoted by historians Henry Sigerist and Erwin Ackerknecht. See, for example, H. Sigerist, *Landmarks in the History of Hygiene*, Health Clark Lectures (London: Oxford University Press, 1965).

DISHING THE DIRT: DIRT IN THE HOME

1 Georges Vigarello, *Concepts of Cleanliness: Changing Attitudes in France Since the Middle Ages* (Cambridge: Cambridge University Press, 1998).

2 Caroline Davidson, *A Woman's Work Is Never Done: A History of Housework in the British Isles, 1650–1950* (London: Chatto and Windus, 1982), 116–17.

3 Elizabeth Shove, *Comfort, Cleanliness and Convenience: The Social Organization of Normality* (Oxford: Berg, 2003).

4 Davidson, *A Woman's Work*, op. cit., 115–17.

5 Pamela Sambrook, *The Country House Servant* (Stroud: Sutton Publishing in association with The National Trust, 1999), 222.

6 Davidson, *A Woman's Work*, op. cit., 119–20.

7 www.thefarm.org/charities/i4at/surv/soapmake.htm.

8 Susan Strasser, *Never Done: A History of American Housework* (New York: Pantheon, 1982), 89.

9 Ibid., 76–84, 117–24.

10 Lydia Matens, 'The visible and the invisible: (de)regulation in contemporary cleaning practices', in Ben Campkin and Rosie Cox (eds.), *Dirt: New Geographies of Cleanliness and Contamination* (London: I. B. Tauris, 2007), 34–48.

11 Ann Oakley, *Housewife* (London: Pelican, 1974), 222.

12 Suellen Hoy, *Chasing Dirt: The American Pursuit of Cleanliness* (Oxford: Oxford University Press, 1995), 89.

13 Ibid., 119.

14 *Independent*, 27 August 2010, 30; Bridget Anderson, *Doing the Dirty Work: The Global Politics of Domestic Labour* (London: Zed Books, 2000); Rosie Cox, *The Servant Problem: Domestic Employment in a Global Economy* (London: I. B. Tauris, 2006).

LEVITICUS BE DAMNED: DIRT IN THE COMMUNITY

1 www.chabad.org/library/article_cdo/aid/82675/jewish/Kosher-Fish-List.htm#NKFL.

2 Mary Douglas, *Purity and Danger: An Analysis of Concepts of Pollution and Taboo* (London: Routledge, 1991).

3 Revert Muslims Association, www.revertmuslims.com/sala_wudu.html.

4 M. A. Guterman, P. Mehta and M. S. Gibbs, 'Menstrual taboos among major religions', *Internet Journal of World Health and Societal Politics*, 5:2 (2008).

5 Jacky Bouju, 'Sanitation and urban governance', in L. Atlani-Duault and L. Vidal (eds.), *Anthropologie de l'aide humanitaire et du développement. Des pratiques aux savoirs, des savoirs aux pratiques* (Paris: Armand Colin, 2009).

6 Masaki Tumadori, 'Soap and detergent product trends in Asian and Pacific Countries', in Arno Cahn (ed.), *Proceedings of the 3rd World Conference on Detergents* (Urbana: AOCS Publishing, 1994), 32–8, www.crcnetbase.com/doi/bs/ 10.1201/9781439832660.ch6.

7 Restroom Association (Singapore), www.toilet.org.sg/index.html.

8 UNICEF, www.childinfo.org/mortality_imrcountrydata.php.

9 X. S. Wang, T. N. Tan, L. P. C. Shek, S. Y. Chng, C. P. P. Hia, N. B. H. Ong, S. Ma, B. W. Lee and D. Y. T. Goh, 'The prevalence of asthma and allergies in Singapore; data from two ISAAC surveys seven years apart', *Archives of Disease in Childhood*, 89:5 (May 2004), 423–6.

10 B. S. C. Woo, T. P. Ng, D. S. S. Fung, Y. H. Chan, Y. P. Lee, J. B. K. Koh and Y. Cai, 'Emotional and behavioural problems in Singaporean children based on parent, teacher and child reports', *Singapore Medical Journal*, 48:12 (December 2007), 1100–6.

11 UNAIDS, www.unaids.org/en/KnowledgeCentre/HIVData/EpiUpdate/EpiUpdArchive/2009/default.asp.

12 Lewis Lapham, *Money and Class in America: Notes and Observations on Our Civil Religion* (New York: Weidenfeld & Nicolson, 1988).

13 Described by Sophie Howarth at Tate Online, www.tate.org.uk/.

14 Sayed Mohammad Kazem Hosseini and Sayed Davood Hosseini, 'Determination of the mean daily stool weight, frequency of defecation and bowel transit time: assessment of 1000 healthy subjects', *Archives of Iranian Medicine*, 3:4 (2000); www.ams.ac.ir/aim/0034/asl0034.html.

15 www.sothebys.com/app/live/lot/LotDetail.jsp?lot_id=159357773.

16 Finfacts Ireland. n.d. Historical Gold Prices 1800–2009. *Finfacts Ireland*. http://www.finfacts.com/Private/curency/goldmarketprice.htm.

17 Charles Kingsley, *Politics for the People* (London: John Parker, 1848), 6.

THE BLUE GIRL: DIRT IN THE CITY

1 Letter to the editor, *Leeds Mercury*, 3 November 1831.

2 *The Long View*, BBC Radio 4, 15 April 2003, www.bbc.co.uk/radio4/history/longview/longview_20030415_readings.shtml.

3 Ibid.

4 Cited in Geoffrey Milburn and Stuart Miller (eds.), *Sunderland – River, Town and People: A History from the 1780s to the Present Day* (Sunderland: Sunderland Borough Council, 1988).

5 Quoted in Michael Holland, Geoffrey Gill and Sean Burrell, *Cholera & Conflict: 19th Century Cholera in Britain and Its Social Consequences* (Leeds: Medical Museum Publishing, 2009), 47.

6 Stephen Halliday, *The Great Stink of London: Sir Joseph Bazalgette and the Cleansing of the Victorian Metropolis* (Stroud: Sutton, 1999), 127.

7 Martin Dawson, 'London's Great Stink and Victorian Urban Planning', www.bbc.co.uk/history/trail/victorian_britain/social_conditions/victorian_urban_planning_01.shtml.

8 Michael Holland, Geoffrey Gill and Sean Burrell, *Cholera and Conflict: 19th Century Cholera in Britain and its Social Consequences* (Leeds: Thackray Museum, 2009), 339.

9 Sheela Patel, 'Sanitation for the poor: the experience of the Indian alliance of SPARC, Mahila Milan and NSDF (1984 to 2003)', Society for the Promotion of Area Resource Centres, October 2003, www.online.citibank.co.in/portal/newgen/Comm/sparc/news1.htm.

10 Personal interview with David Kuria, 21 May 2009.

11 Robert Lacey, *Great Tales from English History* (New York: Little, Brown, 2006), 189.

12 www.infrastructurereport card.org/fact-sheet/drinking-water.

13 Press release, 30 April 2009, http://lautenberg.senate.gov/newsroom/record.cfm?id=312308.

14 William H. Brock, *Justus Von Liebig: The Chemical Gatekeeper* (Cambridge: Cambridge University Press, 2002), 253.

15 Karl Marx, *Capital*, vol. III, cited in Paul Burkett, *Marx and Nature: A Red and Green Perspective* (New York: St Martin's Press, 1999), 127.

16 Alderman Mechi, 'Some of the causes that tend to render farming unprofitable', *Veterinary Review and Stockowners' Journal*, January 1865, 34–42.

17 Or in excess of 500 million gallons: www.riverkeeper.org/campaigns/stop-polluters/cso/.

18 www.waterboards.ca.gov/water_issues/programs/sso/.

19 Suzan Given, Linwood H. Pendleton and Alexandra B. Boehm, 'Regional public health cost estimates of contaminated coastal waters: a case study of gastroenteritis at southern California beaches', *Environmental Science & Technology*, 40:16 (2006), 4851–8.

20 Erving Goffman, *Behavior in Public Places: Notes on the Social Organization of Gatherings* (New York: Free Press, 1963), 83.

21 Charles Duhigg, 'As sewers fill, waste poisons waterways', *New York Times*, 22 November 2009.

22 Charles Duhigg, 'Saving US water and sewer systems would be costly', *New York Times*, 14 March 2010.

23 Cited in Margaret Beattie Bogue, *Fishing the Great Lakes: An Environmental History, 1783–1933* (Madison: University of Wisconsin Press, 2000), 288.

TO LOVE A LANDFILL: DIRT AND THE ENVIRONMENT

1 Not all communities despise landfills. Some towns can earn significant revenue by hosting landfills for larger cities or private waste haulers. Tullytown, Pennsylvania, for instance, saw a reversal of its economic despair when residents agreed to open a landfill for New York and Long Island trash in 1991. The town (population: just under 2,000) earned payments of between $2 million and $4 million a year for more than a decade, funding a new Borough Hall, playgrounds, park, library, police station, fire trucks and an annual 'property improvement allocation' of $1,500 per homeowner per year. See P. Kilborn, 'In Mount Trashmore's shadow, the gravy train slows down', *New York Times*, 1 April 2002.

2 M. L. Ukeles, 'It's about time for Fresh Kills', *Cabinet*, 6 (Spring 2002), 17–20.

3 A. Corbin, *The Foul and the Fragrant: Odor and the French Social Imagination* (Cambridge, Mass.: Harvard University Press, 1986).

4 Landfilling, 'one of the oldest and perhaps the simplest form of biotechnology', accounts for nearly 70 per cent of municipal solid waste disposal in the United States. See J. Suflita, C. P. Gerba, R. K. Ham, A. C. Palmisano, W. L. Rathje and J. A. Robinson, 'The world's largest landfill: a multidisciplinary investigation', *Environmental Science & Technology*, 26:8 (1992), 1486–95.

5 Ibid.

6 Martin and Russell note that garbage generation is 'a universal human activity … Materials discarded are seen as refuse, things that, while they may have some residual value for reuse or recycling, are essentially a nuisance that needs to be removed from the places where people do things', and that garbage can thus produce useful artefacts for research (L. Martin, and N. Russell, 'Trashing rubbish', in Ian Hodder (ed.), *Towards Reflexive Method in Archaeology: The Example at Çatalhöyük* (Cambridge: McDonald Institute, 2000), 57–69, at 57). Needham and Spence also point out that trash is '. . . rich in significance for many aspects of social organization' (S. Needham and T. Spence, 'Refuse and the formation of middens', *Antiquity*, 71 (1997), 77–90, at 77).

7 M. Melosi, *Garbage in the Cities: Refuse, Reform, and the Environment, 1880–1980* (College Station: Texas A&M University Press, 1981), 3–20; W. Rathje, 'Rubbish!', *Atlantic Monthly*, December 1989, 1–10, at 1, 2.

8 T. McLaughlin, *Dirt: A Social History as Seen through the Uses and Abuses of Dirt* (New York: Stein & Day, 1971), 67.

9 Ibid., 27–8.

10 See S. Halliday, *The Great Stink of London: Sir Joseph Bazalgette and the Cleansing of the Victorian Metropolis* (Stroud: Sutton, 1999) for a detailed description of the Great Stink of 1858, when the Thames became so fetid that it stopped the City of London.

11 L. Mumford, *The City in History: Its Origins, Its Transformations, and Its Prospects* (New York: Harcourt, Brace and World, 1961), 447.

12 S. Corey, 'King Garbage: a history of solid waste management in New York City, 1881–1970', unpublished PhD thesis, New York University, 1994, 72.

13 N. Rothschild, *New York City Neighborhoods: The 18th Century* (New York: Academic Press, 1990), 16.

14 New York City Department of Street Cleaning Annual Report, 1905, 74.

15 J. Rykwert, *The Seduction of Place: The History and Future of the City* (New York: Vintage, 2002), 24–5.

16 The transformation of Boston Common from a grazing pasture to a public park marks a significant shift in the way Americans understood the role of green space in an urban context. For more on this fascinating story, see Michael Rawson, *Eden on the Charles: The Making of Boston* (Cambridge, Mass.: Harvard University Press, 2010).

17 According to Garrett Hardin's famous explanation, an unmanaged commons will be used by its members for their individual benefit before any other consideration. This model of resource management dooms any commons, since unmitigated personal gain will always come at the expense of the larger good. See G. Hardin, 'The tragedy of the commons', in John Baden and Douglas Noonan (eds.), *Managing the Commons*, 2nd edn (Indianapolis: Indiana University Press, 1998, first published 1968), 3–16 and 'The global pillage: consequences of unmanaged commons', in G. Hardin, *Living Within Limits: Ecology, Economics, and Population Taboos* (New York: Oxford University Press, 1993), 215–24.

18 A dump may serve as a commons. The difference between a landfill and a dump, according to the US Environmental Protection Agency, is the way in which they are constructed and thus how the garbage within them decomposes. A dump is established without any environmental controls, a polite way of saying that it can spring up nearly anywhere – in an empty lot, down a backcountry holler, along a riverbank. One of the most infamous dumps in the world is Smoky Valley outside Manila. A community of up to 80,000 people scavenged a livelihood from it when it collapsed after heavy rains on 10 July 2000, killing more than a thousand.
 A landfill is not so haphazardly constructed. According to the EPA website, a landfill is a repository for 'non-hazardous solid wastes spread in layers, compacted to the smallest practical volume, and covered by material applied at the end of each operating day' (www.epa.gov/glossary/lterms.html).

19 It is possible to live without creating much trash, but such lifestyles are bracketed as 'alternative' and thought to be impractical. They require at minimum a relationship between an individual and her notions of time that is different from what most Westerners know or want.

20 It's never simple, of course; that bucket of rotting fruit might be destined for a compost heap, which could alleviate some of the nausea that it could provoke. For a thorough discussion of many varieties and implications of disgust see W. Miller, *The Anatomy of Disgust*, (Cambridge, Mass.: Harvard University Press, 1997).

21 There can be a later use for trash, even landfilled trash. Landfill mining is becoming attractive in some parts of Europe (see M. O'Brien, 'Rubbish-power: towards a sociology of the rubbish society', in J. Hearn and S. Roseneil (eds.), *Consuming Cultures: Power and Resistance* (New York: St Martin's Press, 1999), and Tim Webb, 'Why landfill mining could be the next big thing', *Guardian*, 11 October 2010; www.guardian.co.uk/business/2010/oct/11/energy-industry-landfill).

22 W. Stegner, 'The town dump', *Atlantic Monthly*, October 1959, 78–80, at 78.

23 W. Rathje, 'Time capsules: the future's lost and found', *Scientific American: Discovering Archaeology*, November/December 1999, 86–8 at 88.

24 Associated Press, 'Couple plans wedding at town dump' (15 July 2003); 'Couple weds at dump where they met' (3 September 2003).

25 For a more eloquent elaboration, see J. Mitchell, *Up in the Old Hotel* (New York: Vintage, 1993).

26 A thorough description is found in B. Miller, *Fat of the Land: A History of Garbage in New York – The Last Two Hundred Years* (New York: Four Walls Eight Windows, 2000), 127–35.

27 For an admiring if naïve profile of Moses' influence on New York City, written while Moses was reaching the peak of his powers, see C. Rodgers, 'Robert Moses', *Atlantic Monthly*, February 1939, 225–34.

28 Staten Islanders sued the Departments of Health and Sanitation to try to stop Fresh Kills from becoming a landfill, to no avail. See R. Fenton, 'An analysis of the problems of sanitary landfills in New York City', report to the Department of Health, Bureau of Sanitary Engineering, 1947.

29 Quoted in R. Severo, 'Monument to modern man: "alp" of trash is rising', *New York Times*, 13 April 1989.

30 The daily load at Fresh Kills was cut in half in 1988 when the city doubled tipping fees for private carters, forcing them to find cheaper disposal options.

31 Incineration was a popular waste-disposal method in New York for decades, starting in the late 1890s. In 1930, the city had nineteen incinerators, including the three largest in the world. By the 1960s, 'refuse incinerators were deeply rooted in New York City's waste disposal infrastructure. Thirty-six furnaces in eleven municipal incinerators and some 17,000 apartment house incinerators – arguably the largest refuse incineration infrastructure ever assembled in a city – were burning about 40 per cent of NYC's refuse and emitting about 35 per cent of the city's airborne particulate matter' (D. C. Walsh, 'Incineration: what led to the rise and fall of incineration in New York City?', *Environmental Science & Technology*, 1 August 2002, 321).

32 In his 1997 bid for re-election, Giuliani won close to 90 per cent of the vote in most of the borough.

33 Confirmed by NASA; see M. Schoofs, 'Storied New York landfill lives to tell one more tale', *Wall Street Journal*, 28 September 2001.

34 According to Ben Miller (personal communication), Fresh Kills' remaining capacity alone would make it the sixth largest landfill in the country.

35 *Staten Island Advance*, online forum (www.silive.com/), 19 September 2001.

36 N. Dmytryszn, 'Landscape and Memory', in *Fresh Kills: Artists Respond to the Closing of the Landfill*, exhibition catalogue, Snug Harbor Cultural Center, Staten Island, New York, 2002 (emphasis in original).

37 See W. Brekhus, 'A sociology of the unmarked: redirecting our focus', *Sociological Theory*, 16:1 (1998), 34–51. 'Just as we visually highlight some physical contours and ignore others,' he writes, 'we mentally foreground certain contours of our social landscape while disattending others.' Fresh Kills and other landfills hold the physical remains of objects once socially engaged and now purposefully 'unmarked', or, as Ukeles notes in 'It's about time for Fresh Kills', unnamed.

38 This remarkable achievement may never be recognised by a wider public. One of the earliest sanitary landfills in the country was established in Fresno, California, in the 1930s. A few years after it was closed in 1987, a group of scholars proposed it as a National Historic Landmark. The idea inspired a backlash of mocking protest. For the proposal, see M. Melosi, 'The Fresno sanitary landfill as a national historic landmark', *American Society for Environmental History News*, 13:2 (Summer 2002), 1, 3. For the backlash, see J. Dowdell and B. Thompson, 'Landfill or landmark?', *Landscape Architecture*, November 2001, 16; J. Martin, 'Can a landfill become a landmark?', letter to the editor, *Landscape Architecture*, February 2002, 9.

39 The research of Steven Handel, an ecologist at Rutgers University, is one example. He has been working on Fresh Kills since 1993 to determine which species might thrive without compromising its underlying infrastructure. He has had good success with hackberry, crab apple, and mulberry trees, as well as with rose, beach plum and other shrubs. See J. Carlton, 'Where trash reigned, trees sprout', *Wall Street Journal*, 23 January 2002, B1; see also W. Young, 'Fresh Kills landfill: the restoration of landfills and root penetration', in Niall Kirkwood (ed.), *Manufactured Sites: Rethinking the Post-Industrial Landscape* (London: Spon, 2001).

40 M. Douglas, *Purity and Danger: An Analysis of the Concept of Pollution and Taboo* (New York: Pantheon, 1970).

41 New York Department of City Planning. Fresh Kills Park Project: Project History, www.nyc.gov/html/dcp/html/fkl/fkl2.shtml.

ILLUSTRATION CREDITS

All images reproduced by courtesy of the Wellcome Trust, except for those listed below.

page ii: Close 118, High Street, Glasgow. © The British Library Board. L.R.404.g.8.
page vii: Roman cremation burial jar. © Museum of London.
page viii: Delftware plate. © Museum of London.
page 4: Touch Sanitation Performance: Fresh Kills Landfill. Mierle Laderman Ukeles, 1977–1980, ©
 Mierle Laderman Ukeles, courtesy Ronald Feldman Fine Arts, New York.
page 5: Public Offerings Made By All Redeemed By All. Mierle Laderman Ukeles, 2000–2011,
 © Mierle Laderman Ukeles, courtesy Ronald Feldman Fine Arts, New York.
page 24: Child at Queensbridge Housing Project Hygiene Program. Library of Congress.
page 26: Raw Material Washing Hands, Normal (A of A/B) Raw Material Washing Hands, Normal
 (B of A/B). Bruce Nauman, 1996. Acquired jointly with the National Galleries of Scotland
 through The d'Offay Donation with assistance from the National Heritage Memorial Fund
 and the Art Fund 2008. © Tate, London 2010 © ARS, NY and DACS, London 2010.
page 27: A Mother's Duty. Pieter de Hooch, collection Rijksmuseum, Amsterdam.
page 28: Poster by Erik Hans Krause. Library of Congress.
page 52: Housemaid Ironing a Lace Doily with Electric Iron. Library of Congress.
page 53: Portrait of America No. 36. Library of Congress.
page 58: Immigrants arriving at Ellis Island. Library of Congress.
page 60: Outside Water Supply in Slum Area, Washington, DC. Library of Congress.
page 61: Evelyn, a Little Native Maid. Library of Congress.
page 63: Wash Day on the Plantation. Library of Congress.
page 64: The Wife of a Wholesale Grocer in Her Kitchen with Her Maid. Library of Congress.
page 66: A Dutch Interior. Pieter de Hooch, © The Wernher Foundation. English Heritage
 Photo Library.
page 67: Window Series #1. James Croak, 1991, © James Croak. Photograph courtesy of the artist.
pages 68–9: Untitled, (Bremen Carpet). Igor Eskinja, 2010, © Igor Eskinja. Photographs courtesy of
 the artist and Federico Luger.
pages 70–71: Waltzer. Susan Collis, 2007, © Susan Collis. Photographs by Dave Howland. Images
 courtesy of Seventeen Gallery.
page 72: Kitchen Interior with Pot, Broom and Bucket. Geertruid Roghman, courtesy of Atlas Van
 Stolk, Rotterdam.
page 73: Interior with Young Woman Washing Pots. Hendrick Sorgh, © York Museums Trust (York
 Art Gallery), presented by F. D. Lycett Green through The Art Fund, 1955. YORAG:758.
page 100: Mudwrestlers Match. Mud-shack, 2010, image courtesy of www.mud-shack.co.uk.
page 110: John Davison Rockefeller with John D. Rockefeller Jr.: Library of Congress.
page 114: Artist's Shit. Piero Manzoni, 1961, © Tate, London 2010, © DACS 2010.
page 115: Fountain. Marcel Duchamp, 1917, replica 1964. Purchased with assistance from the Friends
 of the Tate Gallery 1999, © Tate, London 2010, © Succession Marcel Duchamp/ADAGP,
 Paris and DACS, London 2010
page 116: Portrait of Hannah Wearing Men's Clothes. Courtesy of The Master and Fellows
 of Trinity College Cambridge.
page 117: Portrait of Hannah as a Slave. Courtesy of The Master and Fellows
 of Trinity College Cambridge.
page 118: Portrait of Jane Brown, a Wigan Pit-Brow Girl. Courtesy of The Master and Fellows
 of Trinity College Cambridge.
page 119: Portrait of Hannah Cullwick. Courtesy of The Master and Fellows
 of Trinity College Cambridge.
page 119: Portrait of Hannah Scrubbing the Floor. Courtesy of The Master and Fellows
 of Trinity College Cambridge.
pages 120–21: Pioneer Health Centre. Dell & Wainwright, 1935. Courtesy of Dell & Wainwright /
 RIBA Library Photographs Collection.

page 122: Pioneer Health Centre. Architectural Press Archive, 1935. Courtesy of Architectural Press Archive / RIBA Library Photographs Collection.
page 123: Finsbury Health Centre. Courtesy of John Maltby / RIBA Library Photographs Collection.
pages 124–5: Finsbury Health Centre. Courtesy of Dell & Wainwright / RIBA Library Photographs Collection.
page 126: The German Hygiene Museum Exhibition Halls. Courtesy of the Deutsches Hygiene-Museum.
page 127: Foyer of the German Hygiene Museum. Courtesy of the Deutsches Hygiene-Museum.
page 128: Poster for the First International Hygiene Exhibition. Photographer; Volker Kreidler. Courtesy of the Deutsches Hygiene-Museum.
page 129: Odol. Stuart Davis, 1924. Mary Sisler Bequest (by exchange) and purchase. 645.1997 © 2010. Digital image, The Museum of Modern Art, New York/Scala, Florence.
pages 130–31: Parseval Airship D-PN-30. Courtesy of the Deutsches Hygiene-Museum.
page 141: Father Thames Introducing His Offspring to the Fair City of London. © The British Library Board.
page 152: Shanti Nagar Pay Toilet. Rose George, 2006. Courtesy of Rose George.
page 158: New York City Sanitation Department Employee Sweeping Street. Library of Congress.
page 160: Your Home Is Not Complete Without a Sanitary Unit. Library of Congress.
page 163: Interior of Crossness Pumping Station. Matthew Wood, 2010. Courtesy of Matthew Wood and Thames Water.
pages 164–7: Supervisors at Thames Water on Site Inspection; Men Working on the Tunnel front in the Southern Outfall Sewer; NESR Sewer; Eltham Relief Sewer. Courtesy of Thames Water.
pages 168–73: Breathing In. Angela Palmer, 2007. © Angela Palmer. Courtesy of the artist.
page 174: Freshkills Park. Courtesy of the City of New York.
page 176: Aerial View of the West Shore of Staten Island. Courtesy of the City of New York.
page 184: Photograph of Serena Korda. Image by Alice Carey, 2011, © Serena Korda. Courtesy of UP Projects.
page 185: Photographs of Serena Korda. Images by Michael Andreae, 2011, © Serena Korda. Courtesy of UP Projects.
page 186: Last Barge. Robin Nagle, 2001. Courtesy of Robin Nagle.
page 189: Athey Wagons at Fresh Kills. Courtesy of Robin Nagle.
page 191: Fresh Kills Landfill on Staten Island. © I. E. Diane Cook / Stone / Getty Images.
page 192: Bank Supervisor's Office, Fresh Kills. Courtesy of Robin Nagle.
page 193: Landfilling at Fresh Kills. Courtesy of Robin Nagle.
page 195: Tractor at Fresh Kills Landfill. Stephen Ferry, 1990. © Stephen Ferry / Getty Images News / Getty Images.
page 196: Active Bank at Fresh Kills Landfill. Courtesy of Robin Nagle.
page 197: Lower Manhattan as seen from Fresh Kills Park. Robin Nagle, 2009. Courtesy of Robin Nagle.
page 199: Touch Sanitation Performance: Sweep 7, Staten Island, 6:00 a.m. Roll Call. Mierle Laderman Ukeles, 1977–80. © Mierle Laderman Ukeles. Courtesy of Ronald Feldman Fine Arts, New York.
page 200: Crushed and Charred Civilian Vehicles at Fresh Kills Landfill. Susan Watts, 2002. © Susan Watts / New York Daily News Archive / Getty Images.
page 201: Fresh Kills Landfill with Debris from the World Trade Center. Michael Falco, 2001. © Michael Falco / Getty Images News / Getty Images.
page 203: Public Offerings Made By All Redeemed By All. Mierle Laderman Ukeles, 2000–2011. © Mierle Laderman Ukeles. Courtesy of Ronald Feldman Fine Arts, New York.
pages 204–5: Freshkills Park. Robin Nagle, 2009. Courtesy of Robin Nagle.

NOTES ON THE CONTRIBUTORS

Rosie Cox is Senior Lecturer in Geography and Gender Studies at Birkbeck, University of London. She has a long-standing research interest in the domestic, dirt and cleaning, particularly paid domestic labour in contemporary London. She is author of *The Servant Problem: Domestic Employment in a Global Economy* (I. B. Tauris, 2006) and co-editor of *Dirt: New Geographies of Cleanliness and Contamination* (I. B. Tauris, 2007).

Kate Forde is Curator of Temporary Exhibitions at Wellcome Collection, London. Recently she has worked on exhibitions examining the mysteries of sleep, the relationship between war and medicine, and the history of anatomical waxworks. Kate is particularly interested in the display of fine art within scientific institutions and the role museums play in the shaping of cultural memory.

Rose George is a freelance writer who has written for the *New York Times, Guardian, Independent, London Review of Books* and many other publications. She is the author of *A Life Removed: Hunting for Refuge in the Modern World* (Penguin, 2004) and *The Big Necessity: Adventures in the World of Human Waste* (Portobello, 2008).

Richard Hengist Horne (1802–84) was a relatively obscure English poet and critic. He was the editor of the *Monthly Repository* and wrote a *History of Napoleon* as well as two tragedies, *Cosmo de' Medici* and *The Death of Marlowe*, but was probably better known for his poem 'Orion' and his long-standing correspondence with Elizabeth Barrett Browning.

Robin Nagle is anthropologist-in-residence with the Department of Sanitation in New York City, and director of the Draper Interdisciplinary Master's Program at New York University. She is the author of *Picking Up* (Farrar, Straus and Giroux, forthcoming), an ethnography about the experience of being a sanitation worker.

Elizabeth Pisani is an epidemiologist who has spent over a decade researching HIV and AIDS. She has worked with the Ministries of Health in China, Indonesia, East Timor and the Philippines, and has advised UNAIDS, the World Health Organisation, the World Bank, US Centers for Disease Control and many others. She is also the author of *The Wisdom of Whores: Bureaucrats, Brothels and the Business of AIDS* (Granta, 2008).

Brian Ralph is full time professor at the Savannah College of Art and Design. His comics and illustrations have appeared in publications such as *Wired*, the *New York Times* and *Giant Robot* magazine, for which he produces a regular comic. He is the author of Cave-in (Highwater Books, 1999), which was nominated for three Harveys and one Eisner award, as well as *Climbing Out* (Highwater Books, 2003).

Virginia Smith is an Honorary Fellow at the Centre for History in Public Health at the London School of Hygiene and Tropical Medicine. Ongoing research interests include the history of grooming, cosmetics, spas, nudity, time theory and contemporary health policies. She is the author of *Clean: A History of Personal Hygiene and Purity* (Oxford University Press, 2007).

ACKNOWLEDGEMENTS

We would like to thank everyone who made the process of creating this book so interesting and satisfying. First and foremost, we would like to thank the authors, Virginia Smith, Rosie Cox, Elizabeth Pisani, Rose George, Robin Nagle and Brian Ralph, for tackling the ideas discussed in this book with such passion and rigour.

We would also like to thank those who offered guidance, advice and support throughout the process, including Ken Arnold, James Peto, Tim Boon, Ted Bianco, Thiago Carvalho, Daniel Glaser, Michael John Gorman, Lisa Jamieson, Colin Martin, Clare Matterson, John Scanlan, Mierle Laderman Ukeles, Lucy Shanahan, Anna Smith, Amy Sanders, Sabien Khan, Adam Hines-Green, Peter Brimblecombe, Serena Korda, Angela Palmer, James Croak, Igor Eskinja, Susan Collis, Stephen Pook, Matthew Wood at Thames Water, Raj Kottamasu at the City of New York, Jonathan Smith at Trinity College Cambridge, Colleen Schmitz at the Deutsches Hygiene-Museum, Emma Underhill and Laura Harford at UP Projects, Val Curtis at the London School of Hygiene and Tropical Medicine, Cathy Ross and Sarah Williams at the Museum of London, and Betsy Wieseman at the National Gallery.